THIS BOOK BELONGS TO:

DINOTOPIA
JOURNEY TO CHANDARA

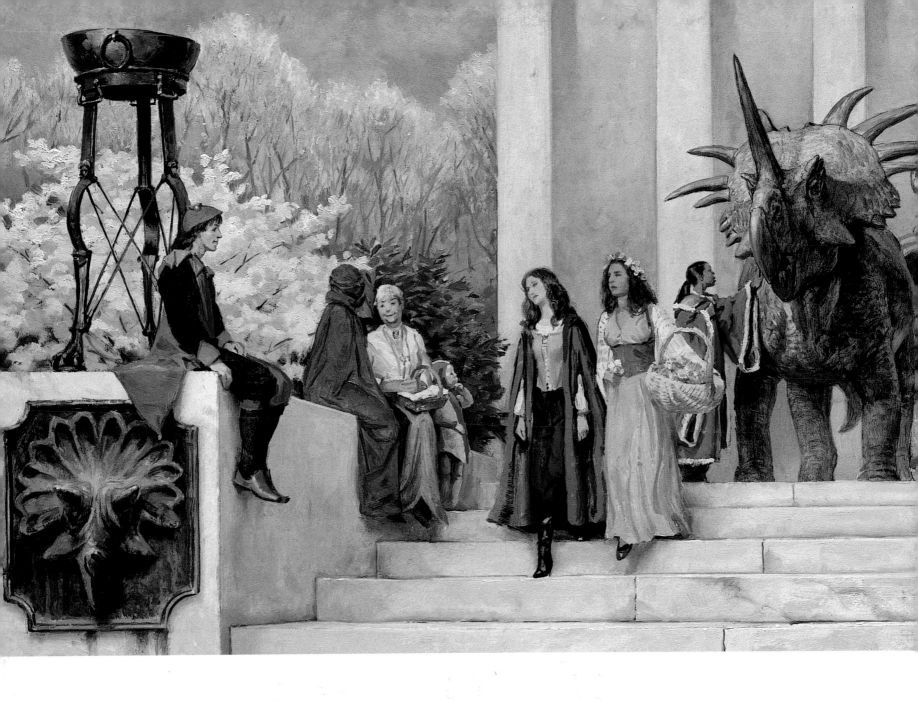

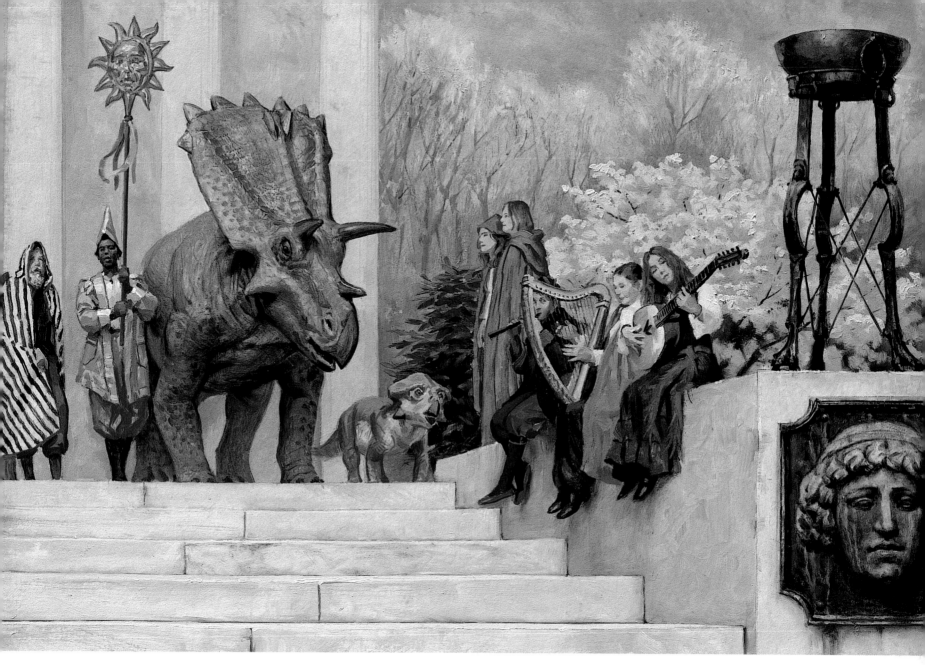

DINOTOPIA
JOURNEY TO CHANDARA

Written and Illustrated by James Gurney

ANDREWS McMEEL PUBLISHING, LLC
KANSAS CITY

I wish to express my thanks to Ernesto Bradford, Mike Breza, M. K. Brett-Surman, Ph.D., Arthur Evans, Patrick Gyger, Dave Krentz, Dorothy O'Brien, Dr. Mark A. Norell, Stephanie Plunkett, Tobey Sanford, Sirikanya Schaeffer, Kathy Younger, Azonthus and the Stockbridge Stompers, the Platte Cove Community, the Felder Family, the Fusillo Reunion Gang, the Jim Henson Creature Shop, the staff and volunteers of the Starr Library, my sons Dan and Franklin, and, most of all, my wife, Jeanette.

The paintings were all executed in oil.

07 08 09 10 TWP 10 9 8 7 6 5 4 3 2 1

ISBN-13: 978-0-7407-6431-8
ISBN-10: 0-7407-6431-4

Library of Congress Control Number: 2007924699

www.andrewsmcmeel.com

If you are interested in Dinotopia, you will learn a lot more at www.dinotopia.com.

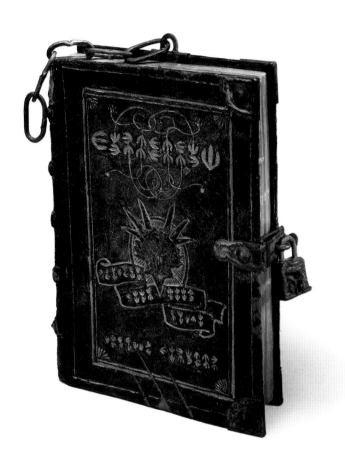

HOW I FOUND THE NEW JOURNAL

by James Gurney

SOME YEARS AGO in a university library I stumbled across a sketchbook by a little-known explorer named Arthur Denison. Like many other travelers in the Victorian Age, he documented the landscapes, people, and animals that he encountered as he journeyed to remote frontiers of the globe. What sets Mr. Denison apart is that the island he described, called Dinotopia, no longer appears on modern maps of the world. Not only that, his sketchbooks portray a society where humans live alongside a race of wise and intelligent dinosaurs.

I have been searching for a long time to find out more about Mr. Denison. My breakthrough came recently when I found the following advertisement: "FOR SALE: Nineteenth-century journal. Cover stamped with footprintlike letters and dinosaur motif. Novelty binding."

I tracked down the dealer who had placed the ad and visited his shop. The book stood in the front window alongside other dusty volumes of travel and adventure. Weathered brass plates protected the corners of the book, and an antique lock clamped shut the pages. The cover was stamped with the unique alphabet known only to Dinotopia. I tried to contain my excitement as I purchased the book and brought it home.

During the last few months, book conservators have studied the journal, and the Smithsonian Institution has displayed the original artifact in Washington, D.C. For the many people who have written me letters asking for further evidence of Dinotopia, I offer the following account, written in Arthur Denison's own hand, of the marvelous new things that he witnessed during his trek in 1869 across the "land apart from time."

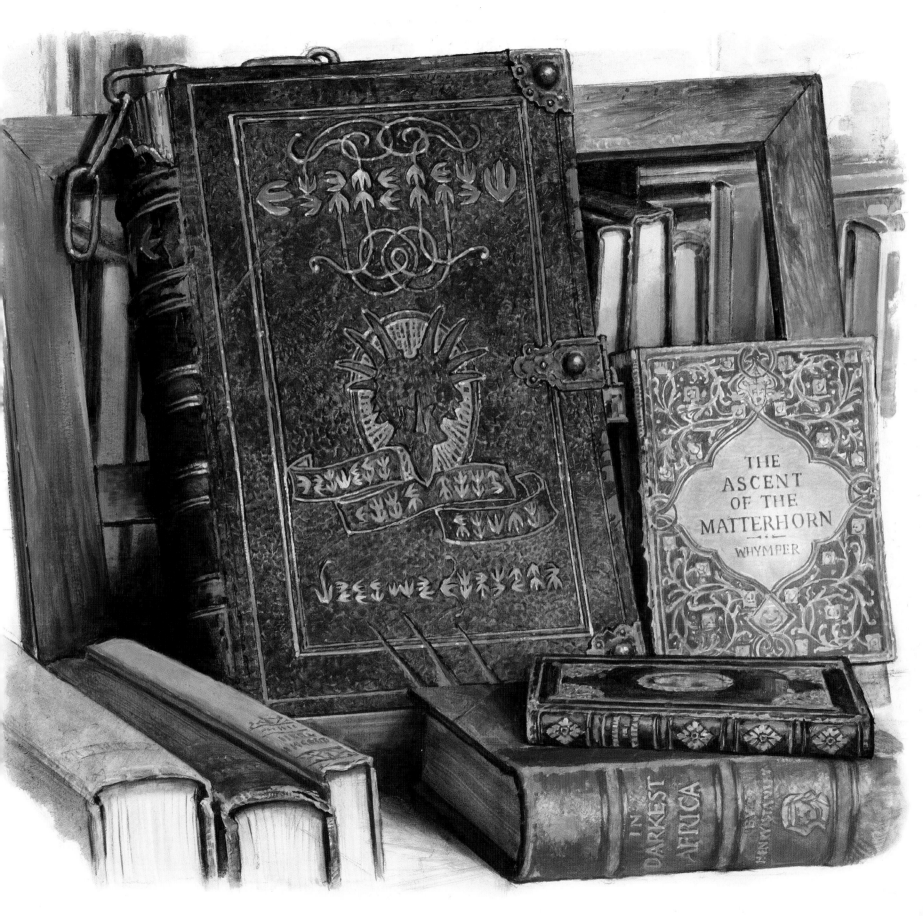

Windy Point

Crystal Caverns
Aftercastle
Esplananade
Gnomon
Beak-head
Widdershins
Estival
Azonthus
Osteo
Abalonia
Mudge Island
Wreck of the Venturer
Camaraton
Bricolage
Grindstone
Romano's Hatchery
Wimple Springs
Gambrel
Durnsmoor
Goombadell
Umbo
Gumley
Witheroot
Halcyon
Baz
Diploville
Aliveria
Chipcharoot
Gullivant
Spondylium
Snickerton
Zygian Island
Nagwan Island
Pooktook
Redwick
Fireside
Skirlton
Alidade
Strunius
Irenic
Mollusk Town
Cornucopia
Lacuna
Deep Lake
Gymkhana
Pogonip
Trogloton Caves
Haemal Arch
Prosperine
Krachong Island
Sparklebrook
Doonsawdle
Hookwood
Stone Reliefs
Treetown
Bent Root
Brumalia
Marmor Quarries
Callicos
Bonabba
Snugmuffle
Proboscis
Pumice Town
Chimeerney
Gundagi
Sharpclaw Territory
BACKBONE MOUNTAINS
NORTHERN PLAINS
Highnest
Ko Veng Island
X Poseidos (sunken)
Cape Banamba
Volcaneum
Buckram
Palace of Kings
Temple Ruins
Mount Spiketail
Sky Galley Caves
Therapsid
Amu River
Green Eel River
Farak
Ahimsa
Bima Kyun
Bodu Kyun
Gulf Haraz
Pionaspis
Naranda
Raptortown
Bogpeat Marsh
Omphalos
Nidus
Skybax Camp
Kuskonak
Gulf Tarabi
Nephridium
Hadro Swamp
RAINY BASIN
Carnassus
Horsetail Grove
MOSS VALLEY
AEGIS GULLY
Pteros
Warmwater Bay
Colebra
Stufanto
Gammawamma
Sweetwater Lake
Gorgonia
Slugmire
Mordant
Canyon City
Farrago
Zygodact
Gol Jafari
Scutemus
Waterfall City
Grandell Falls
Polongo River
Edax Feeding Grounds
Tentpole of the Sky
Mont Joliette
Trilobite Towers
Ancient Gorge
Amu River
Vespertine
Burbleville
Macula
Family Tree
Splendine Forest
Iamborini
Greenglen
Amberclime
Sky City
Thermala
OUTER ISLAND
Chester's Hatchery
Arboria
Sculpted Cliffs
Powdertop
Wild Canyon Gardens
Hardshell
Arduon
Serpentine Cathedral
Churmley
Diluvialis
The Time Towers
Gelid Glacier
Red Rapid Canyon
Tutak Abad
The Sentinels
Ahmet-Padon Ruins
Gopuram Gate
Jaggertooth Coast
Dinglecreek
Snailshanks
Kleptodon Clan
Ebulon
The Portal
Tomb of Mujo Doon
Brinkman Cliffs
Bilgewater
Shortstump
Chapman's Isle
Wescott
Whitestone Quarries
Vagar Wastes
Thanatolian Plateau
Inselberg
GREAT DESERT
Snug Cove
Belluna
Sauropolis
Jupe
FORBIDDEN MOUNTAINS
Palace of the Winds
Baru
Paleopolis
Neopylos
Tokta Range
Honely Hall
Khasra
Samarlak
Dribbling Spring
Vorshatas
Dolphin Bay
Advance
Prince of the Seas
Royal Vanguard
Black Fish Tavern
Spiker
Ruhmsburg
Mandapa
Teleost
Jubila River
Rockslides
El Quahbanukka
Bogapur
Neoknossos
Great Oasis
Meeramu
THE BELT
Colossus of Zagur
FIR ROAD
Aleppo
Oneiros
Blarney
Scuto's Mill
Brackmaw Swamp
Chandara
Pennacian
Pungdok
Strunius
Shaoling
Silver Bay
BLACKWOOD FLATS
Jorotongo
Atrox Clan Grounds
A NEW MAP OF DINOTOPIA
Furble
Middle Wallop
Graystone Observatory
Fimli
BASED UPON AUTHORITATIVE ACCOUNTS AND RELIABLE EYEWITNESSES
Prepared by Cartographic Div.
Spindrift
Bluebottle
Tuckford
Temple of the Demisaurians
Caudalis
Telson
Cape Turtletail
Dragonfly Coast
GLITTERING DELTA SUR

OBNUBIAN RANGE
Stillwater Creek
Polongo River
CRACKSHELL POINT
SCORAMB WASTES
FORBIDDEN

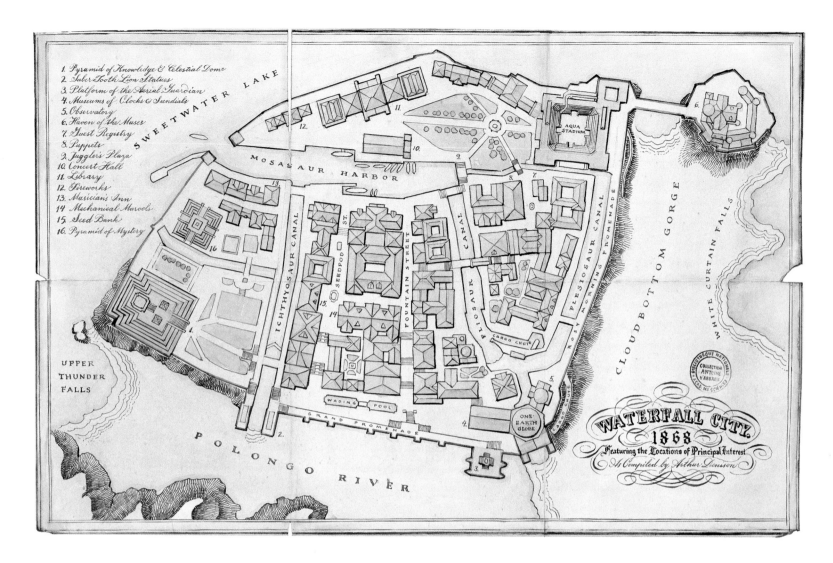

1. Pyramid of Knowledge & Celestial Dome
2. Saber-Tooth Lion Statues
3. Platform of the Aerial Guardian
4. Museums of Clocks & Sundials
5. Observatory
6. Haven of the Muses
7. Guest Registry
8. Puppets
9. Jugglers' Plaza
10. Concert Hall
11. Library
12. Fireworks
13. Musician's Inn
14. Mechanical Marvels
15. Seed Bank
16. Pyramid of Mystery

Journal of Arthur Denison, April 1869

The rising waters of the rainy season have come again to Waterfall City, bringing a flood surge against the northern parapets. Yesterday an entire grove of cottonwoods bobbed downstream and went over the falls one by one, gallantly waving their roots in the air as they careened into oblivion. The dinosaurs are working to remove the snags jammed against the mouth of Mosasaur Harbor. Most days this month the sun has been lost behind clouds. In times like this, Waterfall City resembles a ship in heavy seas. I shudder to recall my own ill-fated voyage on the schooner *Venturer*, which brought me and my son safely to the shores of this remarkable island seven years ago.

But today the sun broke through, scattering the fog for a moment and enabling the skybax riders to bring the mail. They had been delayed for days by the weather, but at last they circled the city triumphantly before heading down Pliosaur Canal on the final run.

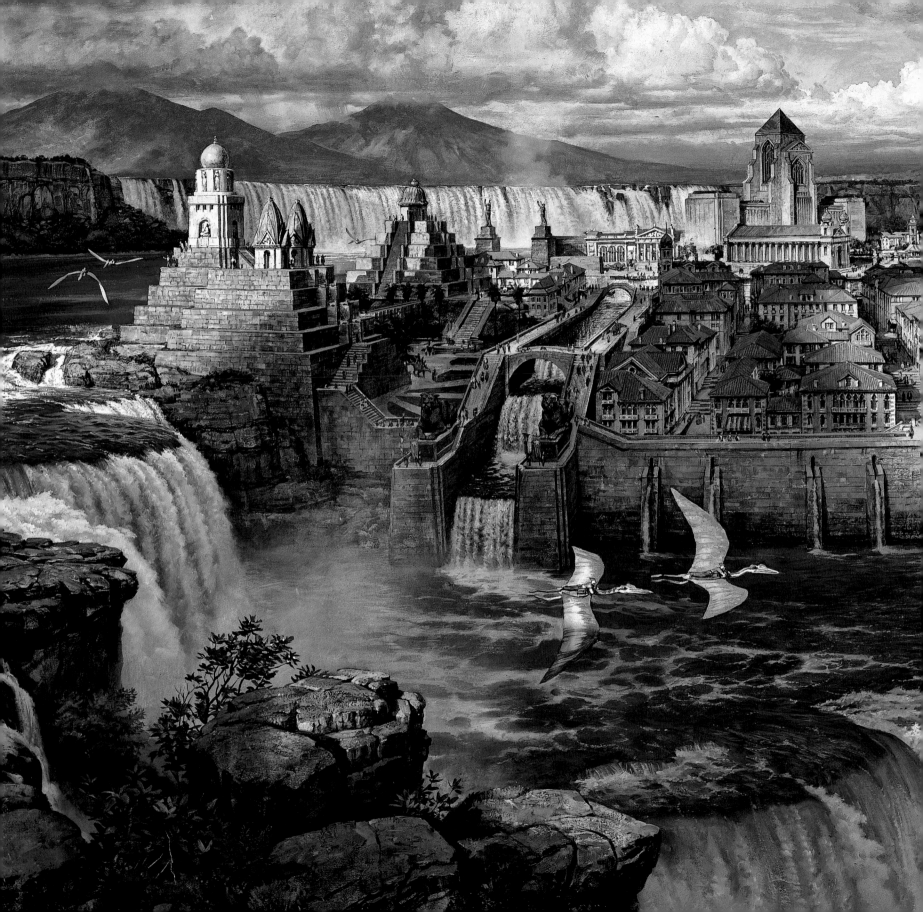

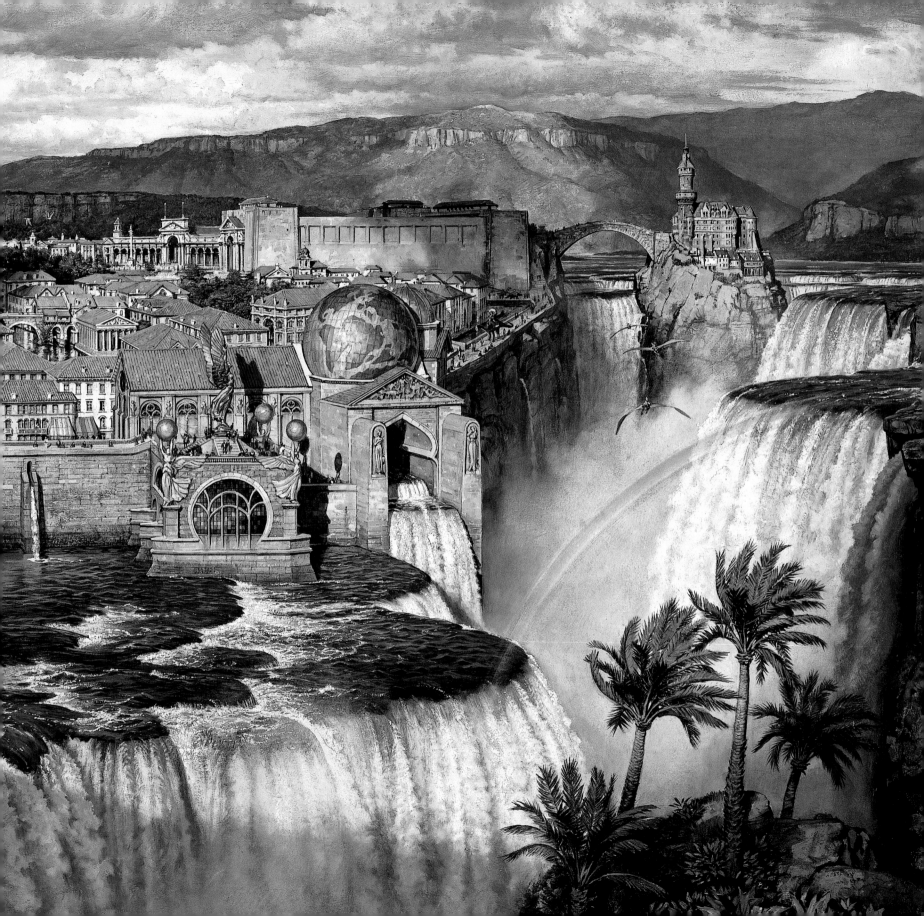

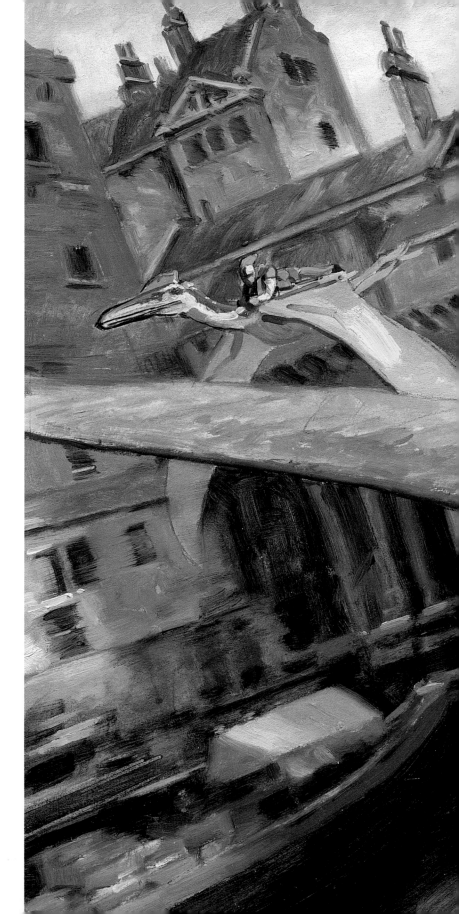

Delivering the mail on a
Quetzalcoatlus skybax

MY SON, WILL, arrived ahead of the other skybax riders, holding the scroll case in his outstretched hand. He and his skybax Cirrus ducked beneath the arched bridge on a bold run over the canal to attempt a flying mail drop. I felt a rush of air as they passed overhead.

I was hoping for a letter since I had resolved to enter Chandara, Dinotopia's eastern empire, which has long been closed to visitors. I had written many letters to the emperor requesting permission and safe passage. Will brought them to officials along the border, but always a polite reply would remind me that no one would be permitted to travel beyond the Great Desert.

So it was with some surprise that a different answer finally came, and I was proud that my own son delivered it. "It's for you, Father!" he shouted. In his excitement as he neared the drop point, he fumbled the scroll, which slipped from his hands and splashed into the canal.

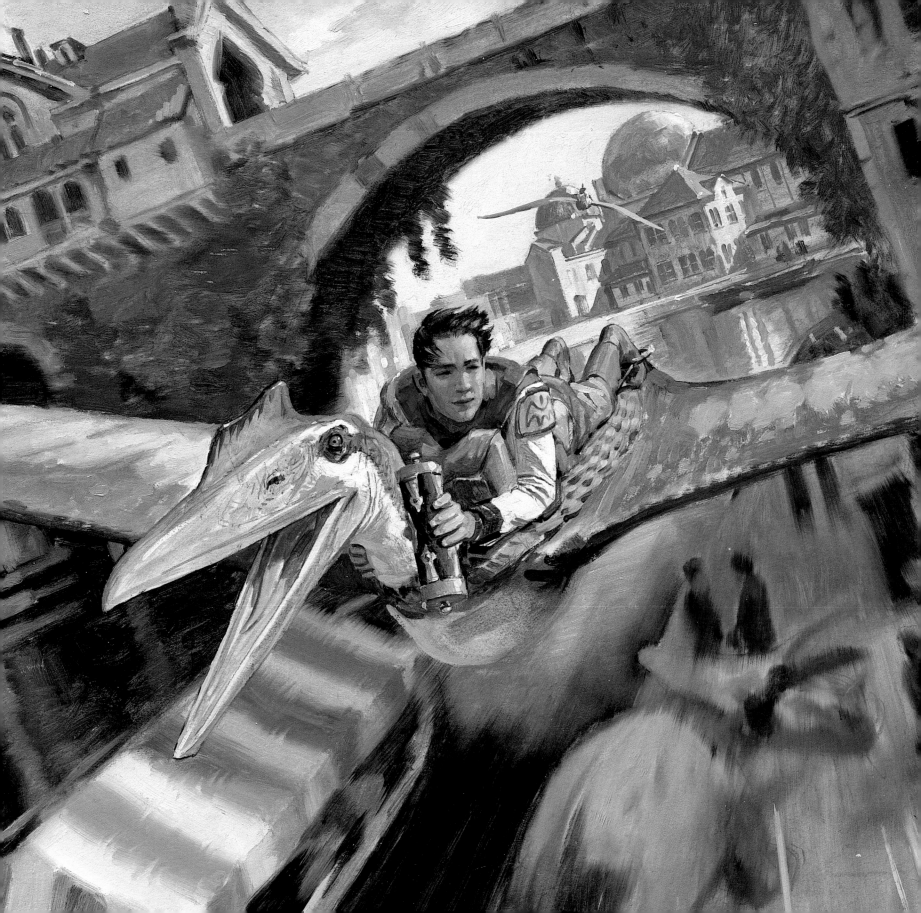

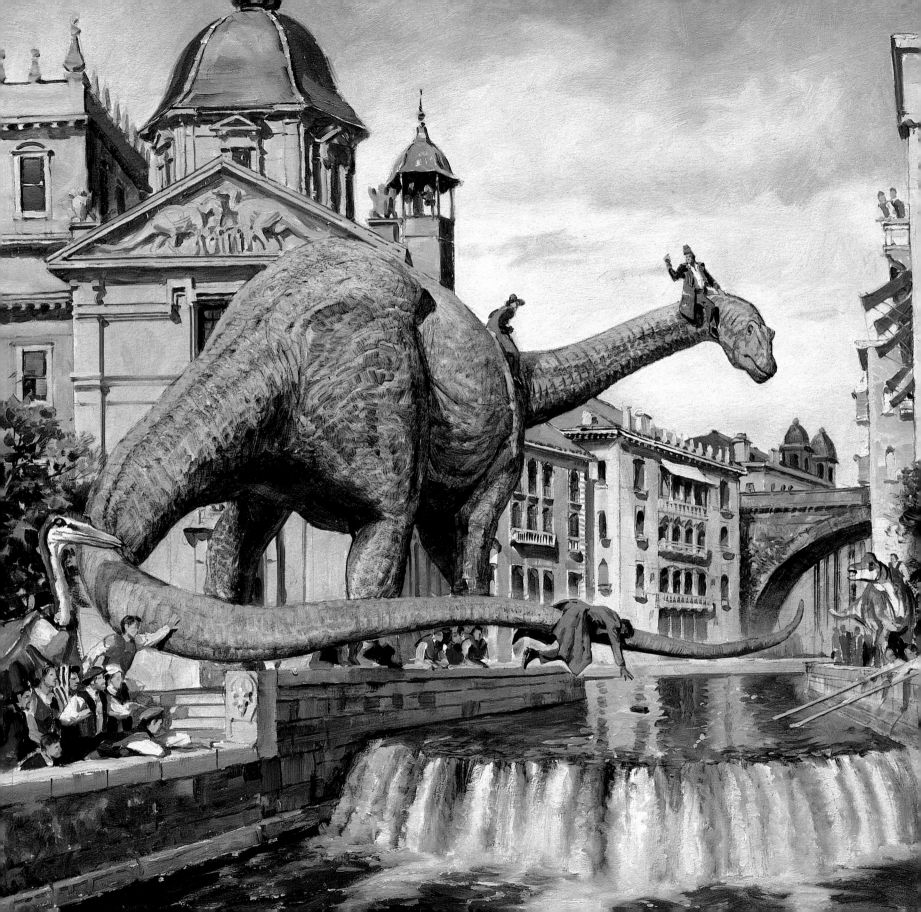

Titania, the Apatosaurus,
lends her tail to the rescue.

The scroll began to drift downstream toward the safety gate above the Cargo Chute. A quick-thinking *Apatosaurus* named Titania swung her tail over the water to try to block the scroll from floating farther downstream. Acting on a mad inspiration, I climbed out on her tail, and felt myself being lifted out over the water. I clung with one hand to the muscular tail while reaching with the other for the bobbing scroll. I seized it at last and tossed it to safety—whereupon my grip relaxed, and I fell into the water.

I was dripping and spluttering when Titania fished me out, and I felt more like a drowned cat than a professor of natural sciences. As I poured the water out of my shoes, Will clapped me on the shoulder. "Sorry, my mistake, Father," he admitted.

Nallab, the assistant librarian, offered to dry the scroll, and suggested we study it together that evening. As for me, I needed a fresh change of clothes.

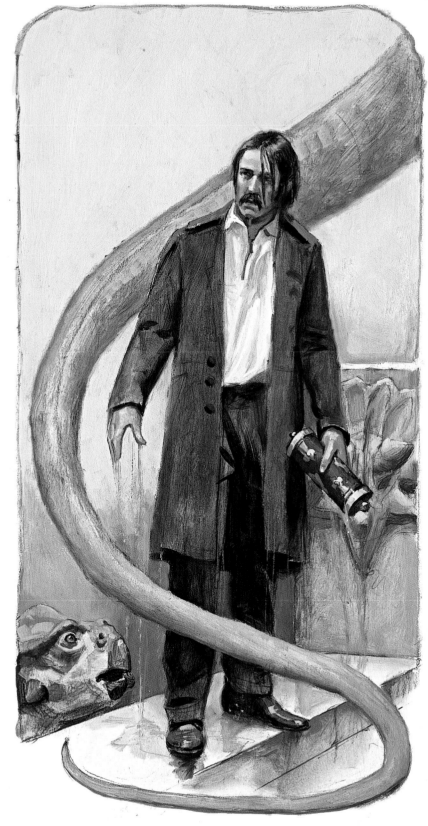

Fished out and dripping wet

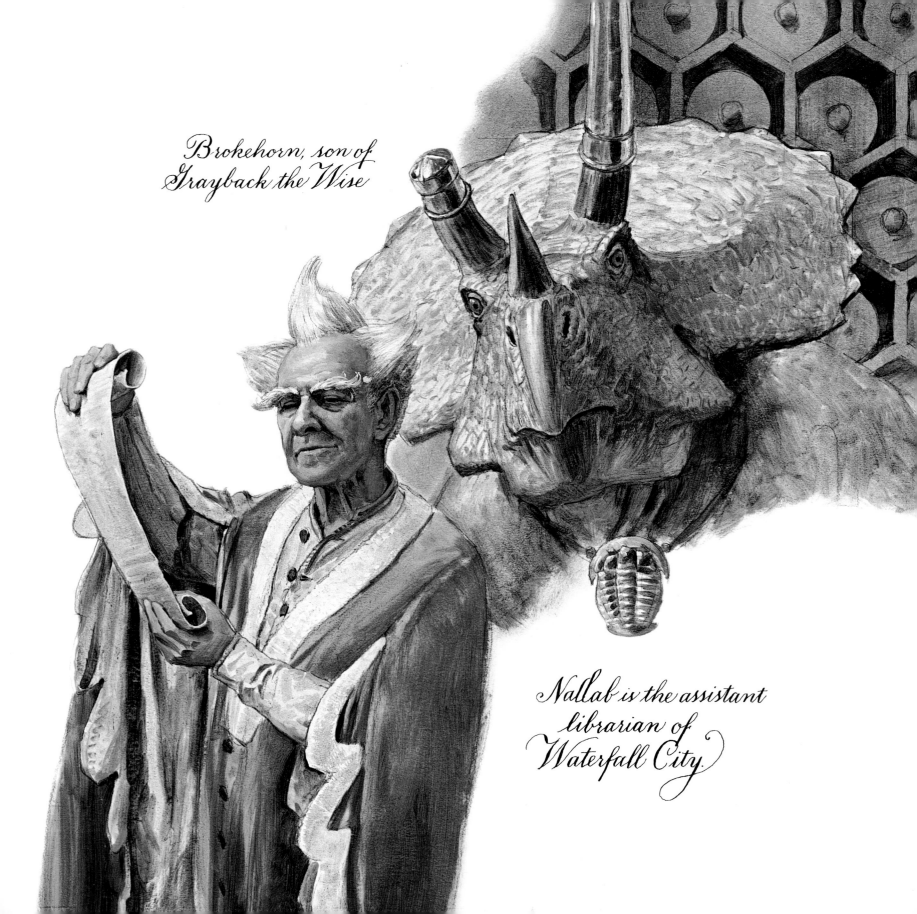

Brokehorn, son of
Grayback the Wise

Nallab is the assistant
librarian of
Waterfall City.

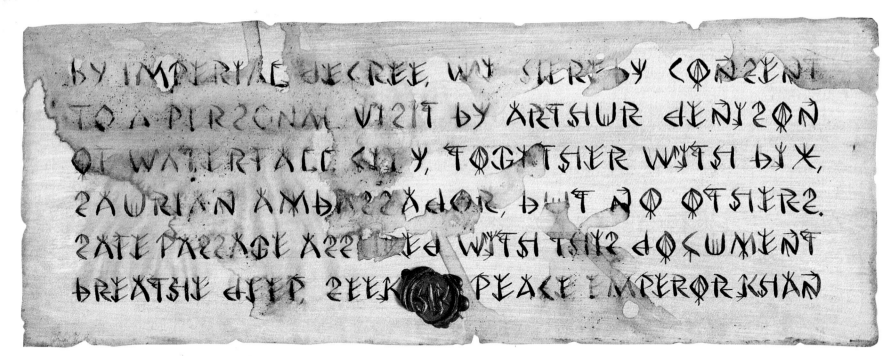

"The water damage is frightful," said Nallab, opening the scroll. "It's written in the old transitional style," he said, reading the following:

BY IMPERIAL DECREE, WE HEREBY CONSENT
TO A PERSONAL VISIT BY ARTHUR DENISON
OF WATERFALL CITY, TOGETHER WITH BIX,
SAURIAN AMBASSADOR, BUT NO OTHERS.
SAFE PASSAGE ASSURED WITH THIS DOCUMENT.
BREATHE DEEP, SEEK PEACE, EMPEROR KHAN

At last I had my ticket to the east! I had been delving into every scroll I could find about Chandara, whether old or new. I studied the accounts of previous explorers and consulted old maps in the collection.

At one time, I learned, Waterfall City and Chandara stood as two equal sisters of civilization who enriched each other through a vibrant exchange of goods and ideas. Caravans once crawled across the mountain passes, bringing spices, silks, and sunstones.

In 1841, leaders in Sauropolis broke off relations with Chandara, deploring the lack of a democratic roundtable and the autocratic rule by Emperor Hugo Khan. By 1845 the Belt Road was officially closed to the trade caravans, and three years later landslides blocked the road entirely.

Legends grew, since few in the west had seen Chandara with their own eyes, and some even whispered of superstition and wizardry. All agreed that *Allosaurus* and *Tyrannosaurus* had crossed into Blackwood Flats from the Rainy Basin and that brigands infested many of the border areas.

But Brokehorn, the elder *Triceratops*, frankly encouraged us to accept the emperor's invitation. "Arthur, we need someone of your scientific standing to separate truth from fiction. Bix, we need an ambassador like you to bring understanding," he said. I thanked him heartily for his words, and we prepared to leave.

Bix, my faithful ally, was a diminutive *Protoceratops*, the size of a sheep and the color of a musk mallow, with a fearless heart, a creaky voice, and an old-style kindliness, like a parrot raised in the company of Presbyterians. We went to see Will, who would be leaving tomorrow with more deliveries, and Bix asked him about Chandara.

"I've heard a little about it from some of the other riders," he replied. "They say it's a big city, and the people eat strange food." He told us that he would be doing his summer skybax training at Ebulon at the fringes of the Chandaran Empire, and that he would try to find out more. "I can tell you one thing for certain," he said. "I have seen some of the tyrannosaurs in Blackwood Flats. Be careful, Father. Breathe deep, Bix."

Lee Crabb brushed off the crumbs from his jacket and forced his squint into a smile. Two spike-headed wardens stood back a little, keeping a close watch on him, for his schemes had often led to trouble. "You can't go on a trip like this without taking me," he implored. "We've been through a squall or two, Professor, but we're mates, ain't we?"

"You know what the letter said: 'No others.' Besides, I'm not sure you're the one I'd want to bring to a formal banquet. They'd have to hide the silver."

As the words left my lips I knew that my joke had misfired. Crabb looked deeply hurt, having of late regarded himself as an aristocrat of fallen estate. He went away smoldering.

I found my friend Oriana at a rehearsal at the Musician's Inn. She congratulated me, and said, "I wish there was a way I could come with you, but my opera is proving so popular that they're going to need me at the concert hall for quite a few months. And I couldn't leave Waterfall City. But I will miss you both."

Cascade Tavern

Bix and I made a last stop at the Cascade Tavern, with its high-backed booths, mugs of hot cider, and lively talk. There we bid adieu to a host of other friends, both human and saurian. They insisted that we show them everything we had packed.

First there were the lightweight scientific instruments: compass, sextant, thermometer, aneroid barometer, pocket watch, and helicoid geochronograph. Next were the necessaries of living: fire steel, shaving utensils, dagger, candles, maps, and mammoth-wool blankets. Then, a few light rations: brick tea, dried fruit, flour, salt, and rice—though we knew we could count on hospitality en route. And finally, to record the journey, Nallab had given me a sketch journal bound in the leather of a *Styracosaurus* whose dying wish was to donate his remains to science.

At last one of the Wing Ambassadors gave us a ride over the gorge in his glider, followed by Will and Cirrus. My heart welled up with pride to watch my own son rise and disappear into the shining mist. With that we commenced our journey.

At the base of Grandell Falls

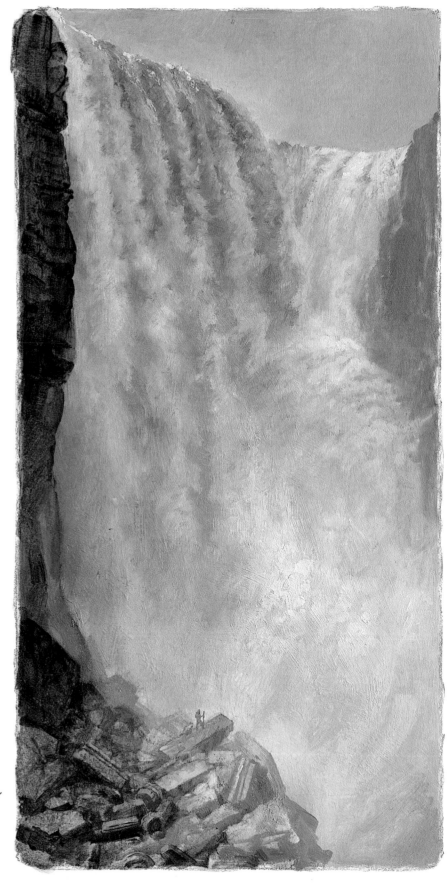

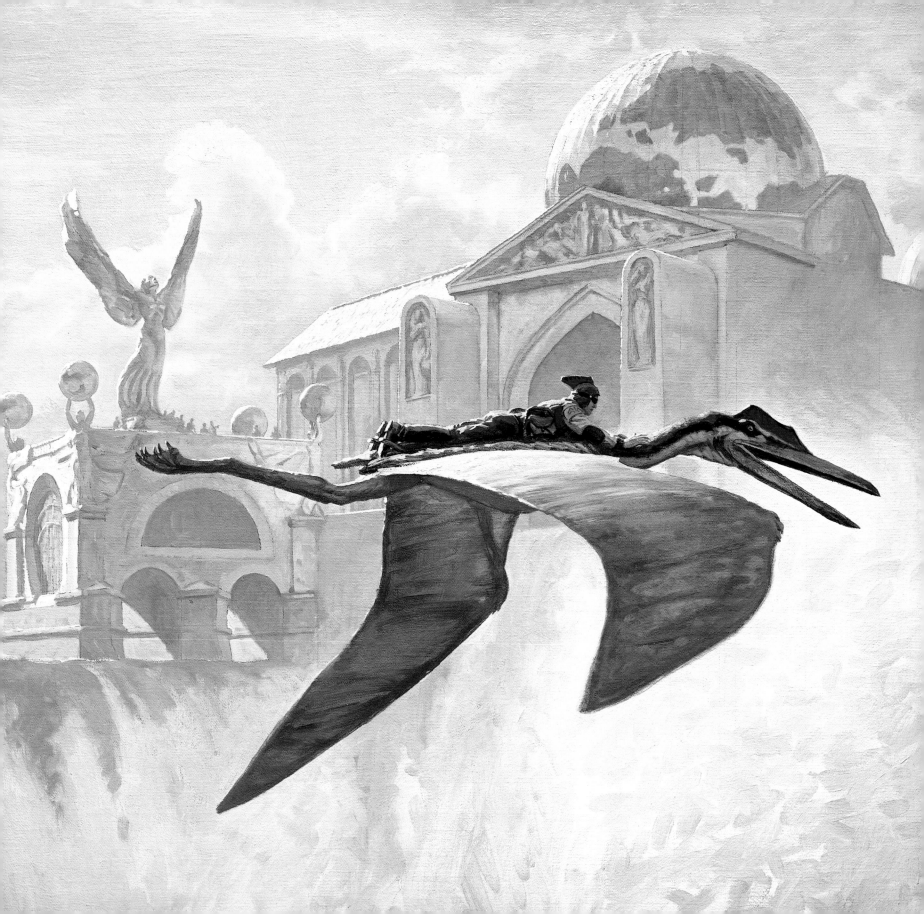

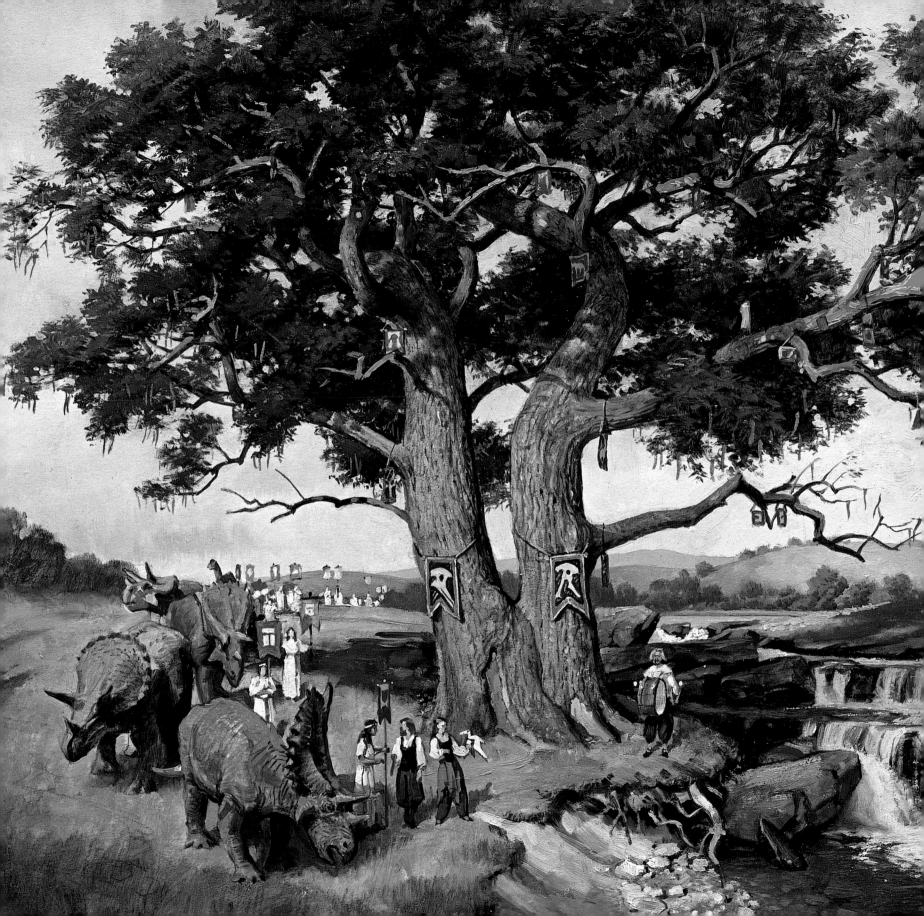

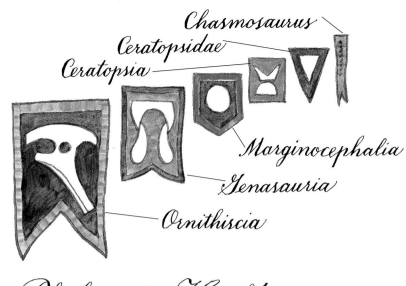

Chasmosaurus
Ceratopsidae
Ceratopsia
Marginocephalia
Genasauria
Ornithiscia

Phylogenetic Heraldry

The roar of the falls faded as the road leveled to a grassy plateau, dotted with oaks. We had come to the edge of the Splendine Forest, where a festival was taking place.

Dinosaurs of all kinds and descriptions, along with their human partners, reverently approached an ancient tree. Bix explained that the tree had been nurtured over time to represent the relationships of the dinosaur clan.

The Saurian Tree is split into two large trunks at the base, representing the twin divisions of the dinosaur group, Ornithischia and Saurischia. At each smaller branching, a special banner was displayed to identify the unique characteristics shared by that group and no other. At the outermost fringe of the tree, each leaf stood for a single species of dinosaur, and a red strip of paper with the name of the species was tied to each twig.

The Dinosaur Family Tree

WE HEADED SOUTH for two days through wooded hills that gave way to pasture-land. When we rounded a birch grove, we came upon a village composed of three ships upended, their bowsprits joined to form a central canopy. A shrill bosun's pipe sounded from the crow's nest, followed by a cry of "Gather up, all hands!"

In ones and twos, all the humans and dinosaurs returned from their labors. They had a curious habit of stopping to peer upward, as if watching for changes in the weather. As the shadows lengthened, we mingled round and introduced ourselves. The smell of frying onions drifted down to us, and a word of welcome brought us aboard for supper, which was served aft in the captain's cabin.

Goldsworthy Marlinspike, a dignified gentleman in a cape and doublet, sat at the head of the table. During supper I told him how I put aside my memories of Boston to make a new life here in Dinotopia. I then ventured to ask him how his people came to make their home in ships.

"Come," he said. "I'll tell you the whole story." We helped to clear away the meal, and he brought us up to his cabin.

The village of Bilgewater

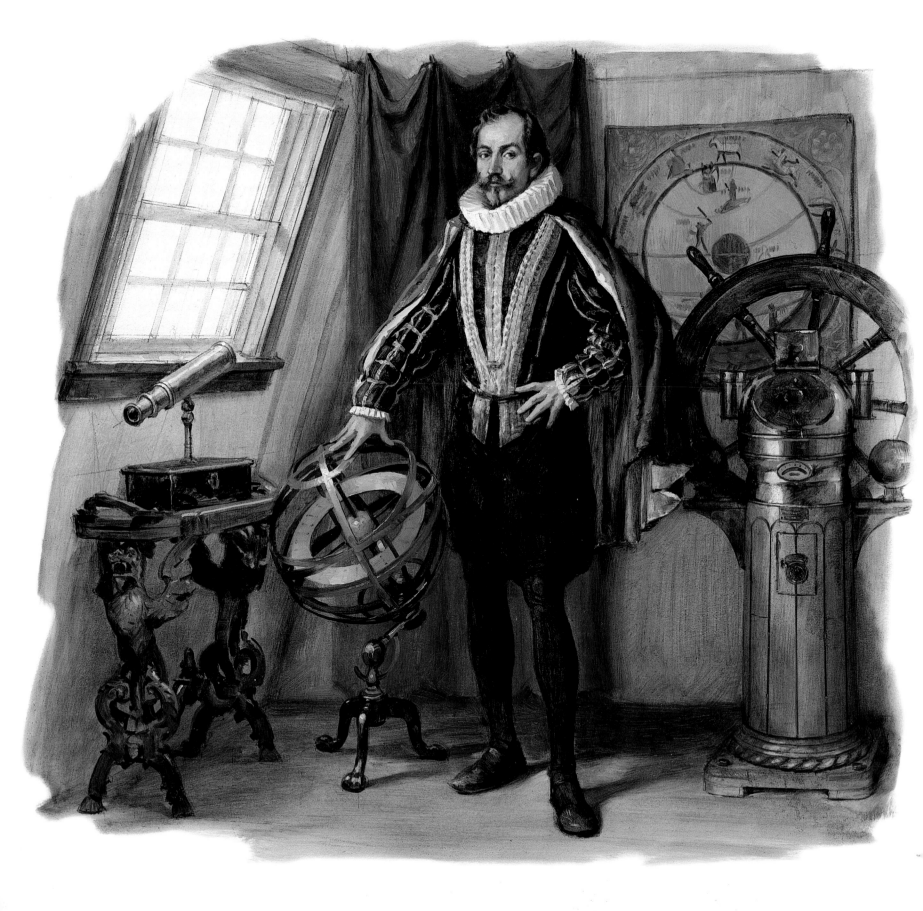

Goldsworthy Marlinspike, Celestial Navigator

As I began sketching Marlinspike's portrait, he told me the story of Bilgewater. "Two hundred and thirty years ago," he said, "our ancestors were aboard the *Prince of the Seas,* the *Royal Vanguard,* and the *Advance.* They challenged the Spanish Armada returning from Manila, but they were outgunned and surrounded. It was certain death. They led a chase, and by good fortune they escaped through the outer reefs and storms that surround Dinotopia. Eventually the vessels struck and sank, but all hands were rescued by dolphins. When they first came ashore they thought they had been delivered to paradise. In time they realized that life here is long, but not everlasting, nor is nature always kind."

"How were the ships brought here?" I asked.

"Elias Marlinspike, my great-great-grandfather, dreamed of rescuing the ships, for the ships had rescued us. He believed that if the ships saved our lives once, they might save us again one day. We floated the ships with the help of the saurians and brought them overland to this place. Our life is good now. But dark days will return. And when they do, we stand ready for the next voyage."

"Not a sea voyage," I observed, noting the telescope, the armillary sphere, and the chart of constellations.

"No, a voyage to the stars. On that day, our ships will rise up and be made whole, and they will bring

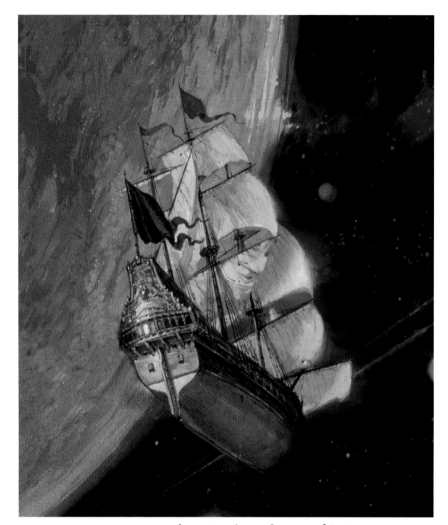

The Flight of the Star Galleon

us to the other side of the sunset, to the buckle on the belt of Orion."

"When do you expect this to happen?" I asked.

"The ships will tell us. Whenever they sense that we're in danger, they begin to lift. Whenever there are storms, or floods, or eruptions, they groan and pull upward on their hawsers. If, heaven forbid, Earth itself should ever strike a reef and sink, these will be our lifeboats. Mr. Denison and Bix, others have joined us. You can, too."

Bilgewater began life with the wreck of three galleons in Dolphin Bay in 1638.

Later, a team of Kronosaurus filled canvas balloons with air to raise the wrecks and float them up the Polongo River.

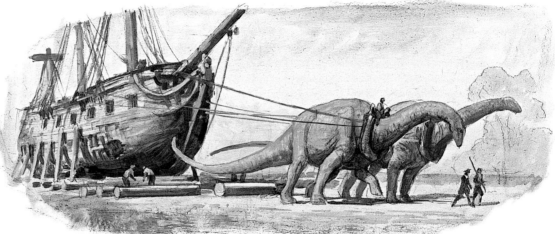

Sauropods then pulled the hulks overland, rolling them on logs.

The ships were then cut in half, tipped on end, and restored.

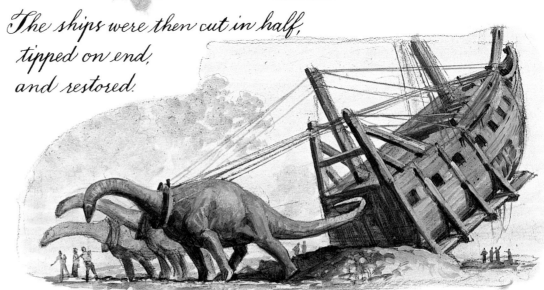

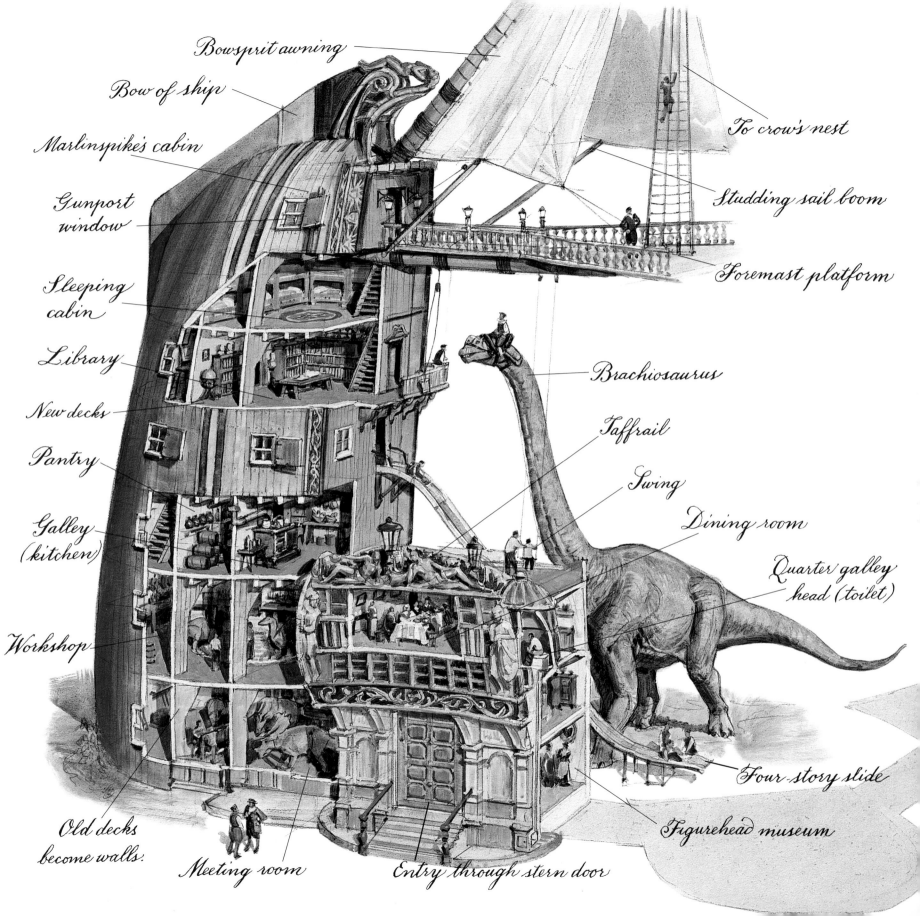

Bowsprit awning

Bow of ship

Marlinspike's cabin

Gunport window

Sleeping cabin

Library

New decks

Pantry

Galley (kitchen)

Workshop

Old decks become walls.

Meeting room

Entry through stern door

To crow's nest

Studding sail boom

Foremast platform

Brachiosaurus

Taffrail

Swing

Dining room

Quarter galley head (toilet)

Four-story slide

Figurehead museum

Sail Away

Sung as a round

We'll gath - er up our breth - ren, we'll cast a-way our bur - dens, we'll

sail a - way and make our home in hea - ven

We spent three days in Bilgewater, long enough to meet all the humans and saurians. We worked beside them in the fields and learned a few of their songs, most of which spoke of a place where flowers never fade and ships never sink.

But the road called to me. I had to convince Bix—who was already becoming a willing alto in the choir—that it was time to continue on. After fond farewells we set forth into the sun-warmth of the grassy fields, serenaded by crickets in the hedgerows, who somehow found enough to sing about even in this mortal world.

Yet in some far corner of my heart there was a whisper of misgiving. Even to this day, whenever I see nature unleash the full fury of her temper, I wonder whether at that moment Bilgewater might be straining at her moorings, about to begin her fateful voyage. If that day should ever come to pass, I shall be too far and too late to travel with them.

The last few miles brought us to the edge of the Polongo River, where we boarded the ferry to Sauropolis. The domes and rooftops were spread out before us in a glorious vista, shimmering in the hazy brilliance.

Through a water gate into Sauropolis

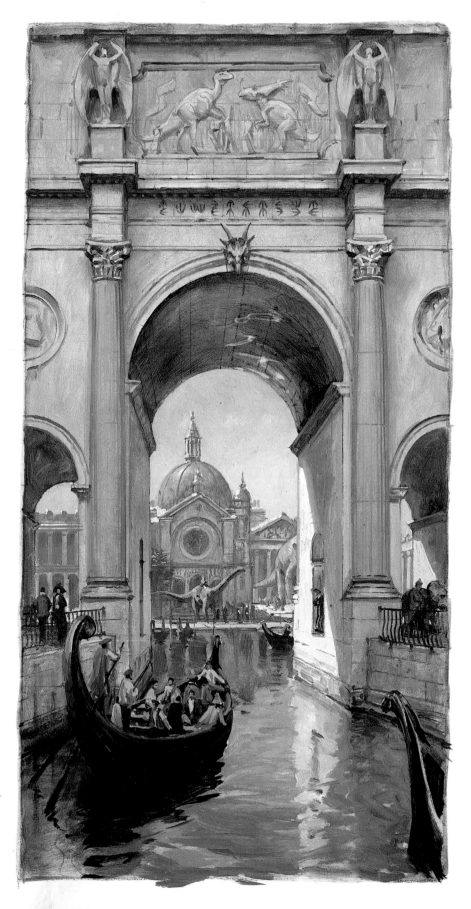

*Augustus Plinth
of Sauropolis*

SO MUCH HAS ALREADY BEEN WRITTEN about the monumental buildings of Sauropolis that I will not further belabor the reader. At a rooftop cafe called the Eye of the Volute, we met Augustus Plinth, an architect. He introduced us to a few of his saurian colleagues, who were noisily sipping pomegranate nectar.

Most dinosaurs prefer the Roman style of architecture, which, like themselves, has survived various extinctions. The greatest compliment is to speak of a building's quiet dignity. Every major structure has an arched entry fifty feet high to accommodate the larger citizens. Smaller creatures find their way up ladders to crowded perches or nest baskets inside the domes. When it was time to find an inn, Augustus recommended one called the Back Pocket, where we slept, as Bix said, "like fossils."

Acanthus,
an Ankylosaurus,
supervises the
construction of
monuments.

Sima, a
Brachiosaurus,
designs rooftops.

Medal worn by the
Guild of Architects

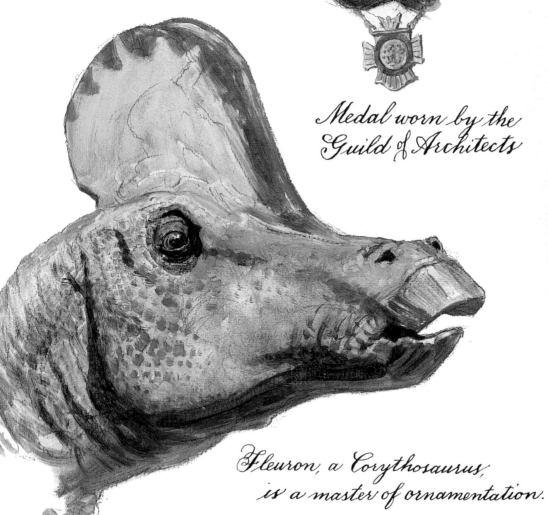

Fleuron, a Corythosaurus,
is a master of ornamentation.

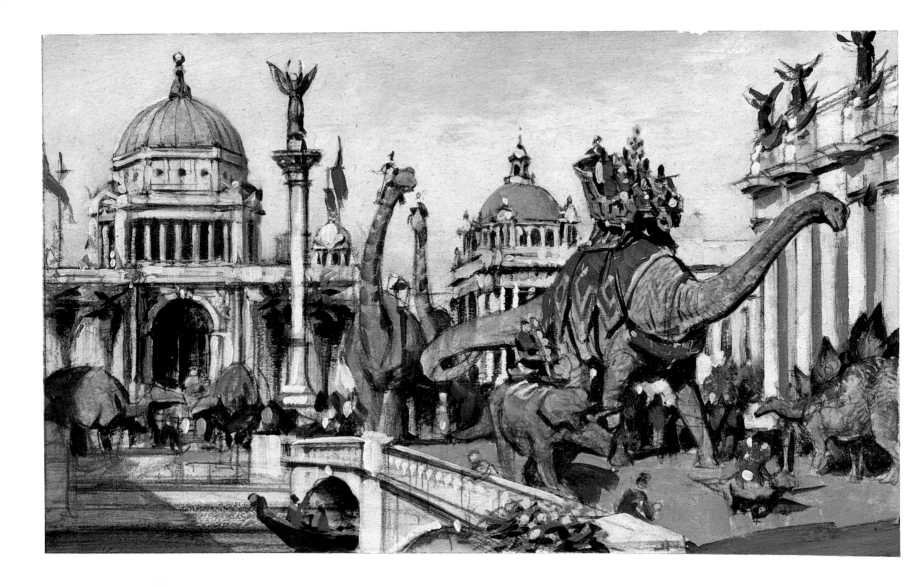

We awoke to a morning cacophony: raptor rickshaws clattering over the cobblestones, distant bells from the skybax towers, copro carters singing as they loaded the dung wagons, and *Lambeosaurus* town criers announcing the day's debates. After a breakfast of sweet cake and bitter coffee, we strolled down Grand Avenue, which crosses all four major canals. Boatmen drifting under the bridges called out witty insults to those above. They were quick to dodge the crab apples hurled down on them in response.

Citizens live mostly in public, spending little time in their small private homes. The ordinary person goes to great lengths to appear fashionably dressed, keeping always well-pressed and spotless. Hats are removed, it is often noted, only when a theater curtain goes up or a house burns down.

View to the bay

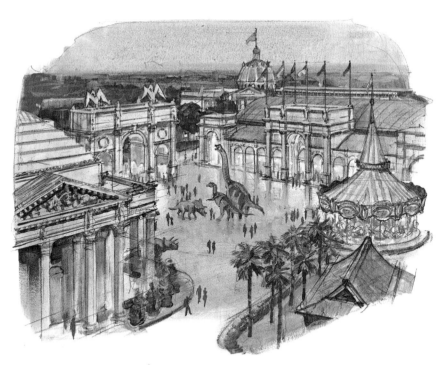

Evening promenade in Carousel Plaza

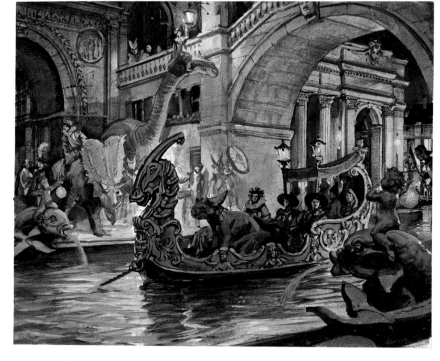

Masks and magic along the canals at night

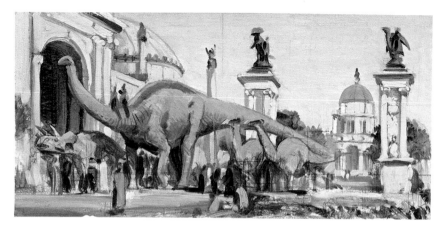

Entrance to the Dialectic Gardens

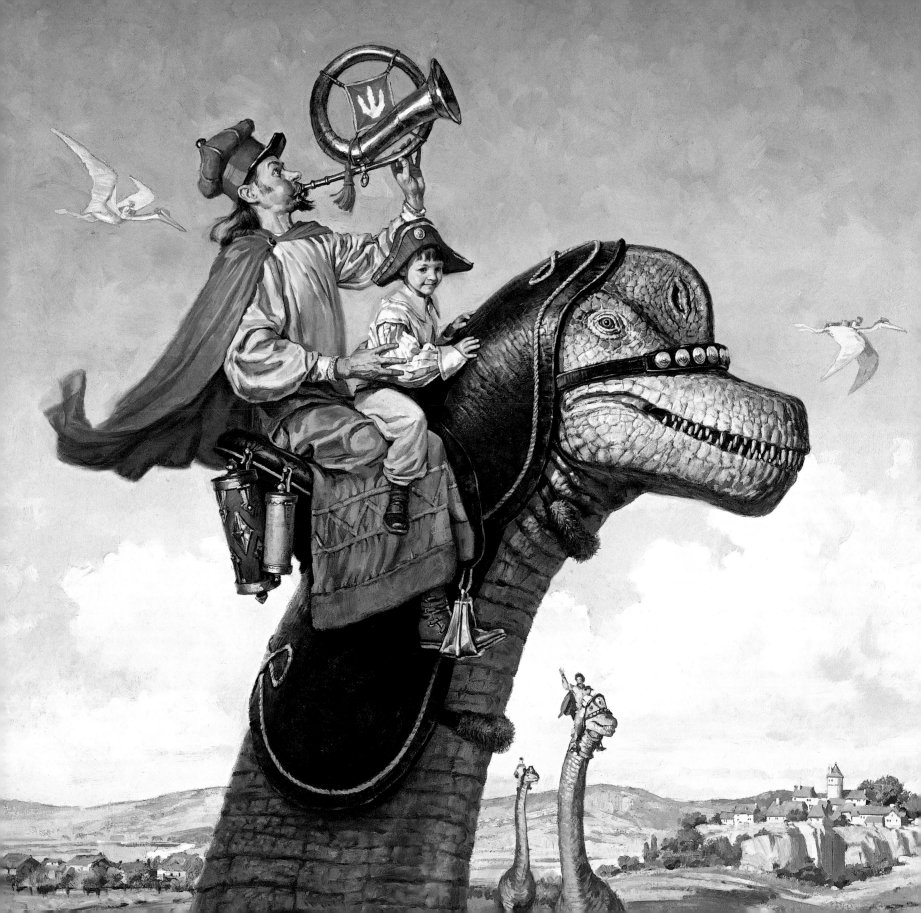

A brass and drum saddle band called
the Callithumpians roams the avenues on a
deaf Triceratops who enjoys the vibrations.

On his hatchday, a child may
ride up high with a trumpet-
herald on the cervical saddle
of a Brachiosaurus.

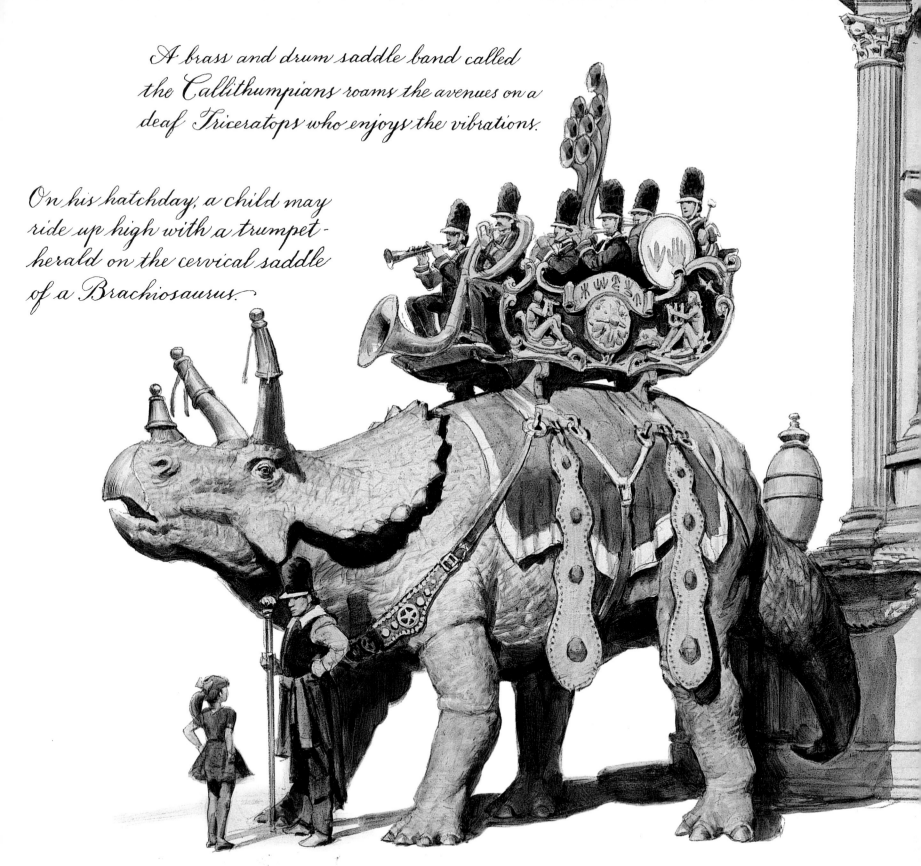

37

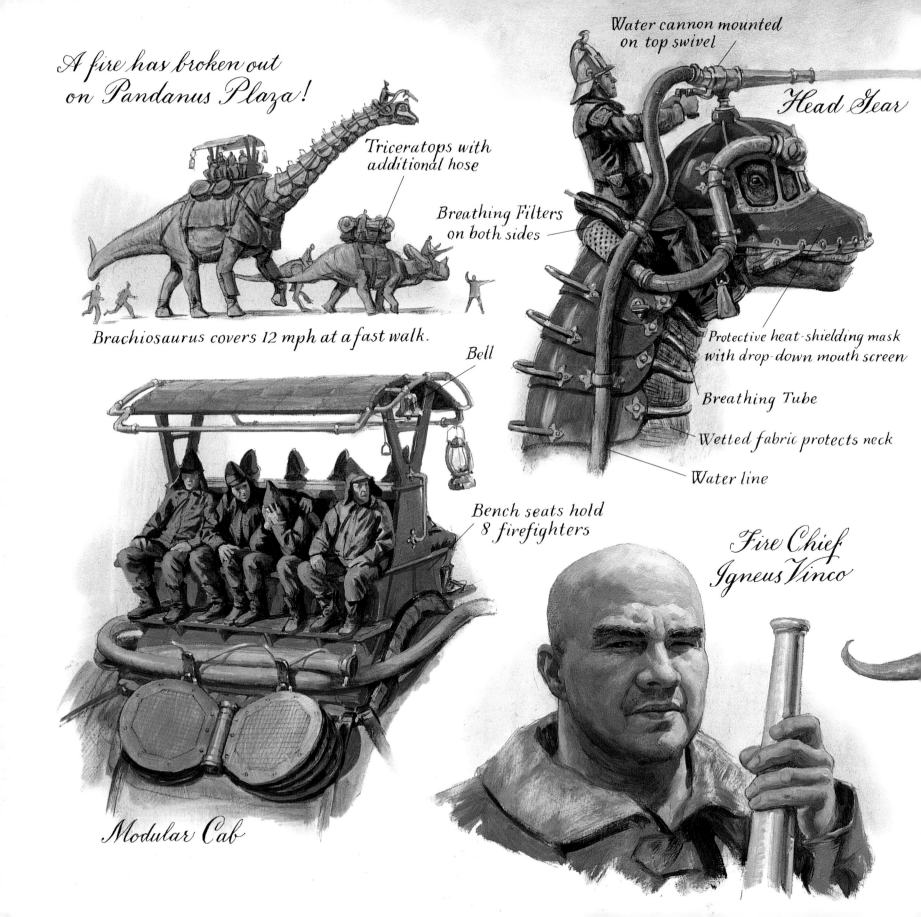

A fire has broken out on Pandanus Plaza!

Triceratops with additional hose

Brachiosaurus covers 12 mph at a fast walk.

Water cannon mounted on top swivel

Head Gear

Breathing Filters on both sides

Protective heat-shielding mask with drop-down mouth screen

Breathing Tube

Wetted fabric protects neck

Water line

Bell

Bench seats hold 8 firefighters

Fire Chief Igneus Vinco

Modular Cab

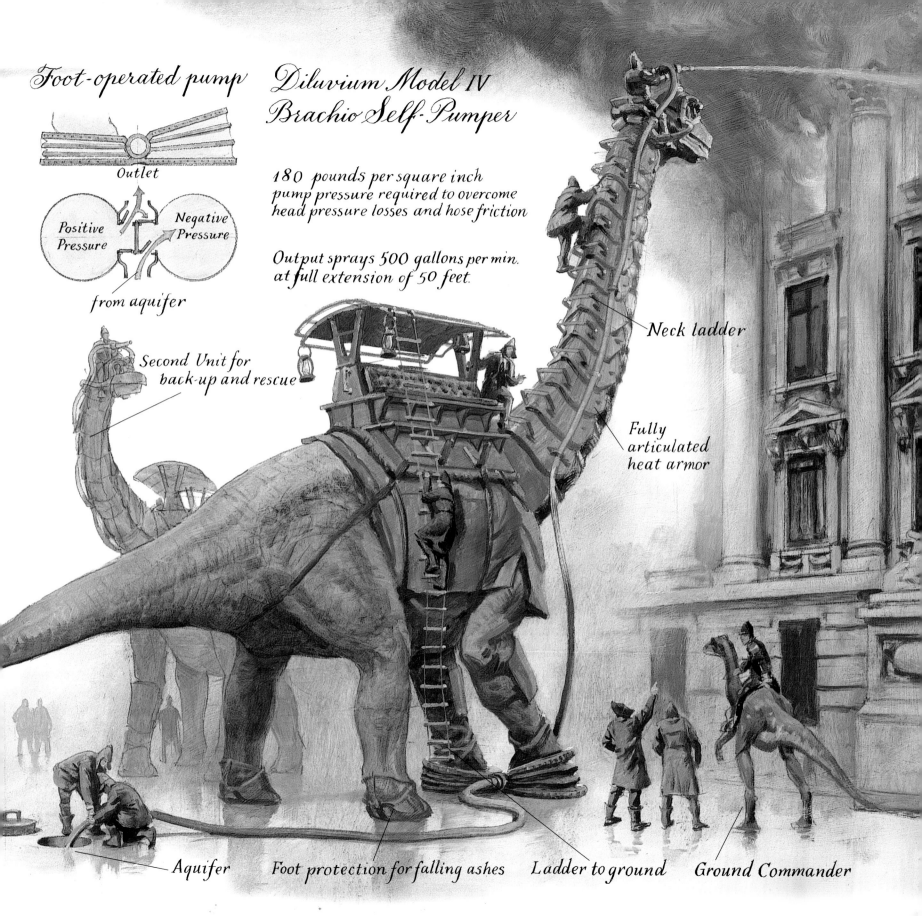

Foot-operated pump

Outlet

Positive Pressure

Negative Pressure

from aquifer

Diluvium Model IV
Brachio Self-Pumper

180 pounds per square inch
pump pressure required to overcome
head pressure losses and hose friction

Output sprays 500 gallons per min.
at full extension of 50 feet.

Neck ladder

Second Unit for
back-up and rescue

Fully
articulated
heat armor

Aquifer Foot protection for falling ashes Ladder to ground Ground Commander

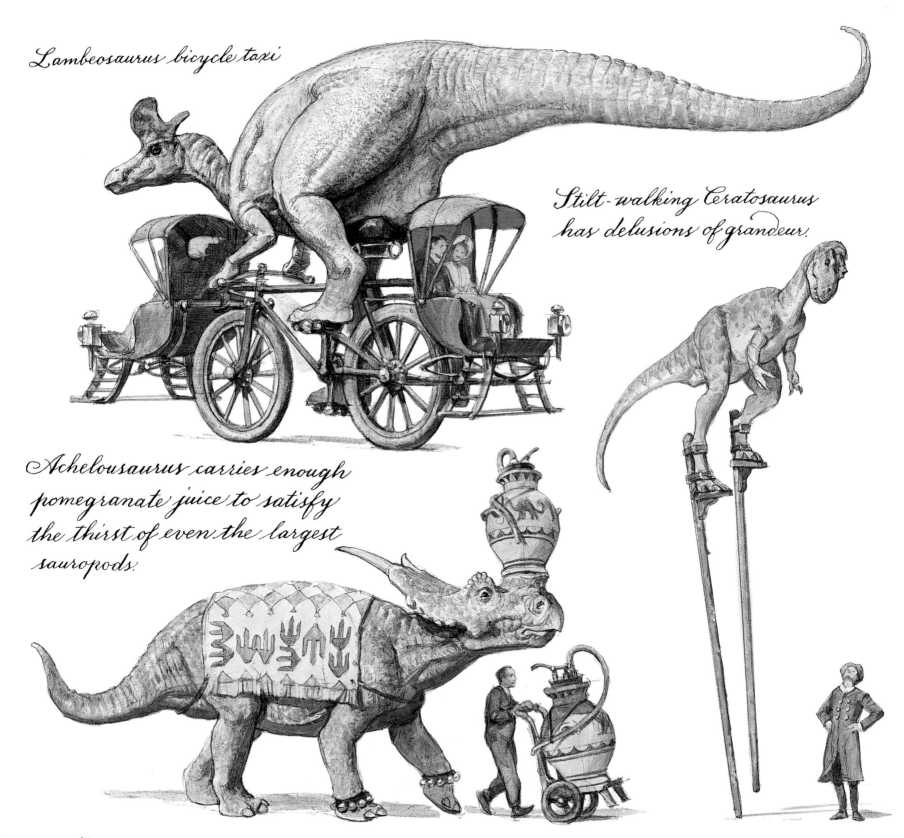

Lambeosaurus bicycle taxi

Stilt-walking Ceratosaurus
has delusions of grandeur.

Achelousaurus carries enough
pomegranate juice to satisfy
the thirst of even the largest
sauropods.

40

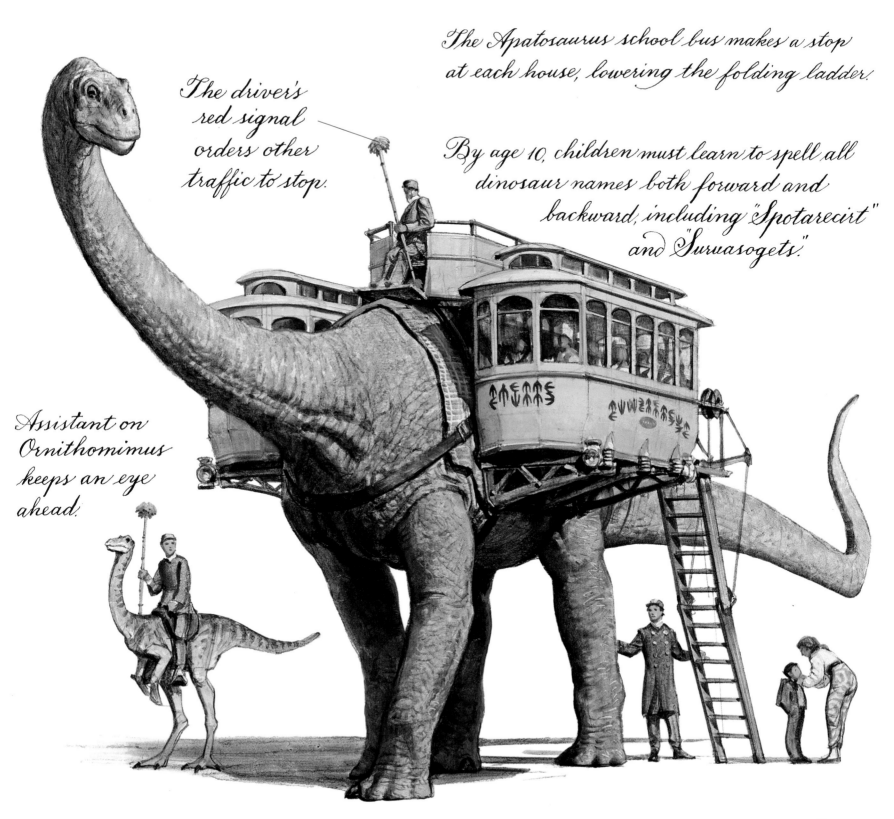

The driver's red signal orders other traffic to stop.

The Apatosaurus school bus makes a stop at each house, lowering the folding ladder.

By age 10, children must learn to spell all dinosaur names both forward and backward, including "Spotarecirt" and "Suruasogets."

Assistant on Ornithomimus keeps an eye ahead.

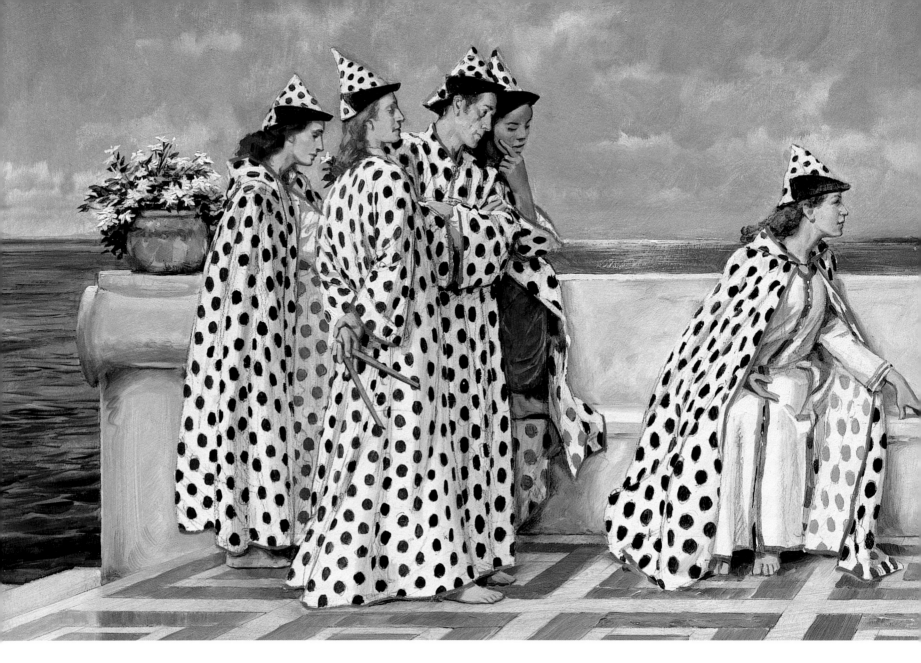

In Sauropolis, every idea is debated by two opposing sides, each with its own distinctive garment. For example, the Spotters and the Liners argue endlessly about how we come to know what is true and real.

The Spotters' argument: "Each of us begins life like an empty white sheet. As we learn and grow, the blankness fills up with spots of personal experience. Every moment that we see or touch something new, we add another spot. In the end, all we know about the world is made up of these spots. There is no other way that we can develop a picture of the world." One of them plucked a jasmine blossom, inhaled its fragrance, and offered it to the other side.

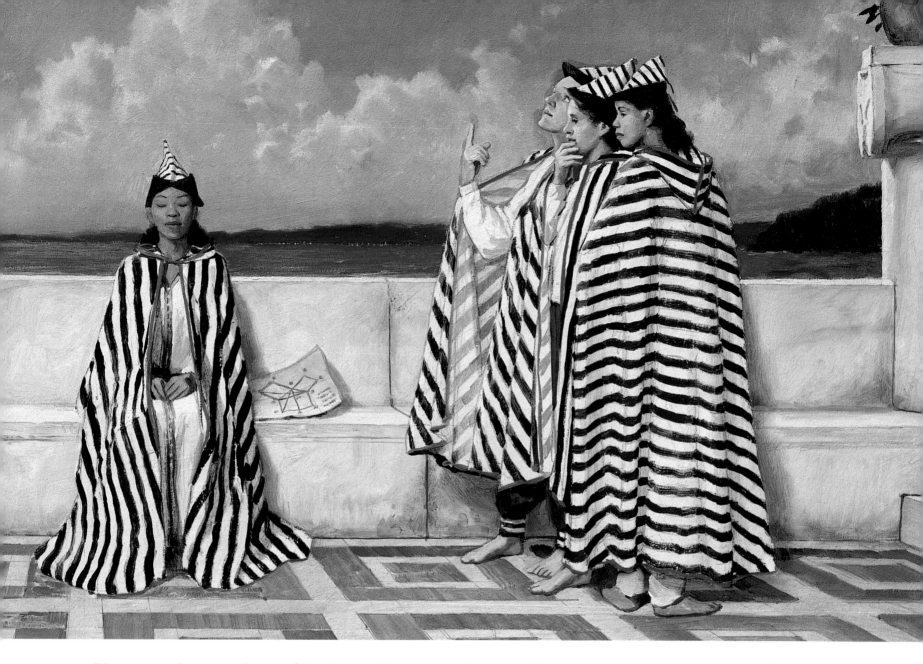

"So you say," returned one of the Liners. "But how can you put such trust in your senses? The moon appears to your eyes the size of an egg, but you know it to be bigger. How can you be sure, never having touched it? What is a number—have you tasted a seven? What is a circle? Is it the drawing on the paper, or the idea in your mind? Nothing is certain but pure thought. The lines on our capes remind us of the narrow limits of perception. Our aim is to cross over the boundary that borders the realm of changeable appearances into the everlasting forms that lie hidden from view. The flower you just gave us is already beginning to wither and turn to dust, but the idea of the flower is what matters, and it will live forever."

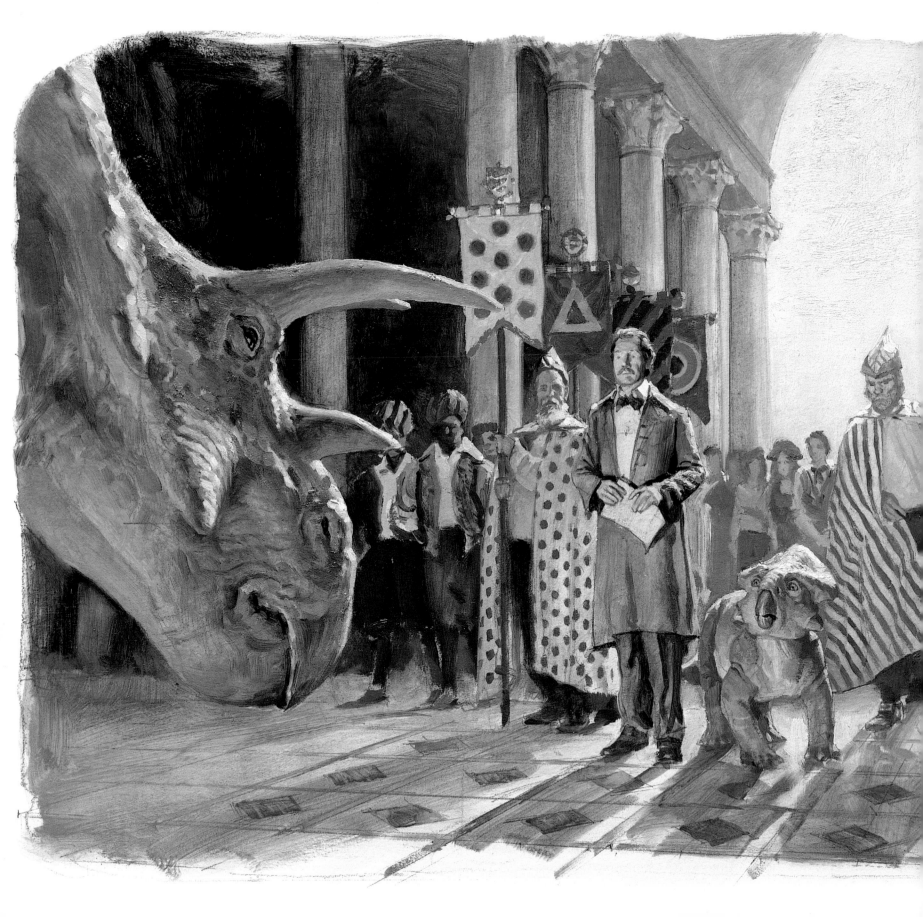

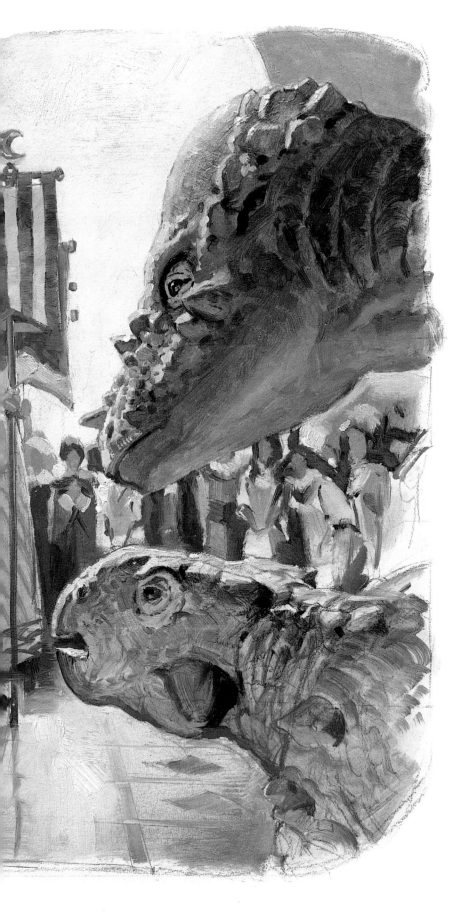

After a few days of exploring Sauropolis, a calamity befell us. We returned to the Back Pocket from a late performance to learn that the emperor's invitation had disappeared! We suspected it to be the work of Lee Crabb. The innkeeper, a thick-headed old *Stegoceras,* was deep in conversation with the two *Stygimoloch* parole wardens assigned to watch over Crabb. I assumed none of them noticed Crabb sneak upstairs, where he stole the invitation, squeezed through the window, and slid down the drainpipe to the ground below.

I took up the matter with two new friends: Paolo, a Spotter, and Willi, a Liner.

Paolo scratched his head skeptically. "How do we know it was Crabb?" he asked. "Did anyone actually see him take it?"

"That's immaterial," Willi countered. "Take the ideal case. Let's suppose Crabb has the piece of paper in his possession. He still doesn't have the invitation, which in truth is the intangible desire of Khan to have you as his guest. Crabb has the mere *representation* of that desire."

Bix had to jump in. "But if Crabb is passing himself off as . . ."

"Enough!" I said. I had no patience for academic arguments. I hastily petitioned the Sauropolis Council to find a swift-footed volunteer to carry us to intercept Crabb. But they were all opposed to our journey in principle anyway.

Bix and I decided to make our way east on foot and see what we could do on our own.

The Sauropolis Council considers our request.

WITHOUT THE INVITATION we would in all likelihood be turned back by the border guards. Nonetheless we continued east in the hope of intercepting Crabb. Surely he would have crossed the Jubila River at Ruhmsburg. This city was once the jewel of the Belt Road before it sank into desolation. Perhaps someone along that route might have seen Crabb, or might be able to advise us on another way into Chandara.

The highway made for easy travel at first, despite the thickets that had gained a foothold in the heaving pavement. The only living creatures were monitor lizards crouching atop heaps of crumbling stones. A dull, cold drizzle drifted down as we approached the outskirts of the ruined city. We veered right off the main road by a narrow path among shattered columns. Bix found a covered ledge along the riverbank with an outlook toward the ruined bridge. We ate our supper of bread and olives there and then made camp. In the haunted stillness we could hear the wind whispering through the willow leaves nearby.

Just then, from the direction of the bridge, there arose a living voice, not that of a man, but of something like a cello, singing mournfully into the gloom. We peered through the fading light of dusk and discerned a small house, improvised from salvaged lumber, perched atop the overgrown tower with a lantern flickering from one of its windows.

The Bridge to Ruhmsburg

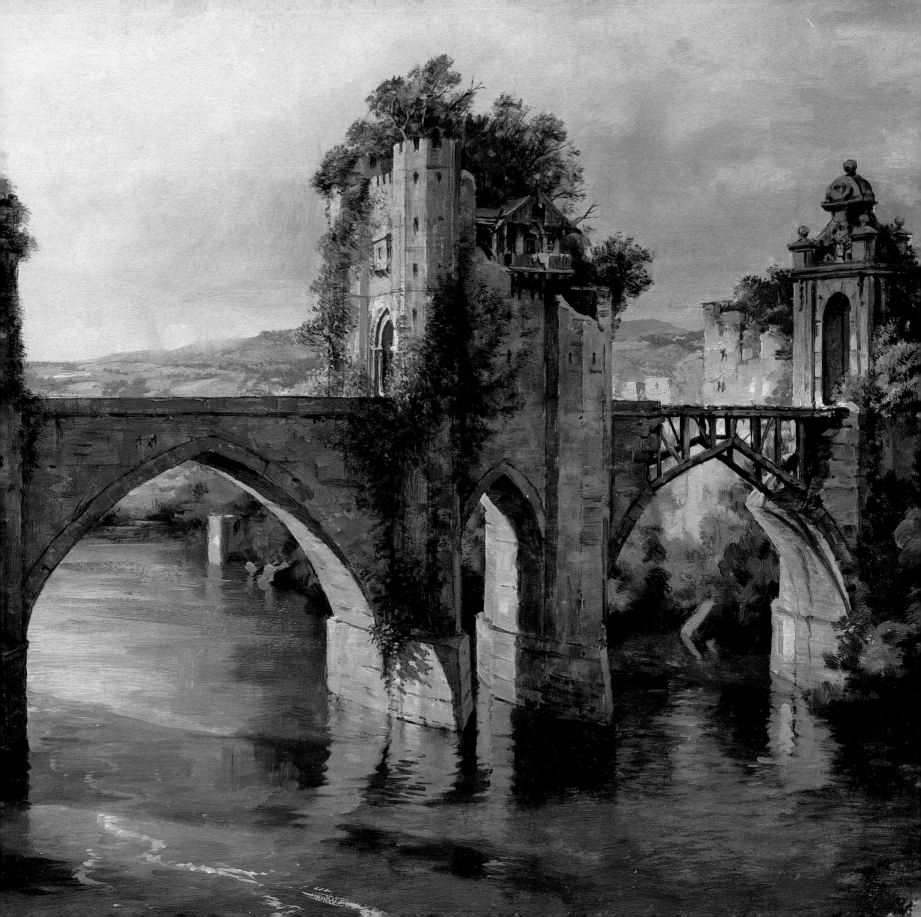

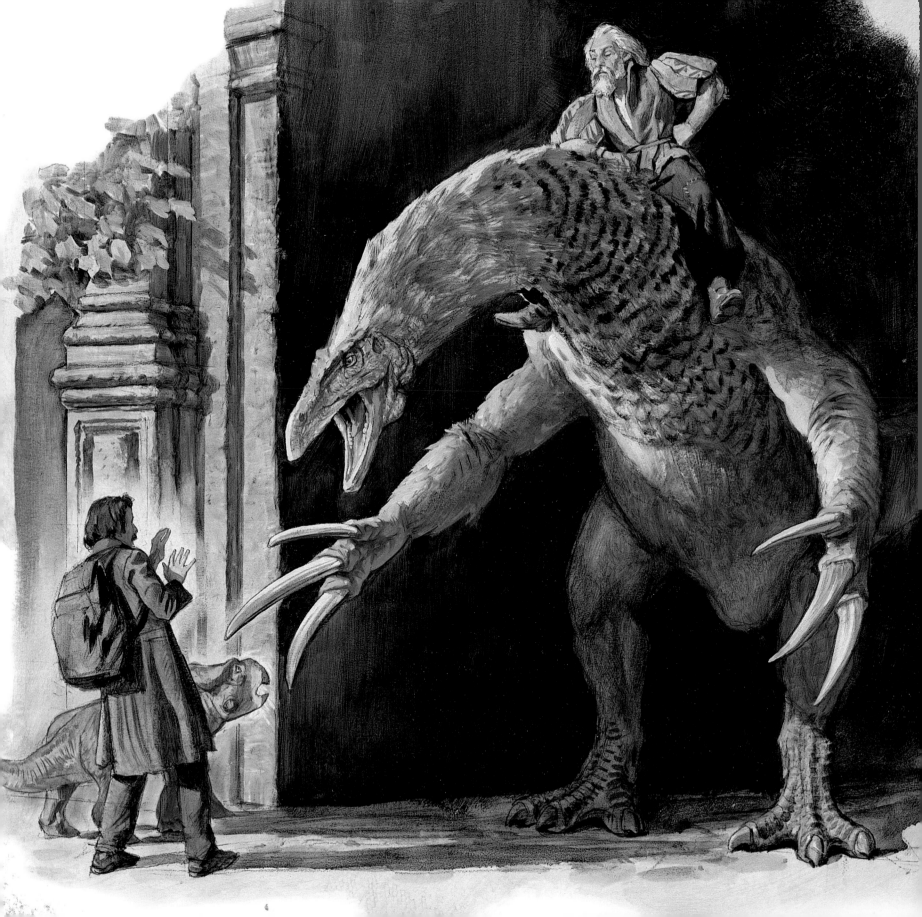

We ventured onto the bridge next morning but were met with a gooselike hissing and a commotion coming from the tower. Before we could retreat, a dinosaur resembling a 2,000-pound chicken, with claws as long as broadswords, confronted us in a darkened archway. Bix had the presence of mind to lilt a tune. This astonished the creature enough to make it blink, tilt its head, and lower its claws.

"Easy! Down girl," said the rider. "Don't worry. This is Henriette. She won't hurt you. She likes people, but she isn't used to many strangers. I heard you singing 'Glorious Ruhmsburg.' Welcome. I'm Cornelius Mazurka."

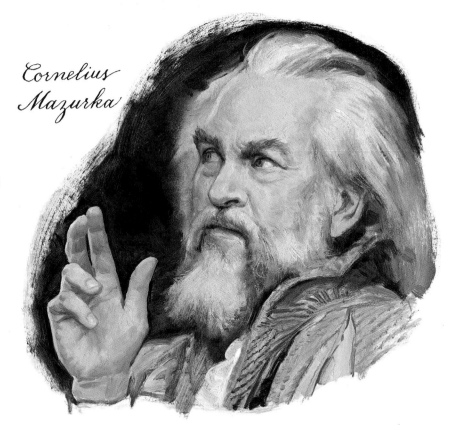

Cornelius Mazurka

Bix admires the claws of Henriette, the Therizinosaurus.

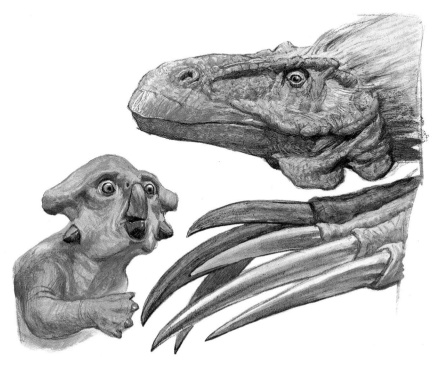

We introduced ourselves and explained our predicament. Mazurka said he certainly had not seen a man of Crabb's description. Evidently, then, Crabb had found some other way across the river and would now be far beyond our reach.

"Rest a while," he said. "The road's not safe past the city. You can stay with me if you like. Are you musicians, by any chance?" We followed him up the partially collapsed staircase to his hermitage. At the doorway he fumbled through a ring of keys and clicked open the locks one by one.

The room inside was in good repair, but the floor was scattered with heaps of yellowed papers and sweepings of broken plaster. Musical instruments of all sorts were arranged along the walls: lutes, lyres, viols, racketts, and sackbuts. Henriette settled down on her resting-couch, drifting deep in reverie and nodding slowly to an unheard rhythm.

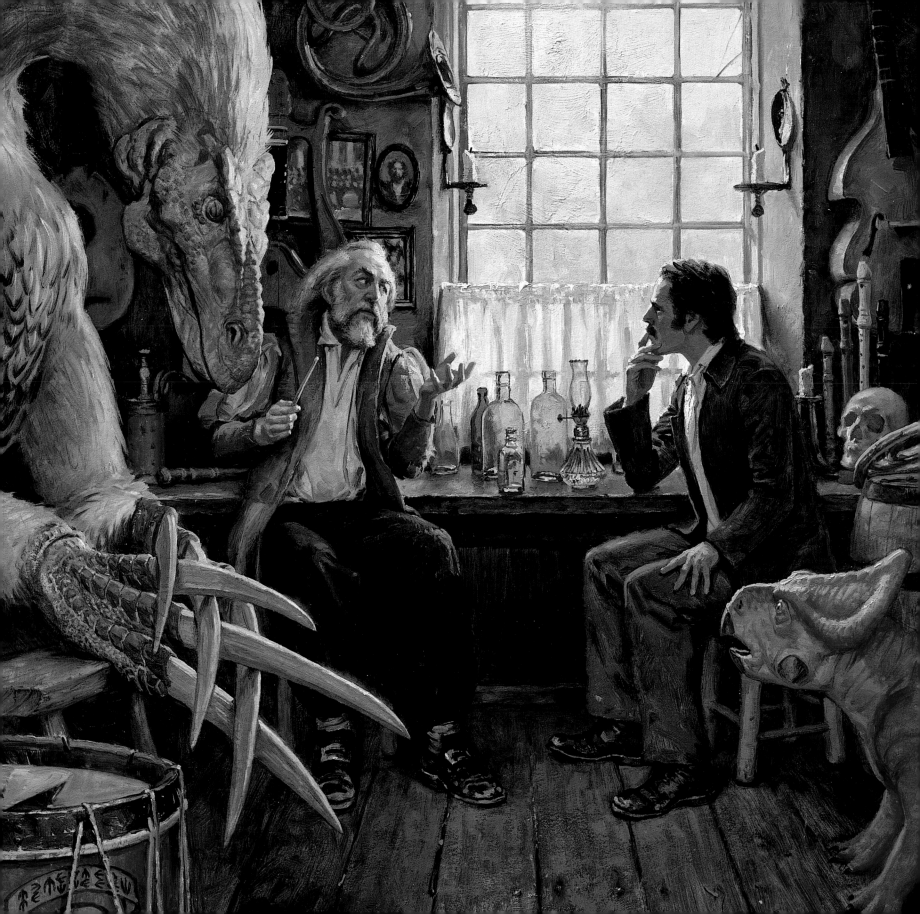

"You'd never know it now," Cornelius said, "but Ruhmsburg was once the top town on the circuit for the big time. The Saurian Grand played *Perils of the Polongo* six-a-day to a packed house. They were all top-notchers in the lineup. We had all the snappy quip-and-jest men. We had Gizelda Pepper doing the Oombajeeva, and Bailey and Brown trilling ditties for a closer. Henriette and I led the Turfwallow Tubamen of Gammawamma. We were a seventy-five-piece consort of brassmen and hadros."

"You're talking about the theater?" I ventured. "We just saw some shows in Sauropolis."

Cornelius shook his head. "There's nothing now like we had back then," he said wistfully. His eyes shifted to a faraway focus. "Those days are long gone. I don't suppose they'll ever come again."

"What's left of the Saurian Grand now?" I asked.

"It went dark after the markets all closed. Then the quake in '48 brought the roof down. And we've been having some more earthquakes recently."

"Why don't you come with us?" Bix suggested. "We're heading to Chandara, and we hear they've got the finest of everything there."

"No, not me," he said. "I don't much care for that kind of music. And you won't get very far without a passport." He told us that everyone who tried the Belt Road without permission from the emperor has come back disappointed. The best chance, he said, might be to head down the coast and try to cross through Blackwood Flats.

We stayed with Cornelius for two days, touring the wrecked theaters and looking through old posters and playbills. One afternoon, a fresh tremor sent chunks of plaster falling on our shoulders. Cornelius confessed that they had been thinking about making a new home somewhere else. Before long, we all agreed to travel south together. We helped Cornelius pack up all his instruments and scrolls in a sturdy cart. Henriette took up the harness and we started down the road toward the coast.

Music is still playing in the head of the old conductor.

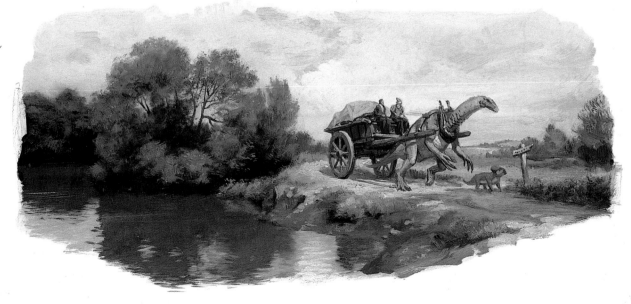

On the road near Scuto's Mill

51

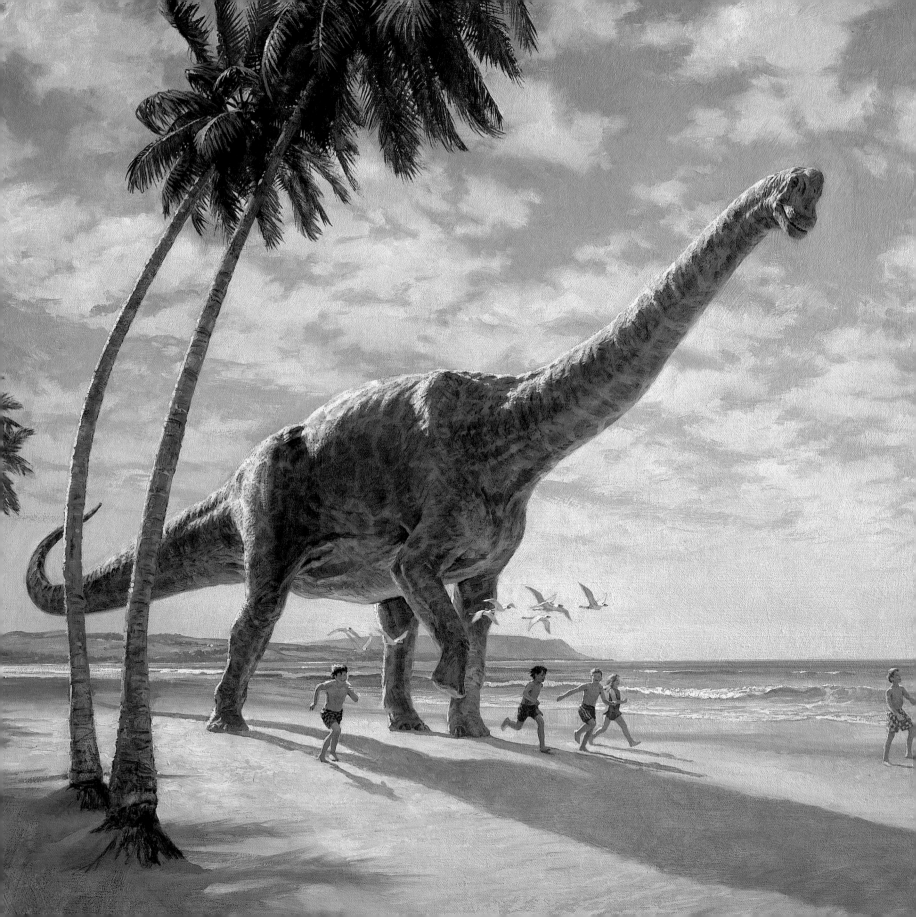

In two days' time we reached the Dragonfly Coast, where sea breezes tossed the heads of the palms, and a reticulated brachiosaur, along with his human friends, chased their shadows along the beach.

About noon, we were the victims of a playful ambush. We had noticed a pack of children hiding in the undergrowth. They leaped into the road ahead of us, waving imaginary spears. "Halt. We have you surrendered," declared their leader, a girl with a flowered coronet.

"Surrounded!" corrected her lieutenant.

"Dictate terms!" Cornelius replied.

"Join with us and forfeit everything. What do you have in the cart?"

When they heard about the musical instruments, they were overtaken by curiosity and dropped their invisible weapons. Cornelius reached into a bag of homemade whistles and handed them out, along with patient instruction. Henriette, meanwhile, had invented a game with the others, who were tossing their hooplike coronets onto her outstretched claws.

Fast friends, we accepted an invitation to supper. We learned that they were from the village of Jorotongo, just a mile farther on. With no room on the cart, they rode on Henriette's shoulders, patting her coat of soft feathers.

53

JOROTONGO was well known from the history scrolls that Cornelius had read. It was one of Dinotopia's peregrine villages, never staying in one place on the map. Every few years the entire settlement was taken apart and rebuilt in a new location. That location was chosen in a remarkable way. The first child or hatchling born in the new site was watched closely, for upon the day of its first steps, the villagers were obliged to make a long day's march in that direction, whatever it might be, and place the new village on that spot.

The people of Jorotongo, Cornelius said, descended from a group of Pilgrim Separatists on the *Sunflower*, a sister ship of the *Mayflower*. It left England in 1620 but was lost at sea and never accounted for in the world outside.

We were given a mighty welcome, and we took our place among the elders to drink the ceremonial *kava*, followed by a feast of yams, bread, coconut, and mango. The townsfolk had a gift for improvisation and organized a comic concerto in our honor, playing their own treasured heirlooms: a flute, cornet, tambourine, and a set of handbells that had been smuggled aboard the *Sunflower* against the wishes of the Pilgrims.

Henriette lifted the cover from the cart. She placed before many sets of wondering eyes the crown jewels of Ruhmsburg, musically speaking. Cornelius demonstrated the finer points of each instrument, while the children lined up for lessons.

Festival Day
at Jorotongo

55

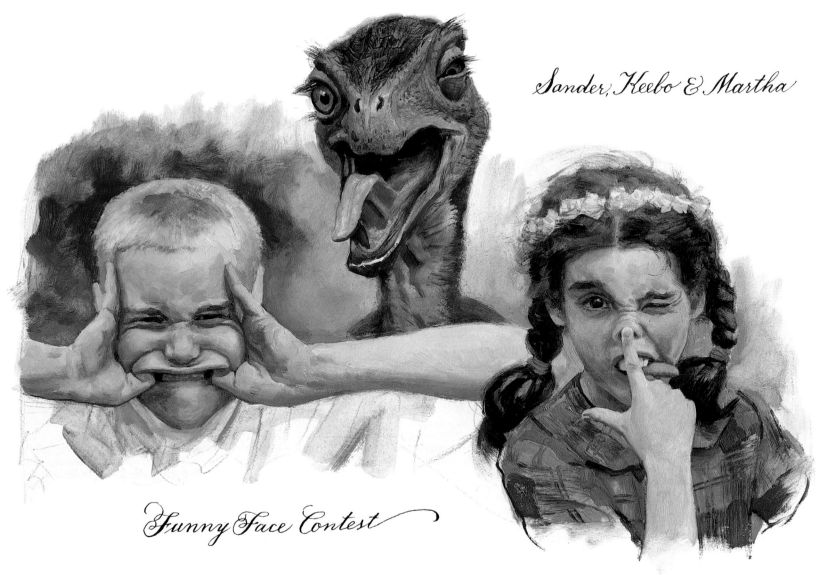

Funny Face Contest

"We're getting ready for a funny face contest," announced a voice at the side of my hammock next morning. I blinked myself awake. It was Sander, Keebo, and Martha, three serious young clowns. "Which one do you like best?" Such marvelous contortions must have required practice, especially considering that the village had no mirrors. I put on my shoes and breakfasted on what was left of the *dawas*, or dark blue plums. In my lapel was a *pua* blossom corsage, given to me by a spotted *Struthiomimus*.

Bix was already awake, helping to set up a lawn bowling game. Henriette was down the beach, having joined a group of young artists drawing pictures in the sand. Cornelius was under a banyan tree rehearsing some young singers on the tunes from *Perils of the Polongo*.

We were told it was Festival Day, decided by popular vote at breakfast. I asked an *Achelousaurus*: "Is every day Festival Day? When is Work Day, or Worship Day?"

"When work or worship needs to be done, we agree to do it," he replied. "And then we try to think of how we can make it into a form of play."

"But isn't it sacrilegious to turn worship into some kind of play?"

"Not at all. We regard play as the highest form of praise."

Just then three teams of plank-walkers plodded by. They carefully lifted their hand ropes in unison, moving the right and left planks like a single pair of feet.

"With all respect," I persisted, "your life here seems to be governed by the pleasure of the moment. Living in this way, how can you work toward a goal?

And without a larger goal, how can you accomplish anything lasting in your lives?"

The dinosaur munched thoughtfully. "A moment well spent is the best accomplishment. Yesterday is a phantom, and tomorrow a mirage. The only day worth living is this one. If we can do that well, the yesterdays and tomorrows take care of themselves." He groaned and stood up. "Too much talk. Please, come. The young ones have invented some new games, and we should not miss them."

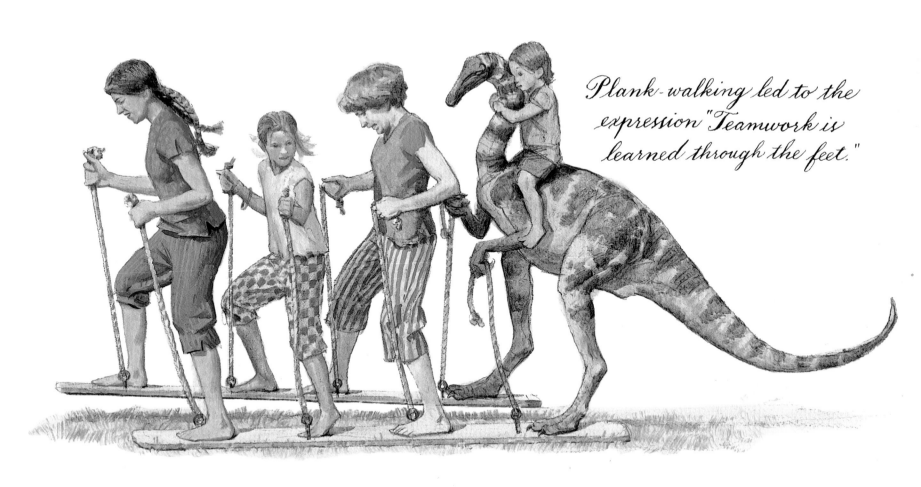

Plank-walking led to the expression "Teamwork is learned through the feet."

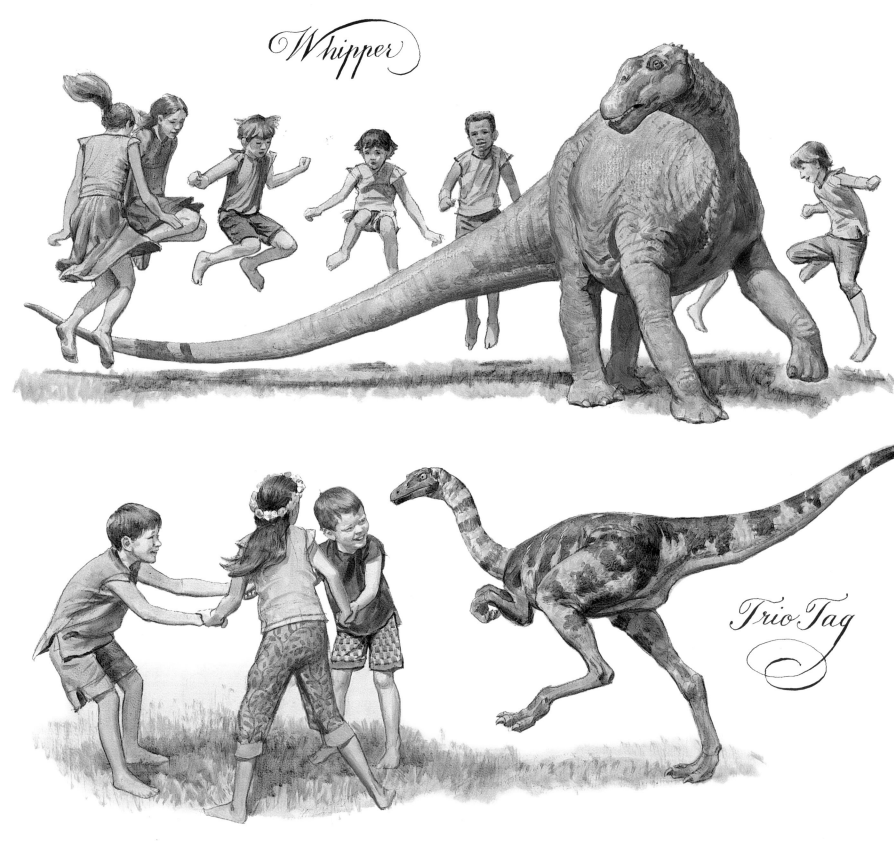

Whipper

Trio Tag

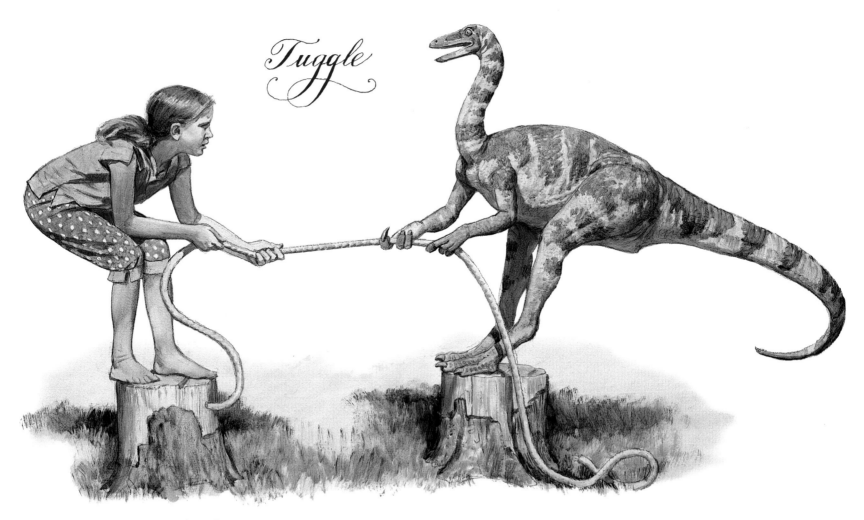

Tuggle

WHIPPER. A *Coloradisaurus*, a long-tailed dino-saur, stands in a large clearing with jumpers stand-ing in a circle behind him. As the tail wags back and forth, slowly at first, each must jump over it. Players who are touched by the tail must step back until a single winner remains standing.

TRIO TAG. In this game for four players, three stand facing each other, holding hands. One (here in yellow) is called the Morsel and the other two the Guards. It is the job of the Guards to work together to protect the Morsel from the Allosaur (here played by a harmless *Struthiomimus*). As the Allosaur circles, trying to tag the Morsel, the Guards turn to protect him. Tagging across the triangle or on the hands is not allowed. Once tagged, the Morsel becomes the next Allosaur.

TUGGLE. Two players crouch on stumps or over-turned buckets facing each other and holding a thick rope. At a signal they begin tugging, with the aim of unbalancing the other. The first to force the other to the ground or to gain full possession of the rope is the winner. In this game neither strength nor weight is any advantage. A smaller player can win by tricking a larger player into anticipating a strong tug. Then a sudden release of tension will send the other falling backward.

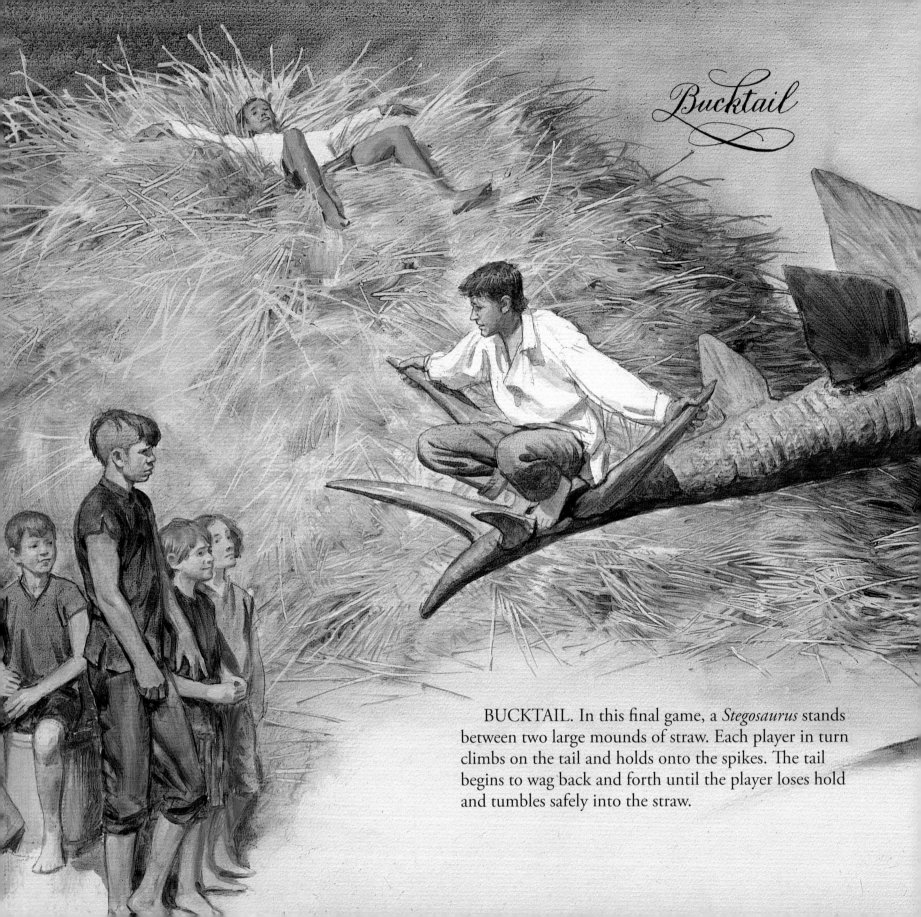

Bucktail

BUCKTAIL. In this final game, a *Stegosaurus* stands between two large mounds of straw. Each player in turn climbs on the tail and holds onto the spikes. The tail begins to wag back and forth until the player loses hold and tumbles safely into the straw.

The festival was over. We climbed the bamboo ladder to the sleeping loft for the last good rest before our trek into Blackwood Flats. Next morning we said farewell to the villagers and especially to Cornelius and Henriette. They said they had resolved to stay with the Jorotongans "at least for now."

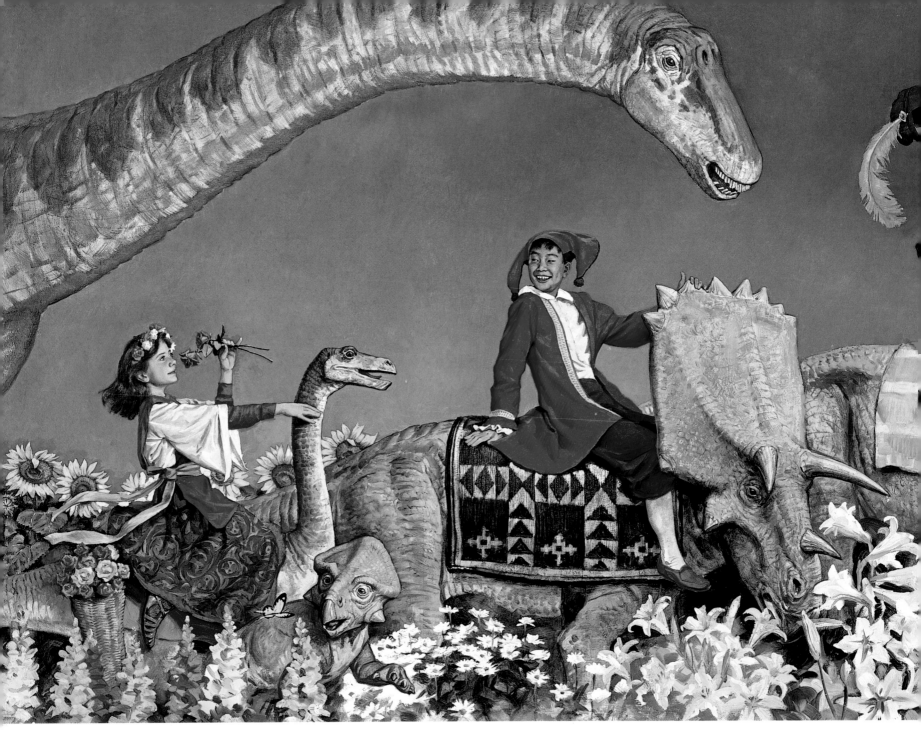

A jovial band of children and dinosaurs escorted us through a field of flowers.

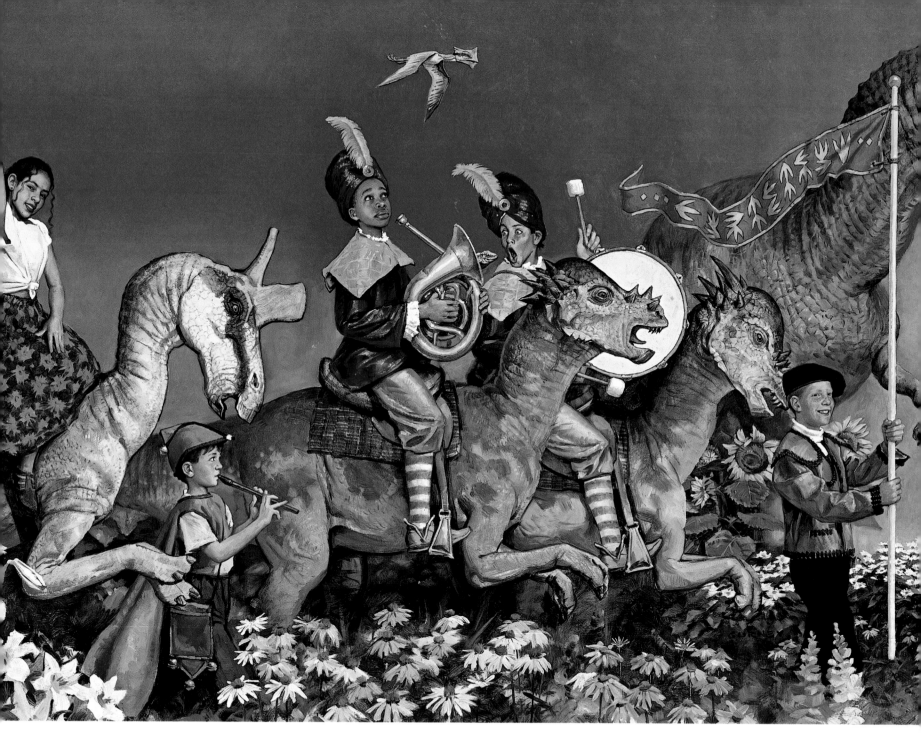

The road grew more wild as we approached Blackwood Flats.

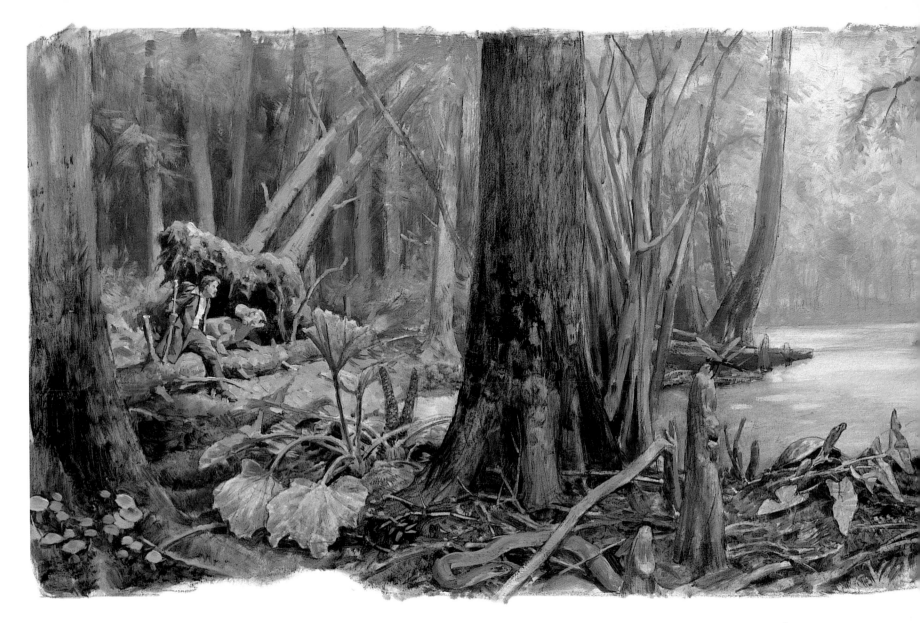

BLACKWOOD FLATS lay between us and the beast. If we could make a direct trek across it, we could save time. We had heard reports of big meat-eaters, not just from Will, but from Habitat Partners like Bracken and Fiddlehead. In other places like the Rainy Basin, travelers ward off attacks by moving in armored convoys. Our plan was to go on foot, unprotected, hoping that a light step would draw less attention.

The first half mile of jungle was easy traveling, threaded with a maze of trails leading in all directions. Farther along, the vegetation grew thicker and thornier. Several times the way was blocked altogether by a solid wall of brambles. Bix, probing low to the ground and ducking under branches, found passages that she guessed were made by the piglike *Archaeotherium*. I crawled on my hands and knees, remaining vigilant for snakes.

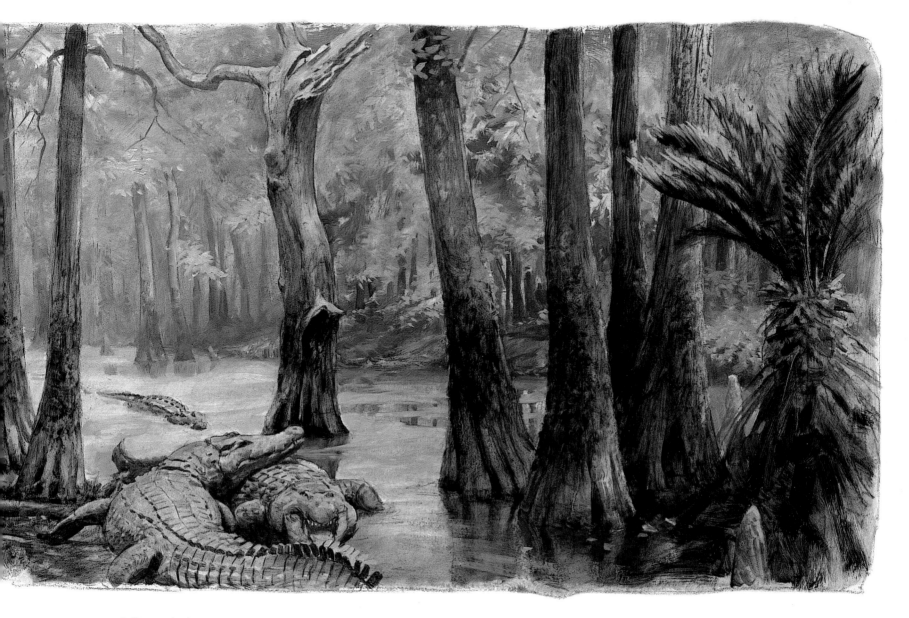

We followed the compass eastward, and we crossed a quagmire paved green with duckweed and infested with crocodiles. In places we sank to our knees in mud or broke through decaying logs into fetid cavities. From time to time a deep roar reverberated through the forest, followed by the eerie, nervous chatter from packs of *Ornitholestes*. They seemed to follow us at a distance for most of the day, but we never saw more than a momentary glimpse of them. At one point a graceful *Camptosaurus* approached us warily, her eyes glistening. But then she stiffened at the sound of something that we could not hear and bounded away in terror.

The way grew more and more swampy and the sound of roaring more ominous. We resolved to change our course, bearing leftward with the goal of crossing over into Chandara by the high passes.

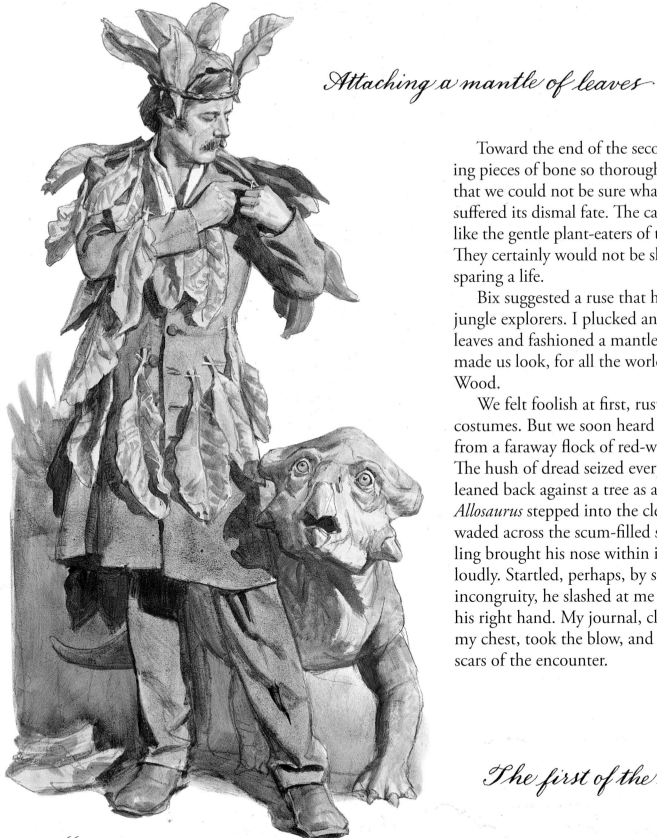

Attaching a mantle of leaves

Toward the end of the second day we began finding pieces of bone so thoroughly broken and gnawed that we could not be sure what kind of creature had suffered its dismal fate. The carnosaurs here were not like the gentle plant-eaters of the rest of the island. They certainly would not be shamed or scolded into sparing a life.

Bix suggested a ruse that had succeeded for other jungle explorers. I plucked an armful of nicotiana leaves and fashioned a mantle for each of us that made us look, for all the world, like bushes in Birnam Wood.

We felt foolish at first, rustling along in our leafy costumes. But we soon heard the staccato alarm call from a faraway flock of red-winged *Scaphognathus*. The hush of dread seized every living creature. I leaned back against a tree as a troop of tiger-striped *Allosaurus* stepped into the clearing. One by one they waded across the scum-filled slough. A curious yearling brought his nose within inches of mine, sniffing loudly. Startled, perhaps, by some apprehension of incongruity, he slashed at me with the three claws of his right hand. My journal, clutched instinctively to my chest, took the blow, and to this day bears the scars of the encounter.

The first of the troop of Allosaurus

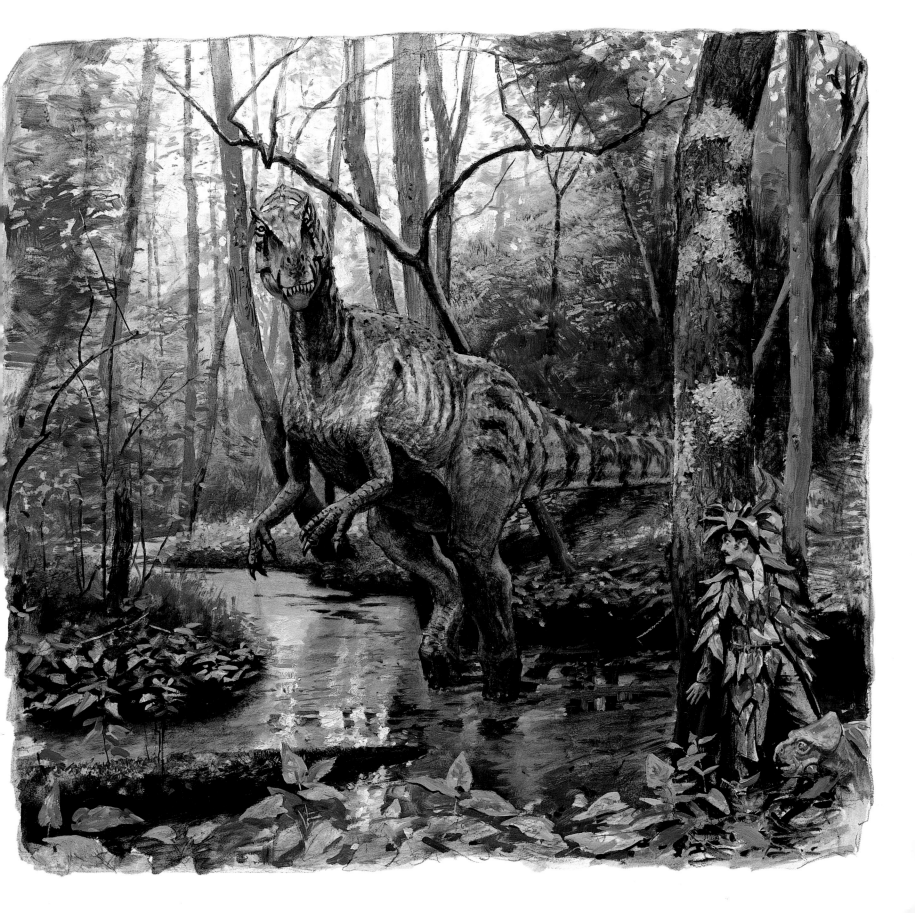

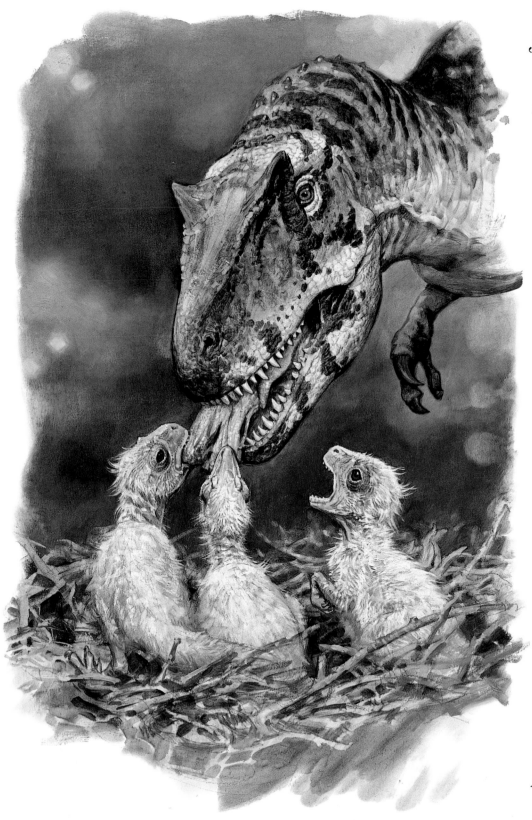

We moved on in this way for three days with bolstered confidence. By keeping absolutely silent and blending into the undergrowth, we were able to witness the rare sight of an *Allosaurus* tending her hatchlings in the nest. We guessed the chicks were about seven days old. They responded to the mother's "shup-shup" call with a lusty cheeping and begging, eager for scraps of meat.

We tiptoed safely away next morning before first light when the family was still roosting. Around noon we came upon a group of red-faced *Tyrannosaurus*. Bix assured me that these were not the aggressive predators of the Rainy Basin, but rather mere scavengers. The brutes observed a respectful distance as long as we maintained a high-stepping show of health and vigor, but if we dragged or rested, they stalked us like undertakers.

A crocodile defends its territory from a two-year-old Allosaurus.

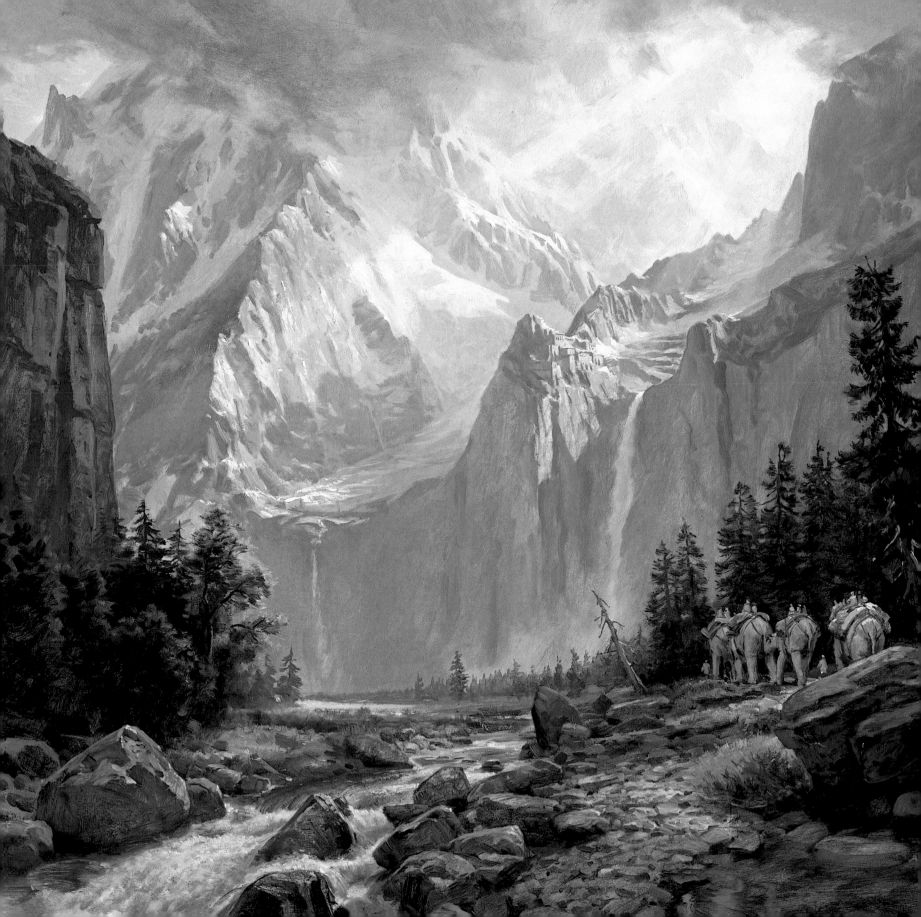

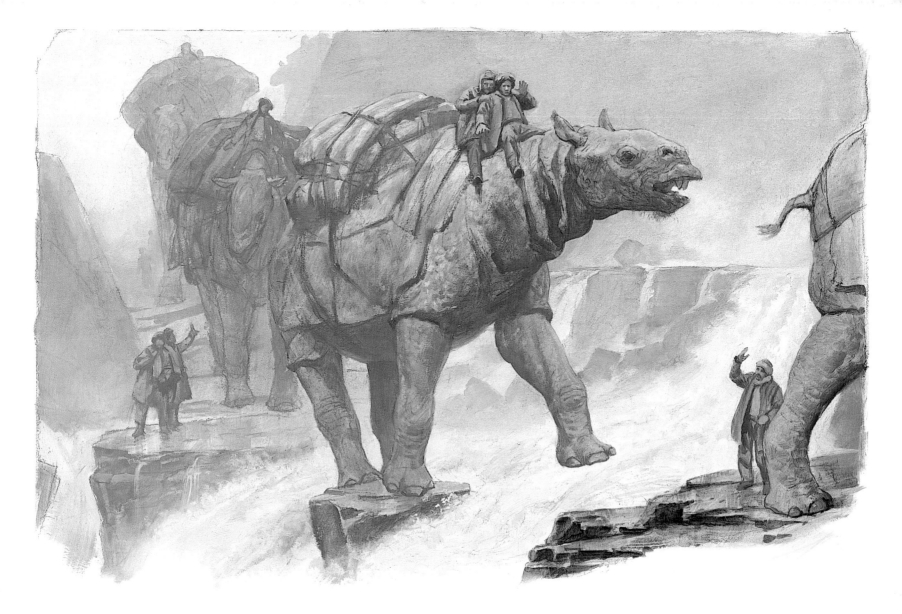

Into the High Country

WE DEPARTED the low country, with its stagnant vapors and biting insects and climbed onward, always higher and colder, into the Forbidden Mountains. The Cenozoic mammals, long departed elsewhere from the earth, thrive here in abundance in this last stronghold of the Ice Age.

We skirted the lower flanks of the Tokta range, and were lucky to find one of the *Paraceratherium* supply caravans on its way from Snailshanks to the steaming valleys of Simang and the high camps of Kangduk. I scaled the greasy rope ladder thrown down to me by the mahout and then hoisted Bix in a sling. The upland trail was steep and narrow, often choked by fallen boulders and gouged by foaming torrents that plunged headlong with a deep and sinister roar.

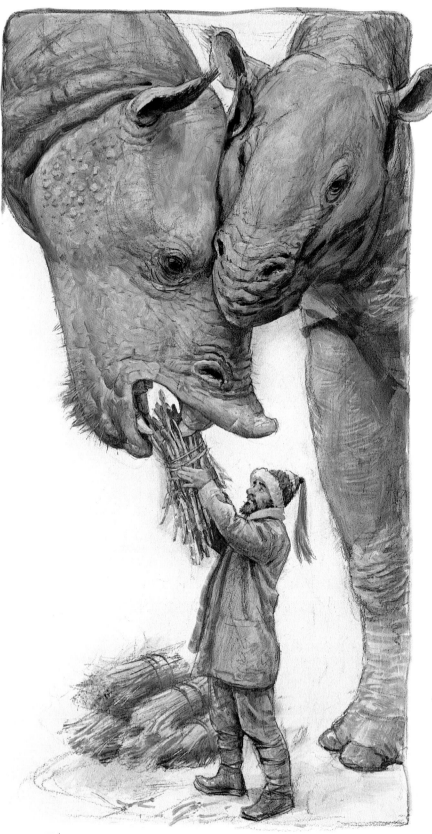

Our *Paraceratherium* was named Muhimmi, the smallest and the most timid of the group. Still, she was four times the weight of the largest outworld elephant. She ate with a dainty precision, curling back her lip in the way of all giant rhinos. On the trail she lagged to the back of the line, struggling at times to keep up with the others. She moaned softly at the prospect of uncertain footing, hesitating with short, cautious steps, ears flattened, swinging her head from side to side. Only the most eloquent assurances from the mahout convinced her to cross one stretch of makeshift bridge work that cantilevered along a sheer cliff.

Above the tree line, a layer of new snow dusted the trail, disguising slippery rocks. A thick mist enveloped us in oblivion, and Muhimmi halted. We dismounted, and the mahout sent out a long blast on his *Pelorovis* horn. Soon, to our great relief, a sixteen-point *Megaloceros* emerged from the fog and guided us step-by-step with sounds of patient encouragement.

A giant fallow deer Megaloceros, often called the Irish Elk

Kamba and Muhimmi always eat together. They prefer barley and clover.

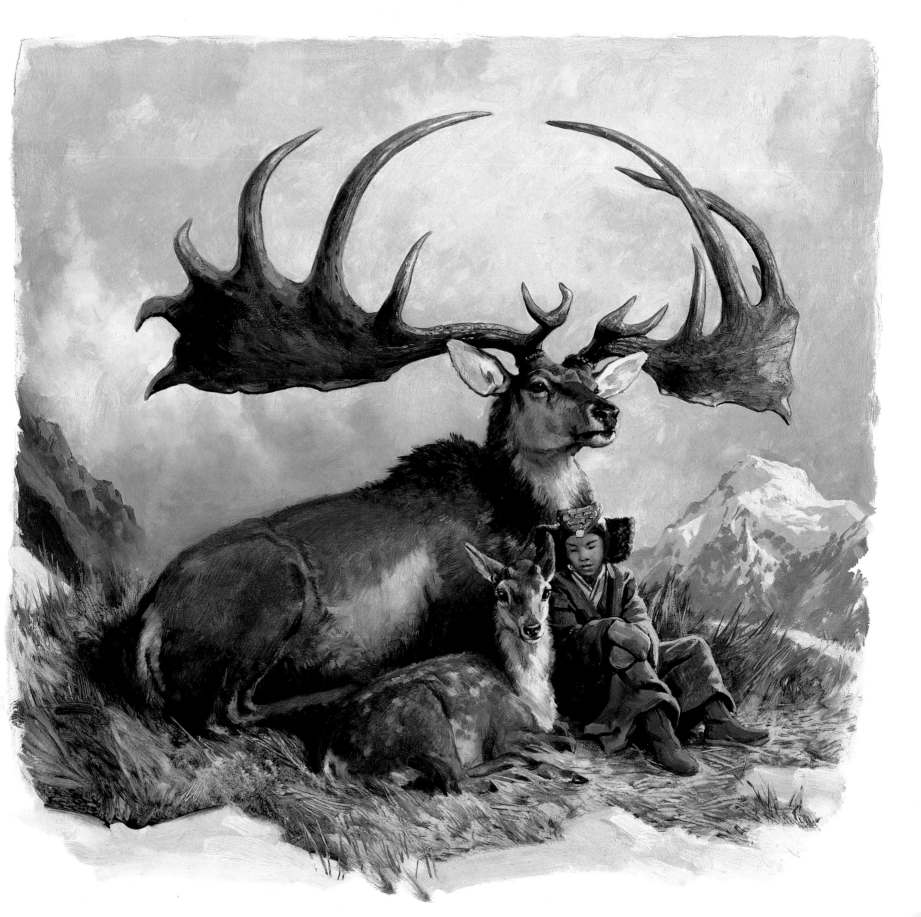

At Kangduk the mountain caravan could go no farther. We said farewell to Muhimmi and the others. The summit villages like Powdertop, Sky City, and Thermala have to rely on sky galleys for their supplies. Bix and I would have to climb the rest of the way on foot.

We bartered most of our tea and salt in exchange for a portable stove, an ice axe, and a few coils of rope, as well as warmer sleeping blankets. For Bix we even found felt boots and an oversize woolen sweater (designed to fit a therapsid). She insisted she was not cold-blooded, but I could see from her resolute shivering that this was not a good place for a *Protoceratops*.

For the next two days we wallowed hip-deep in soft snow or clung to icy ridges buffeted by bitter gusts that whistled through the crags. At last we plowed through the drifts to the gates of Thermala, where we were welcomed with astonishment and ushered into a warm room full of bouquets of peonies and lilacs.

Thermala was more spacious inside than I would have guessed. The rooms were joined with vaulted passageways lit by flickering butter lamps. Some of the larger chambers, which housed the mammoths and the camelids, were tunneled deep into the mountain, with windows peering out of cliff faces.

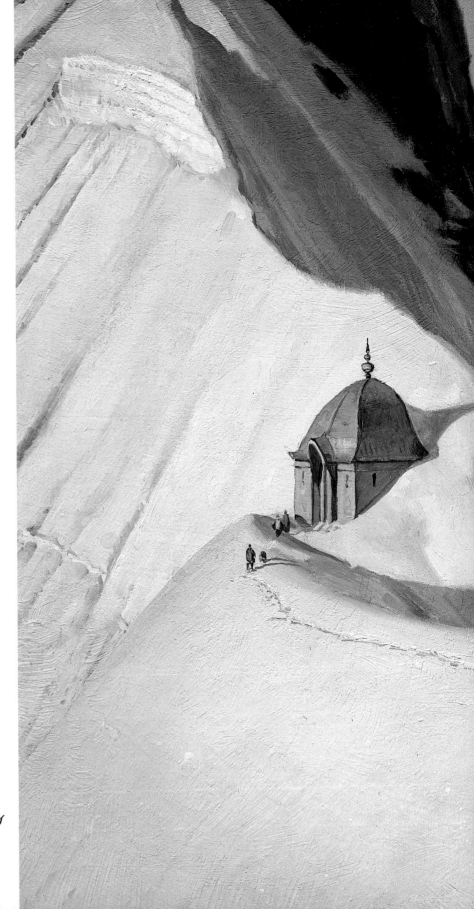

Thermala, one of the alpine hideaways

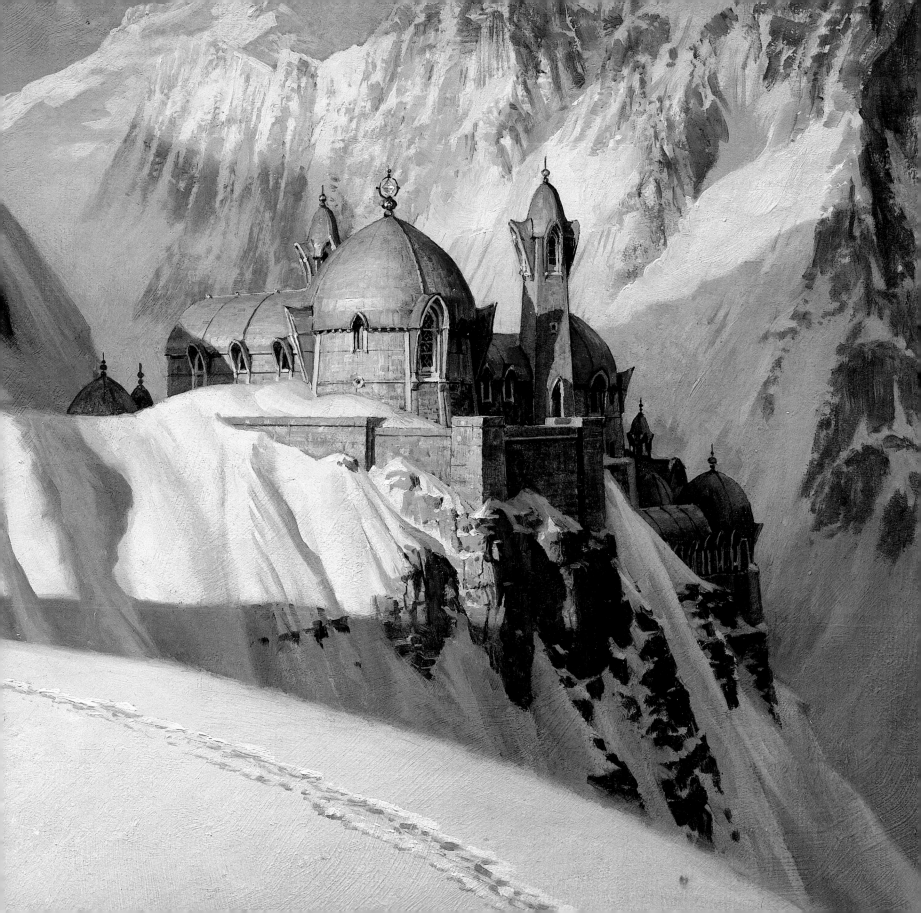

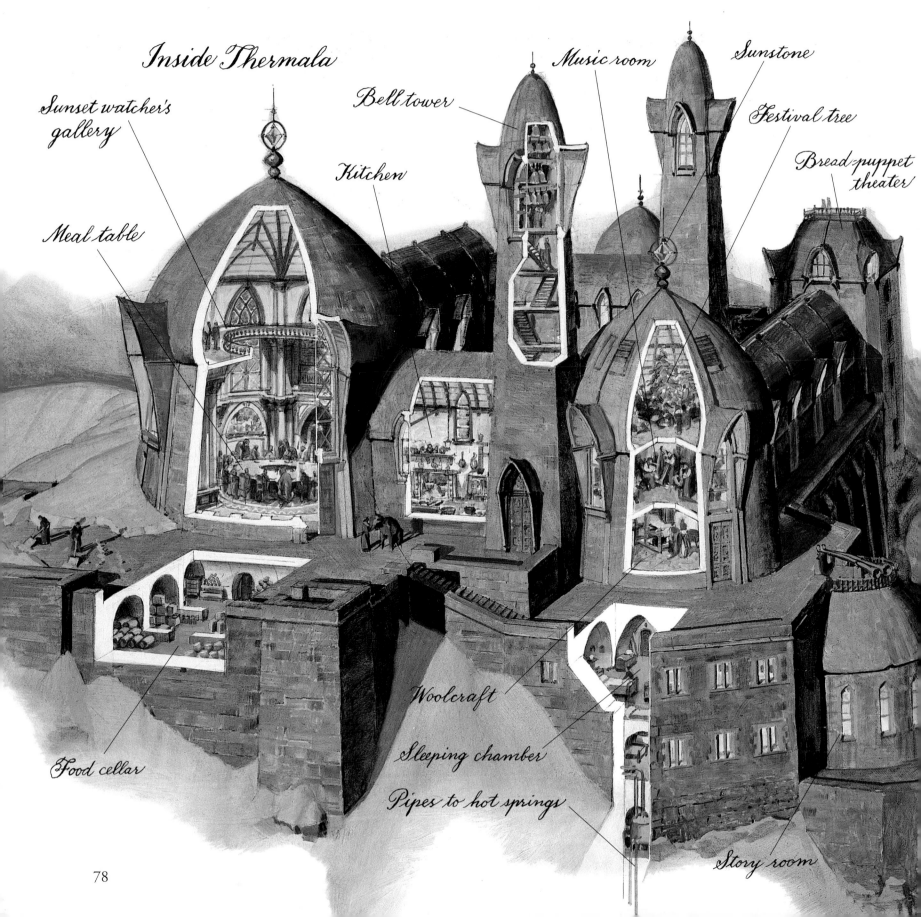

Inside Thermala

Sunset watcher's gallery

Bell tower

Music room

Sunstone

Meal table

Kitchen

Festival tree

Bread-puppet theater

Woolcraft

Sleeping chamber

Food cellar

Pipes to hot springs

Story room

78

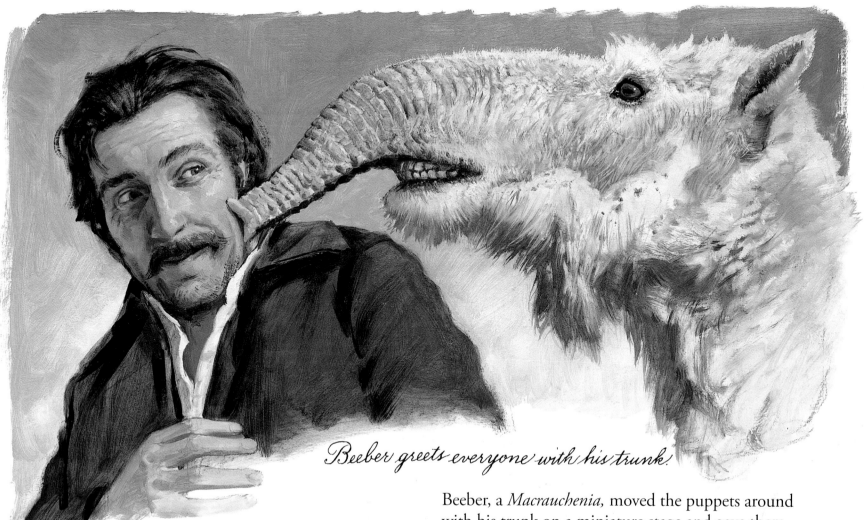

Beeber greets everyone with his trunk.

Bix and I settled into a routine that kept us busy during two weeks of hard weather outside. Each day we joined the cubs for the puppet stories of Esther Volant. This grand white-haired woman wore magnificent damask robes embroidered with gold dragons emerging from the sea. She was born and raised in Thermala, never married or bore children, and had been down the mountain only once, when she was seventeen.

To aid in her storytelling, she made little figures of bread dough, baked fresh each morning. Her assistant, Beeber, a *Macrauchenia,* moved the puppets around with his trunk on a miniature stage and gave them to the cubs to eat when the stories were over. The puppets were all fantastical: angels, demons, centaurs, and mermaids. But to Esther Volant they represented a world as real as rocks and snow. One day, hoping to rid the cubs of their fanciful nonsense, I helped shape a batch of bread-puppets based on factual animals. "You are in your middle years, Mr. Denison," she observed gently, "so your eyes are the test of all things. When one is very young or very old, one sees more with the heart than with the eyes." When I asked to sketch her portrait, she would always say, "Perhaps later. Come back when you're older."

79

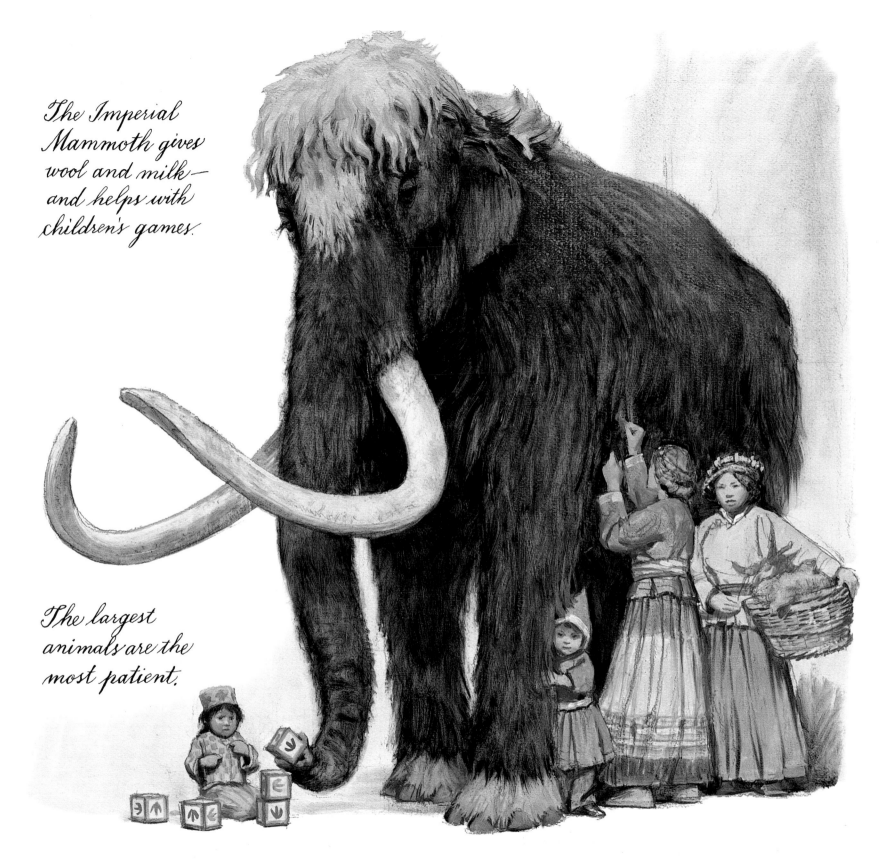

The Imperial Mammoth gives wool and milk— and helps with children's games.

The largest animals are the most patient.

80

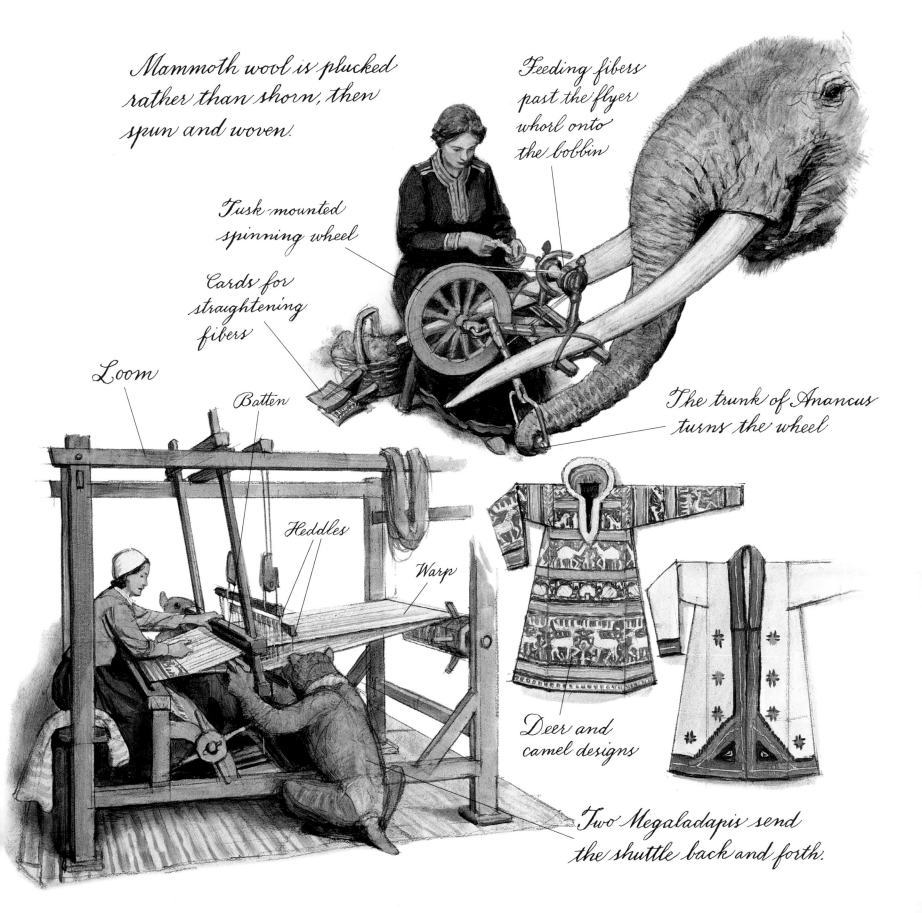

Mammoth wool is plucked rather than shorn, then spun and woven.

Feeding fibers past the flyer whorl onto the bobbin

Tusk-mounted spinning wheel

Cards for straightening fibers

The trunk of Anancus turns the wheel

Loom

Batten

Heddles

Warp

Deer and camel designs

Two Megaladapis send the shuttle back and forth.

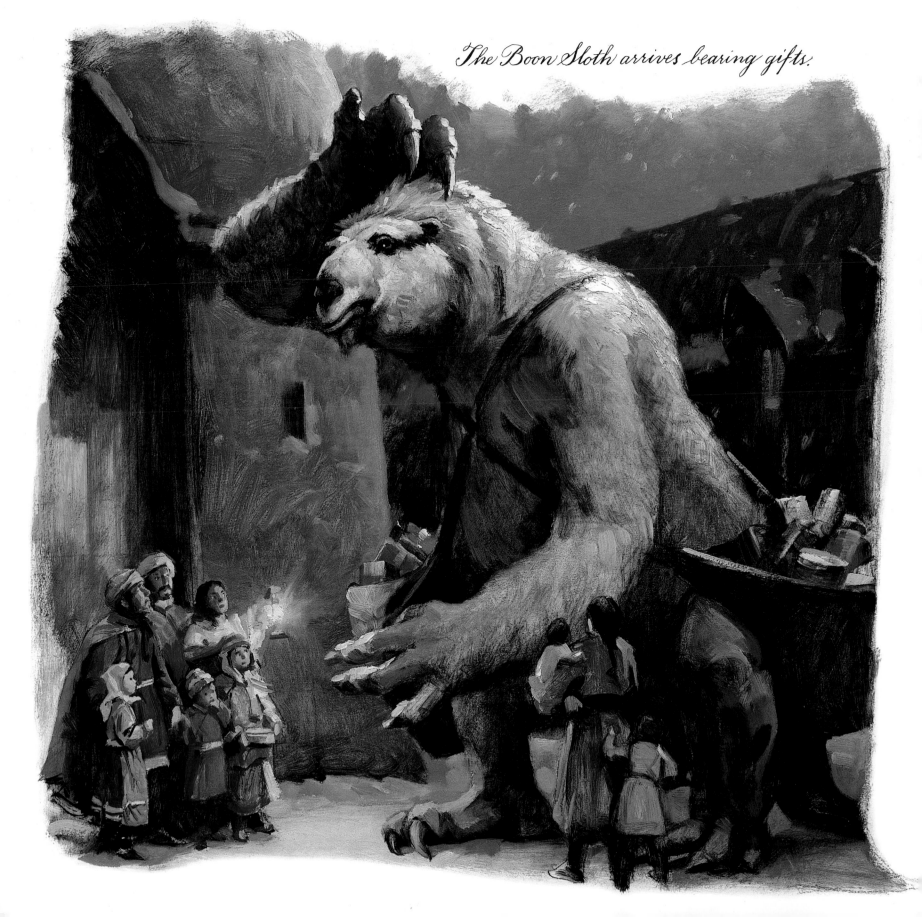

The Boon Sloth arrives bearing gifts.

Descending from the Forbidden Mountains

At one of the bread-puppet performances, there was talk about the advent of the "Boon Sloth." This sounded like another of Esther Volant's fantasies, until I witnessed it myself on the appointed night. We all waited outdoors in the circle of lamplight, peering into the swirling darkness. From his lair somewhere high on the mountain, the creature, a *Megatherium,* shambled into the plaza, his gift bags nearly dragging alongside.

He seemed absentminded and poor of hearing. Each of us had to repeat our name two or three times. But he had a kind word and a gift for everyone, even for Bix and me. When I unwrapped the gift later, I found a fine Culpeper-type microscope that must have taken great effort to acquire. We packed our treasures and took our leave, crossing the high passes to begin the long descent down the eastern face of the mountains.

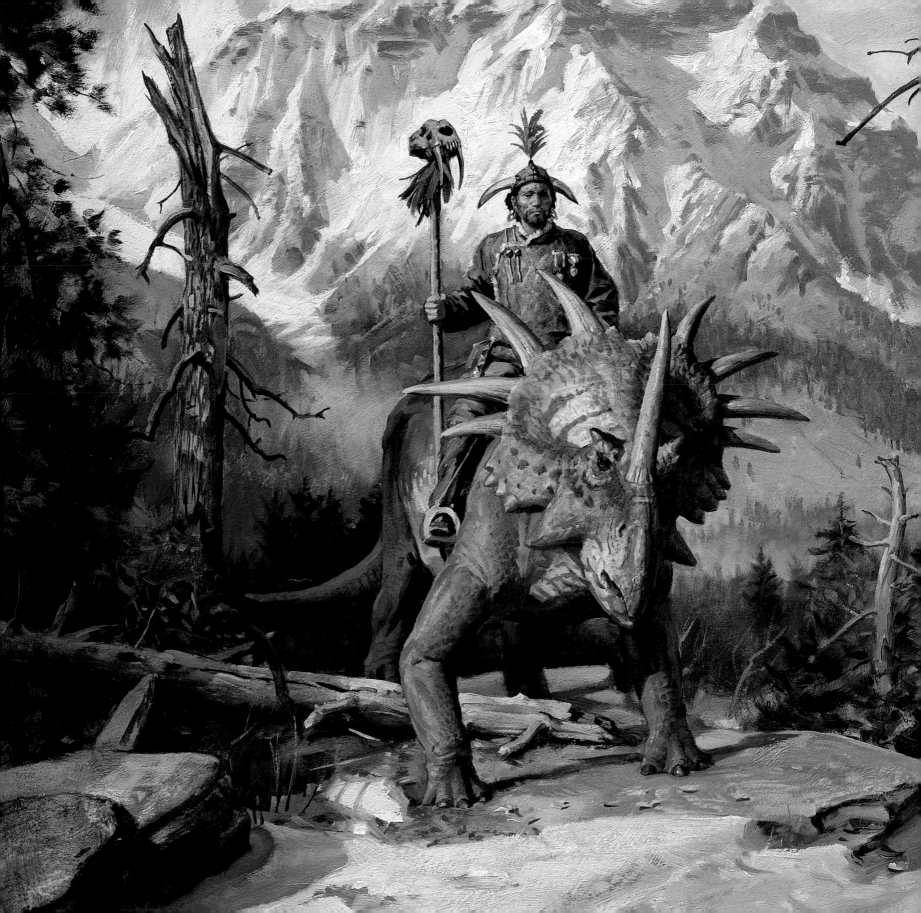

THE EASTERN MOUNTAINS are a wild, largely unsettled region, a good place to enter the western edge of the Chandaran Empire without much opposition from official guards—but there were current reports of brigands. One afternoon at the edge of a pine forest, a flock of small pterosaurs landed on a nearby branch, folded themselves like umbrellas, and began muttering in a coarse dialect. A few snatches of their conversation reached us: "Nothing worth much" and "Should we tell the others?"

Alarmed, we extinguished our cooking fire and stayed off the main trail. We crawled on our bellies up to each new ridge to scan ahead for signs of trouble. I peered through my telescope and saw a cluster of gray yurts on a rubble-strewn hillside.

A storm was gathering, and night was descending early, so I put my sketch-journal in the hollow of a dead tree for safekeeping. Dark clouds rolled in, releasing a drumbeat of rain on the small square of canvas that we strung between saplings. I lay down in my damp clothes, and Bix crouched like a cat. Sleep must have finally overtaken us. As the day broke, the storm abated, but our position did not look cheerful. Standing on the ridge near us was a mountain tribesman clutching a sabertooth halberd.

Nibor Dooh and the Styracosaurus Sacul of the Kleptodon Tribe

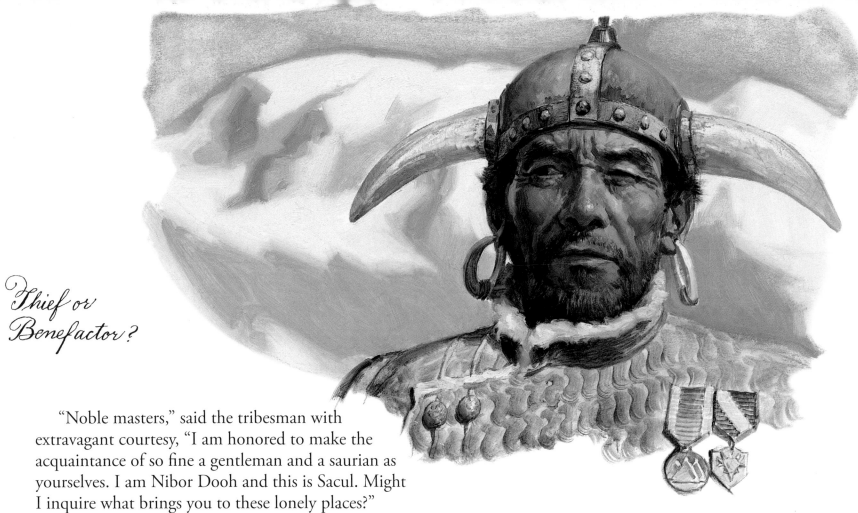

Thief or Benefactor?

"Noble masters," said the tribesman with extravagant courtesy, "I am honored to make the acquaintance of so fine a gentleman and a saurian as yourselves. I am Nibor Dooh and this is Sacul. Might I inquire what brings you to these lonely places?"

We came to our feet guardedly and answered that we were travelers, hoping that strangers here might find hospitality.

"Hospitality?" he said, bowing slightly. "It is the law of hospitality here to give everything to one's neighbor."

My thoughts went at once to my watch, barometer, sextant, compass, and most of all my new microscope. How sorry I would be to lose them. Bix wondered aloud, "Are you a benefactor or a thief?"

"Neither. Or both. I shall ask you now for the generous gift of all your clothes and possessions. Of course you will receive fair recompense. For you see, I have in this bundle," he said, holding up a dirty sack, "all of the worldly goods of the last man who came through here. Everything that he owned is now yours. All of your things shall be given to my next guest. I shall keep nothing for myself."

By now his grinning henchmen encircled us. There was no choice but to strip down, give away all, and accept the bundle. It contained a desert robe, a head scarf, a walking staff, sandals, a water gourd, prayer beads, and a little book that neither Bix nor I could read.

They sauntered off. When it was safe, I recovered my journal from the hollow tree. We then descended to a region of arid badlands, where we met the encampment of a caravan from the north on its way through the desert to Ebulon.

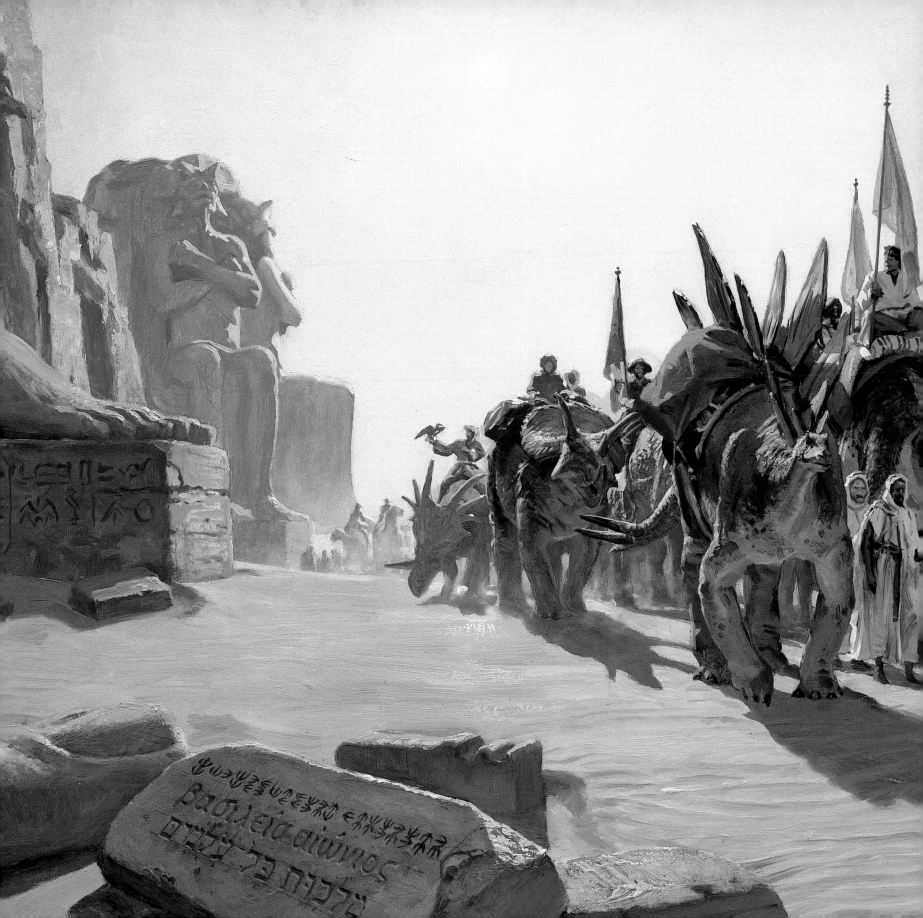

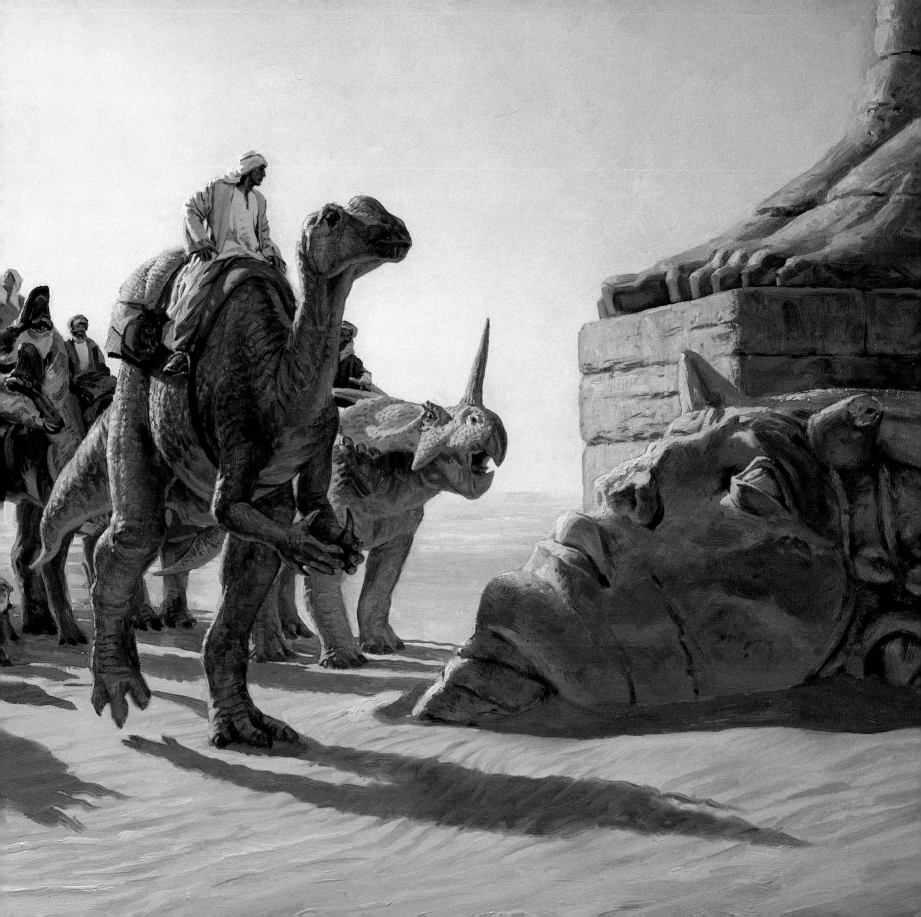

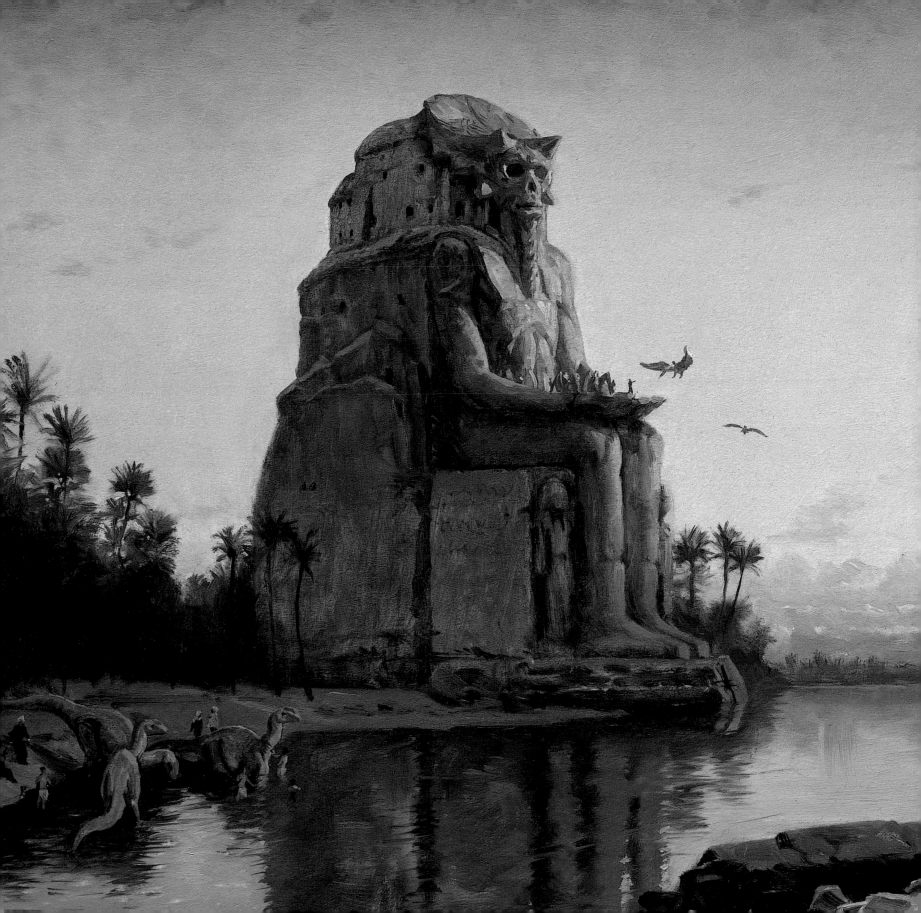

NIBOR DOOH'S GIFT of the turban, robe, and sandals had come at the price of all my other possessions, but now at least Bix and I could blend into the caravan from Canyon City. We never aroused the suspicion of Chandara's border guards, whom we encountered several times patrolling on *Diatrymas*.

The caravan route led us among the ruins of Ebulon, a group of twelve colossal seated figures quarried from pillars of volcanic tufa. These towering monuments survey the vast expanse of desolation in profound tranquility, mute testaments to long-vanished glory and power.

The largest figure represents the demisaurian Amon-Ceratops, half human and half saurian, at whose feet stretches a palm-fringed lake. In the cool waters of this magnificent oasis, I gratefully found refreshment.

If Will was following according to plan, he and his fellow skybax students should be here for summer flight training. As dusk settled, I was overjoyed to see the pterosaurs return and come to rest on the flight platform.

The Seated Colossus of Ebulon

Bix lingered to gather gossip while I climbed the stairs to the flight platform looking for Will and Sylvia. I found them alone just as they finished unsaddling their mounts.

"Father, is that you?" Will exclaimed. "What brings you here?"

I told him about Crabb's theft of the invitation and our encounter with the Kleptodons. He seemed to grow increasingly bemused by my appearance. "What sort of person did those clothes come from?" he asked.

"I have no idea. But when people see me, I get all manner of strange reactions. All I know is that I'm lost without my watch and compass. I don't know what time it is and I don't know where I am."

"You're here. Come on with us. We'll show you around."

Ebulon, I learned, was built as a gift from King Ogthar to Queen Almestra to commemorate their union in the Fifth Kingdom. The hollow chambers once served them as a royal palace, but in later centuries they have been the home of strutter-men, mystics, farmers, and now skybax riders. The lower doors can be sealed off with huge stone wheels. Gardens round about the base, fertilized by skybax guano, bear a rich harvest of melons, tomatoes, grapes, and apricots.

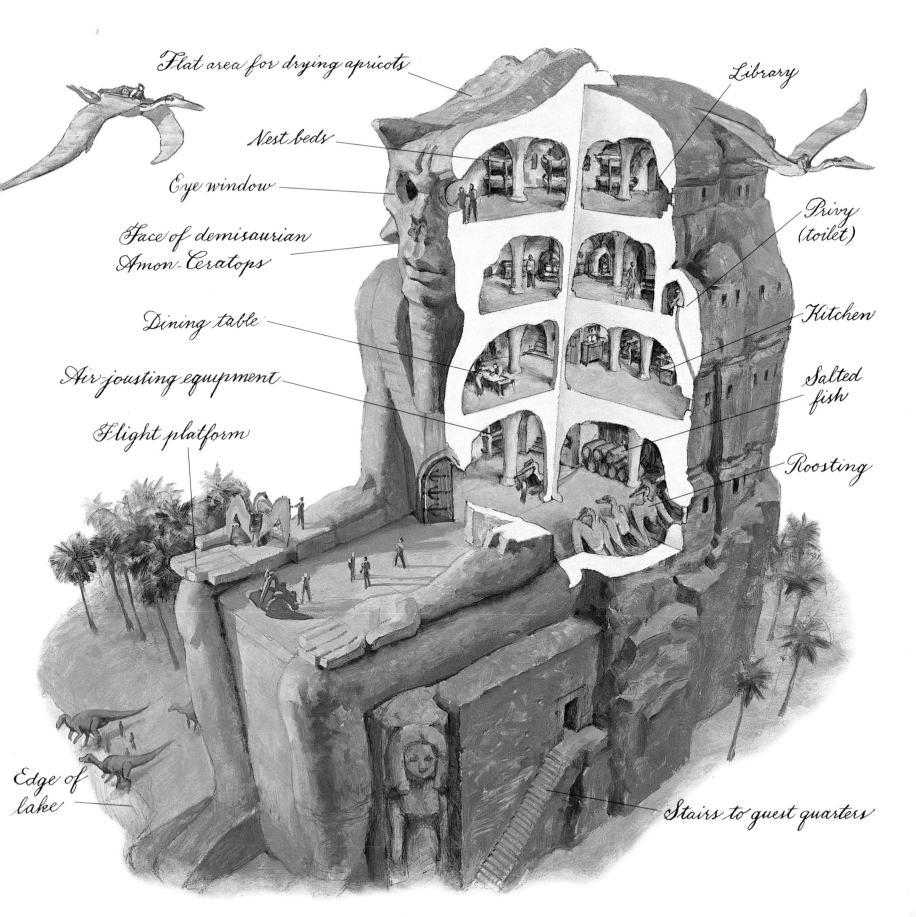

Flat area for drying apricots

Library

Nest beds

Eye window

Privy (toilet)

Face of demisaurian Amon-Ceratops

Kitchen

Dining table

Salted fish

Air-jousting equipment

Roosting

Flight platform

Edge of lake

Stairs to guest quarters

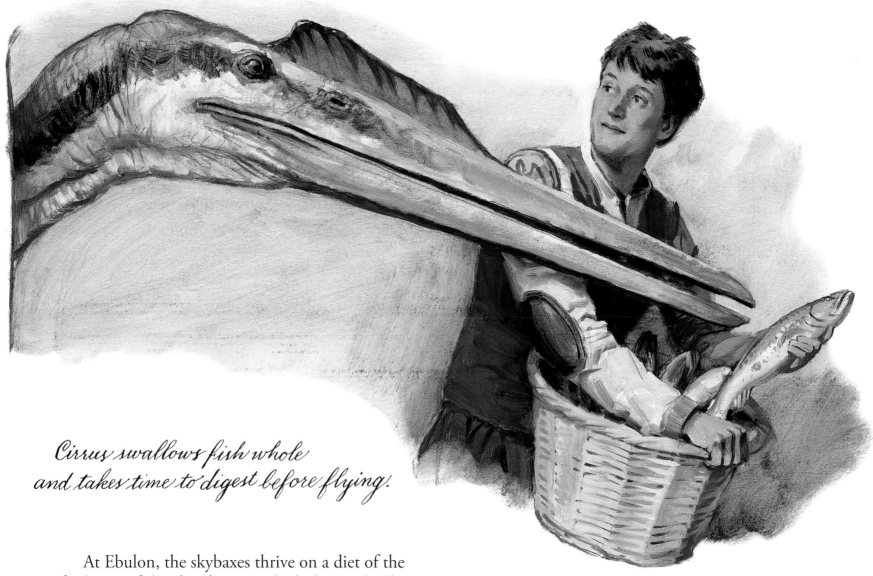

*Cirrus swallows fish whole
and takes time to digest before flying.*

At Ebulon, the skybaxes thrive on a diet of the freshwater fish *Chondrosteus*, which they gather by skimming low over shallow water at dusk and flipping the fish up into the air to be caught by the rider. This practice is also of great value for developing the pterosaur's flying skills and the rider's lightning reflexes.

The *Quetzalcoatlus*, known informally in Dinotopia as the skybax, is the largest of the pterosaurs. Swift and agile in the air, they are less graceful on the ground, where they balance on their rudimentary fingers. It is not possible to take off from level ground while bearing the weight of a rider, so they must always be in a position to launch from a high place. Skybaxes prefer to travel in small groups of six to ten individuals. They can be found in the wild in the hollowed cliffs at Highnest and Prosperine to the north.

Tomorrow, Will explained, air jousting would begin.

Better to stand back when skybaxes spar with each other.

Before every flight, rider and mount exchange a soft series of hums and trills to build trust.

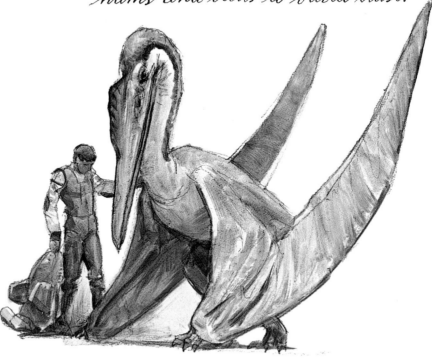

Catching fish while flying low over the lake

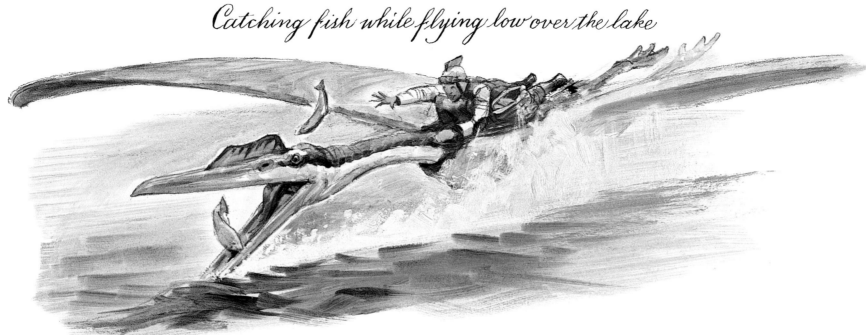

Soft padded tip

Air jousting builds a flier's confidence in direct encounters, and it helps address the fear of falling. The midair attack strategy is based on actual behaviors that skybaxes practice with each other during breeding season.

The event is a relic of the chivalrous era when the Desert Resistance overcame the Strutter Invasion more than 3,500 years ago. Now in a more peaceful time, the event is conducted with safety foremost in mind. To save weight, the shield and shaffron are made of wood and joined with hemp and linen. Riders grip the saddle with their knees in the manner of the pioneer rider Gideon Altaire. The lance is made of lightweight wood and tipped with a padded coronel. The skybaxes fly toward each other on a low approach over the lake, listening carefully to voice commands. At the last possible instant, they each roll one quarter revolution to the left and tuck their wings in slightly. When the riders meet, the impact of the lance on the shield usually unseats one of the riders, who then falls harmlessly into the water.

Shaffron blocks forward vision

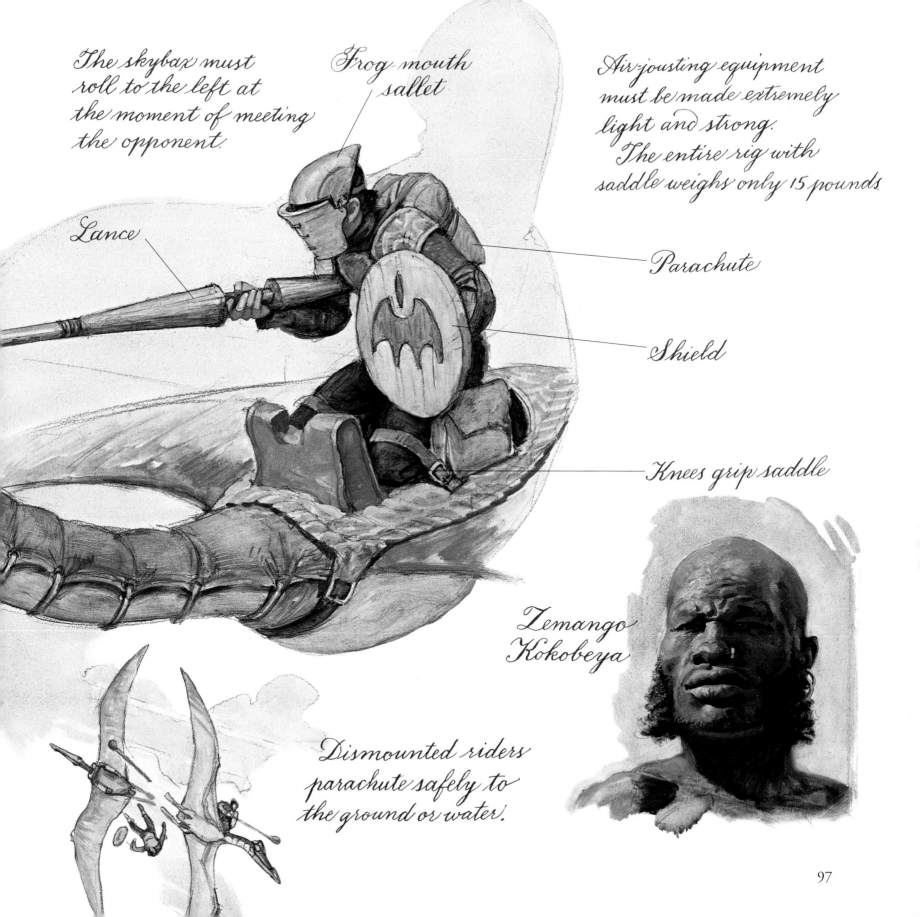

The skybax must roll to the left at the moment of meeting the opponent.

Frog mouth sallet

Air-jousting equipment must be made extremely light and strong. The entire rig with saddle weighs only 15 pounds.

Lance

Parachute

Shield

Knees grip saddle

Zemango Kokobeya

Dismounted riders parachute safely to the ground or water.

97

Will loses the joust but leads the races.

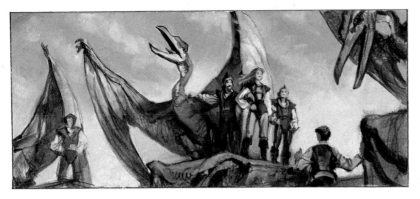

Sylvia dares the boys to a duel.

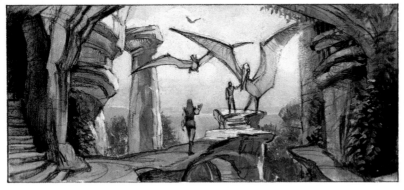

Exploring the ruins of Jebel Bek

The caravan was now fully rested and resupplied. There was a frenzy of preparation for the trek south to Samarlak. Bix and I were resolved to head in a more easterly direction toward Khasra. Unfortunately this would take us directly through the dreaded Vagar Wastes. Everyone warned us against such a route. The one who seemed to know the most about it was Zemango Koko-beya, whose maternal ancestors traced back to Nubian charioteers. "The desert will kill you, or worse, drive you mad," he said. "Men and dinosaurs have been lured to their doom by the voices of unhappy spirits. Many have lost their way, wandering in circles."

When I expressed doubt about such voices, he asked me to sit with him on the head of the colossus the next morning at sunrise. There I experienced a remarkable phenomenon. At the moment of the sun's first appearance through a streak of red in the east, there issued from the bulk of the stone tower a most mournful sound, a kind of low groan. I took this to be the result of warm air being expelled from the hollows of the rock into the cooler surrounding atmosphere. But Zemango insisted that this was the voice of Amon-Ceratops offering his salutation to the King of Day.

Will and Sylvia appeared behind us, huddled silently together, rubbing their eyes, still in the spell of sleep. Though they were exhausted from yesterday's tournament, they came to say good-bye and to wish us luck.

The whole sky was now festooned with glowing streamers, rosy below and gold-spangled above. A peculiar sense of calmness and mystery stole insensibly upon my inmost being. We were in the grandest of all earthly temples: its floor the level reach of sand, its columns the great towers of stone, and its dome the wide-arching firmament.

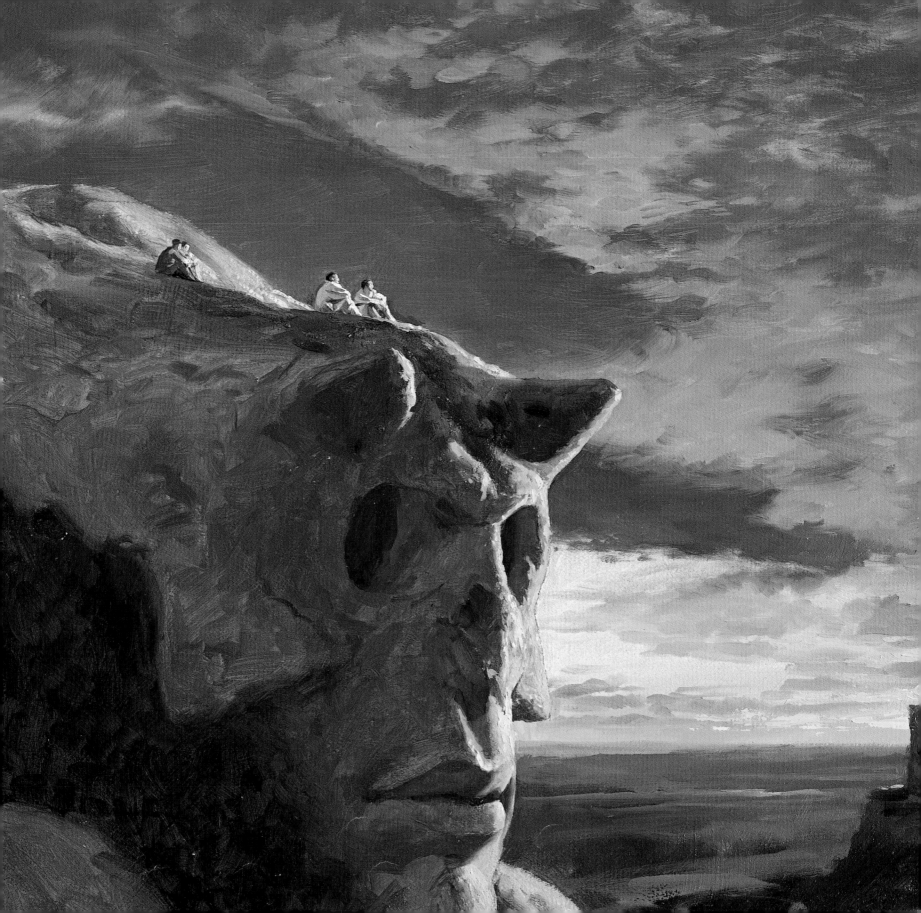

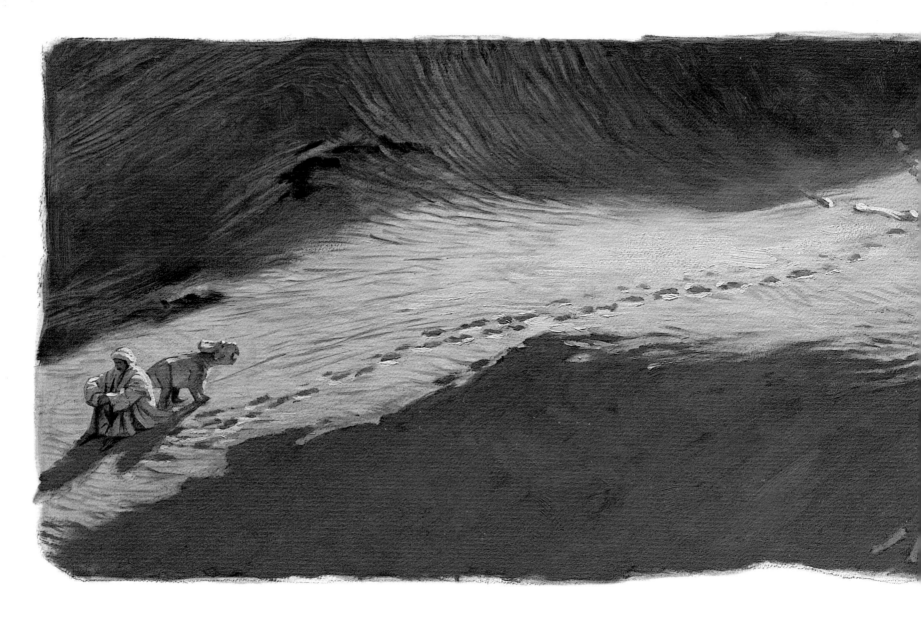

Bix and I began the journey across the Vagar Wastes, guided in a general way by the sun. Without compass or map, we had to rely on guesswork. No roads were marked out in these sand hills, no definite landmarks to fix our course. The air was stagnant from sunrise until about ten o'clock, when a loathsome wind stirred up a blinding haze of sand.

At the crest of one dune we chanced upon the remains of an *Apatosaurus*, who had met its end here many years before, no doubt struggling as we had been against a burning thirst. For several long days there was neither pond nor puddle, bush nor blade of grass. The water in the gourd was almost gone. What little remained we parceled out by droplets.

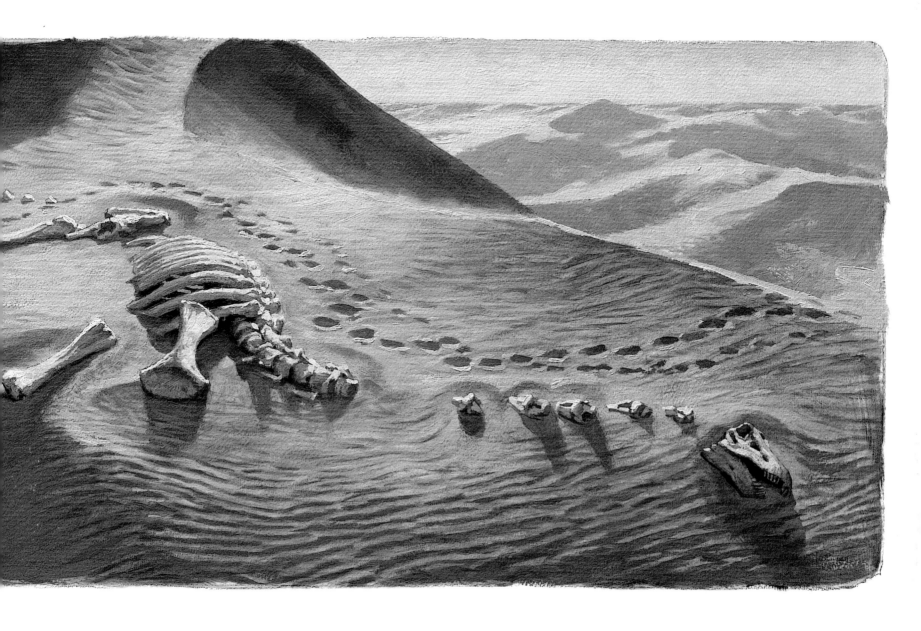

As the sun reached its zenith we looked for any scrap of shade to escape the fiery heat. There we rested or slept until afternoon, our faces wrapped in cloth. One day we wandered like ants beneath a stand of giant stone mushrooms. Later we came upon a petrified forest, where ragged stone columns had fallen in the very places where once stood a primeval woodland.

We staggered on through the dreary monotony of daylight. Long undulating hills succeeded each other like waves in a bleak ocean. By night, a chill descended over the earth, while above, the festival of stars and planets lit their million gleaming lanterns. In the spell of this enchantment we beheld the fabled domes and towers of Khasra.

101

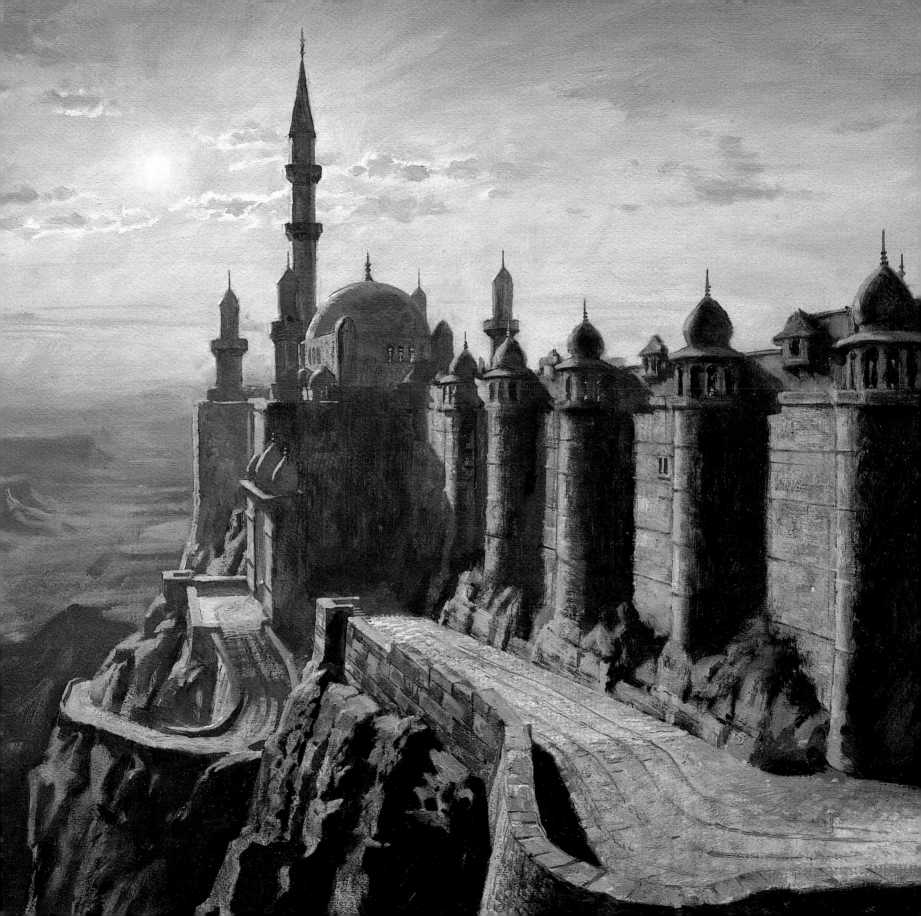

A SENTINEL'S WARNING CRY rang out as we ascended the long ramp to the gatehouse. Visitors after nightfall were evidently not a common sight. We approached the heavy gates and stood exposed in the flickering torchlight.

A small hatch slid open, and a voice called out a riddle: "What are the five names of nothing?" Bix hesitated for a moment, then answered in a perfect Canyon City dialect: "aught, naught, cipher, nil, and zero."

This satisfied the sentry enough to let us in the wicket gate. Four fierce *Dilong* guards of the garrison pelted us with questions, their *silahlik* sashes bristling with cross-staffs and Napier's bones.

The guards glowered in my direction. I put my nose in the little book, nodded thoughtfully, and hoped I wasn't holding it upside down.

Bix explained, "He has taken a vow of silence. Could you please direct us to the protoceratopsids?" A bulldoglike *Cynodont* escorted us through the dark streets to the compound run by Bix's distant cousins. There was cool mint tea in a pitcher on the table and a soft round mattress for each of us in the inner courtyard beside a bubbling fountain.

The thousand and one domes of Khasra

103

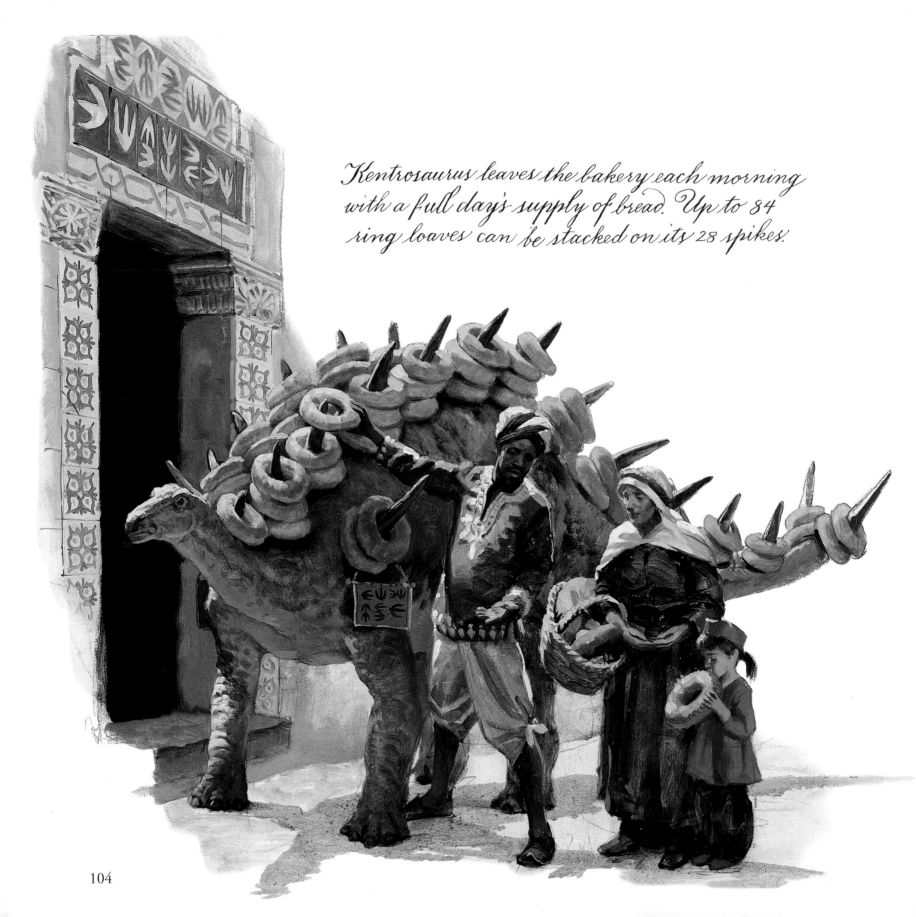

Kentrosaurus leaves the bakery each morning with a full day's supply of bread. Up to 84 ring loaves can be stacked on its 28 spikes.

104

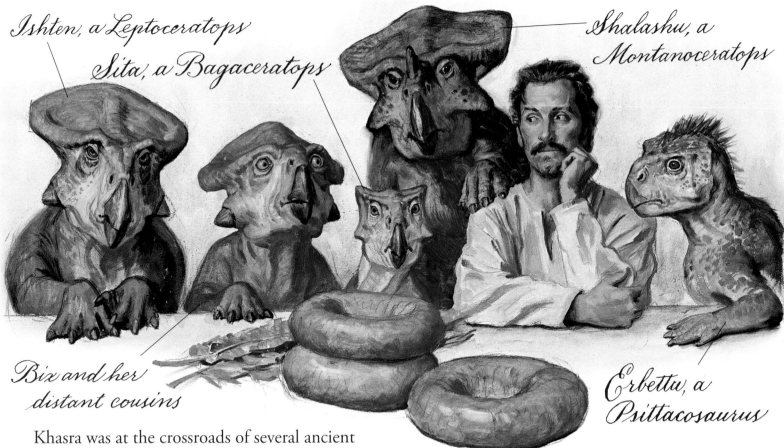

Ishten, a Leptoceratops

Sita, a Bagaceratops

Shalashu, a Montanoceratops

Bix and her distant cousins

Erbettu, a Psittacosaurus

Khasra was at the crossroads of several ancient trade routes and was famous for its waters, drawn from the Subamu River, which courses through caverns deep underground. The protoceratopsids operated the caravansary, which houses the desert-trading dinosaurs and their human partners. With their parrotlike vocal apparatus, the protos could pronounce all the major human dialects, as well as a rich array of animal languages and sound effects.

At dawn I awoke to the sound of their mellifluous chirruping. I put on my robes—whether those of a monk or pilgrim I still didn't know—and expected to spend the day deep in contemplation in a tiled *tepidarium*. But Shalashu, the *Montanoceratops*, commanded me around like the lowliest servant. At his orders I shoveled hadrosaur droppings out of the privy, hauled them to the Fibonacci Gardens, brushed

the dust from two Orofani stegosaurs, brought home a stack of ring loaves looped over a pole, and finally fluffed up the nest beds for the coming night.

But during my chores I caught a few glimpses of the marketplace. The arches along the main avenues were built forty feet above the ground, high enough for the biggest sauropods to pass beneath, ducking only slightly. Breezes drifting from the narrow alleys carried bewitching aromas: the curries from Meeramu, the sweet fragrance of wood from the lute-maker's workshops, and the fruity tang of the Fimli oranges. I stood for a moment watching the *Utahraptor* barbers with their razor-sharp claws calmly shaving customers in a passageway crowded with swerving carts and swinging tails.

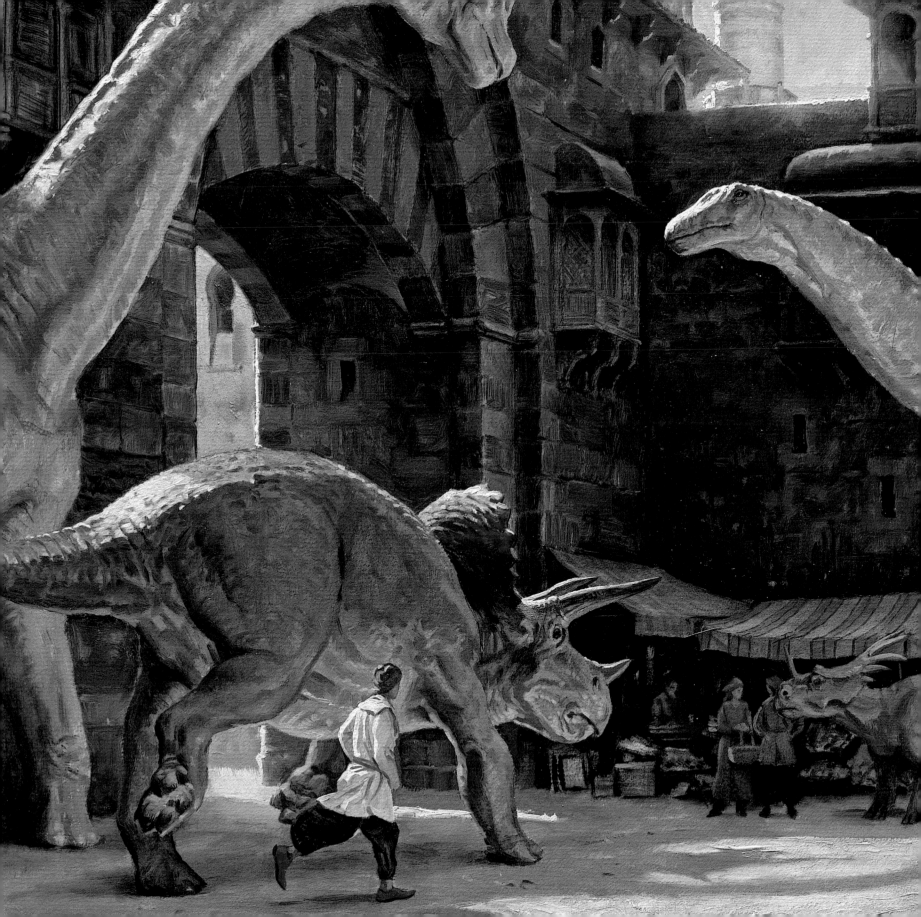

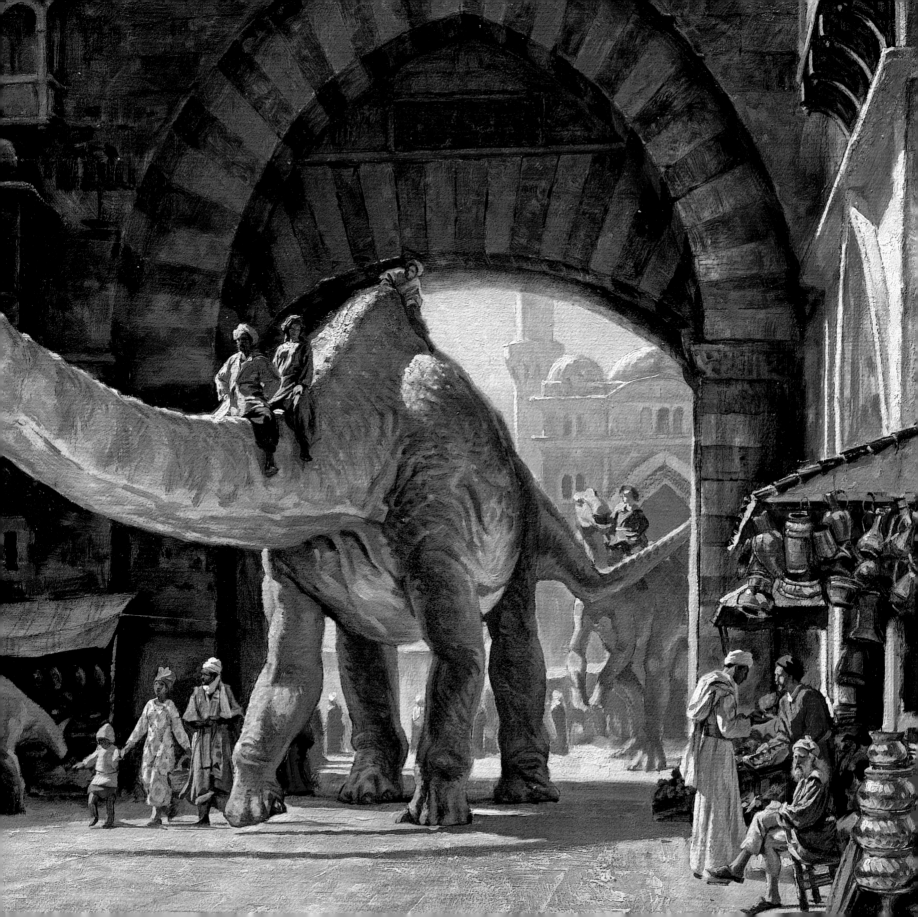

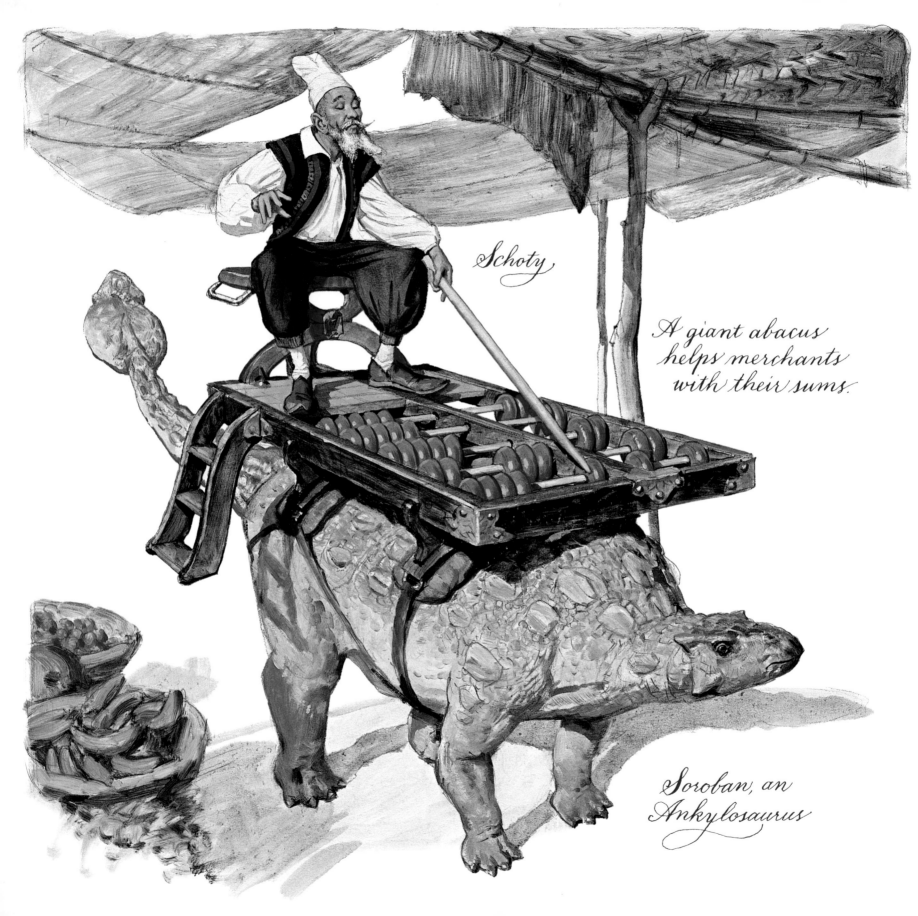

Schoty

A giant abacus
helps merchants
with their sums.

Soroban, an
Ankylosaurus

The marketplace was alive with the clattering noise of Schoty and Soroban, a team who used an immense abacus to help merchants with their arithmetic. Each time he was ready for a new problem to solve, Schoty raised his right hand in a grand gesture. Someone then shouted out two numbers to add.

In a flash, Schoty's wooden stick began jabbing at the beads, slamming them back and forth until he was ready to call back the total. Soroban preferred to do sums in her head. If she agreed with Schoty's result, she slapped the ground with her tail, kicking up a cloud of dust. If she disagreed, she shook her whole body, leaving the beads in chaos.

The abacus is a rectangular wooden frame arranged with several columns of beads on wooden rods. Each column represents, starting from right to left (or Soroban's front to back): the one's place, ten's place, hundred's and so on.

A central partition divides the frame lengthwise into two sections. In the smaller top section, there are two beads, each worth five units. In the wider section below, each bead counts as one. A bead is made active by sliding it toward the partition.

Bix, hungry as always, had been busy counting out two big piles of seeds for our lunch. She barked out, "236 plus 127." Schoty got to work.

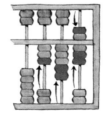

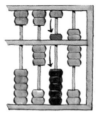

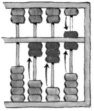

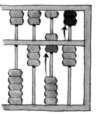

To register the "236," he slid two beads toward the partition from the hundred's column, followed by three beads from the ten's. The six was represented by one bead from the top section, worth five, and one from the bottom.

To add "127," he slid one new bead toward the partition from the hundred's column and two beads from the ten's. He tallied the seven with one bead from the top section, and two from the bottom.

This raw total then had to be converted. In the ten's column, all five beads in the bottom section were slid away in exchange for a single bead from the top.

Then the one's row was converted by sliding away the two beads in the top section in exchange for a single bead from the ten's row. Schoty called out "363." Soroban slapped her tail to the ground, and I coughed from the dust.

Khasra is rich with tile patterns, often composed of interlocking and repeating shapes.

Pavimentum, an Edmontonia, tends the Fibonacci Gardens.

110

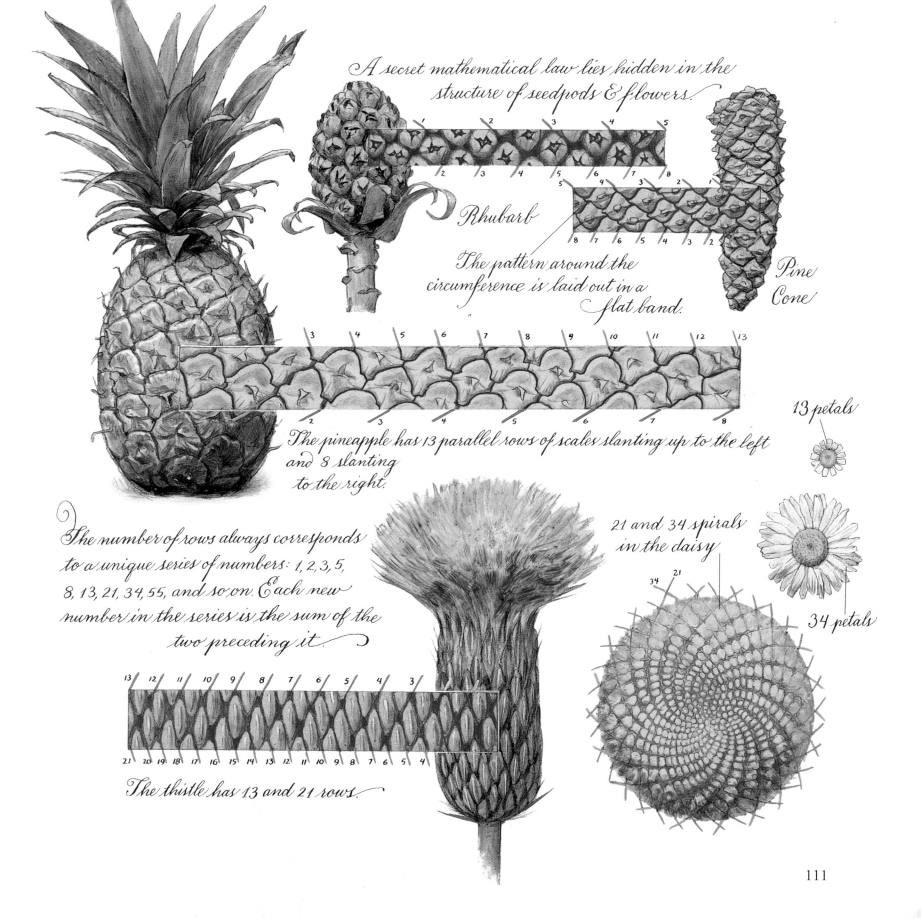

A secret mathematical law lies hidden in the structure of seedpods & flowers.

Rhubarb

Pine Cone

The pattern around the circumference is laid out in a flat band.

The pineapple has 13 parallel rows of scales slanting up to the left and 8 slanting to the right.

13 petals

The number of rows always corresponds to a unique series of numbers: 1, 2, 3, 5, 8, 13, 21, 34, 55, and so on. Each new number in the series is the sum of the two preceding it.

21 and 34 spirals in the daisy

34 petals

The thistle has 13 and 21 rows.

111

The eastern gate of Khasra

WE DEPARTED KHASRA from the eastern gate and pressed on toward the hilly country bordering the southern desert. The land grew greener and more productive. We made camp away from the road behind a stand of poplars, hoping to avoid unnecessary questions from shepherds and cart drivers. I was often approached by these rustics asking for cures or prophecies, apparently being taken as a doctor or a holy man. The small set of benedictions that Bix taught me seemed to do no harm, but my poor subjects usually went away with a befuddled look, as if I had just handed them a wilted flower.

Next day we came into a region of farms built on stair-step terraces. A steady breeze drifted up the valley, slowly turning the sails of a proud windmill, at whose base stood a cluster of thatched houses.

Teleost, the windmill village

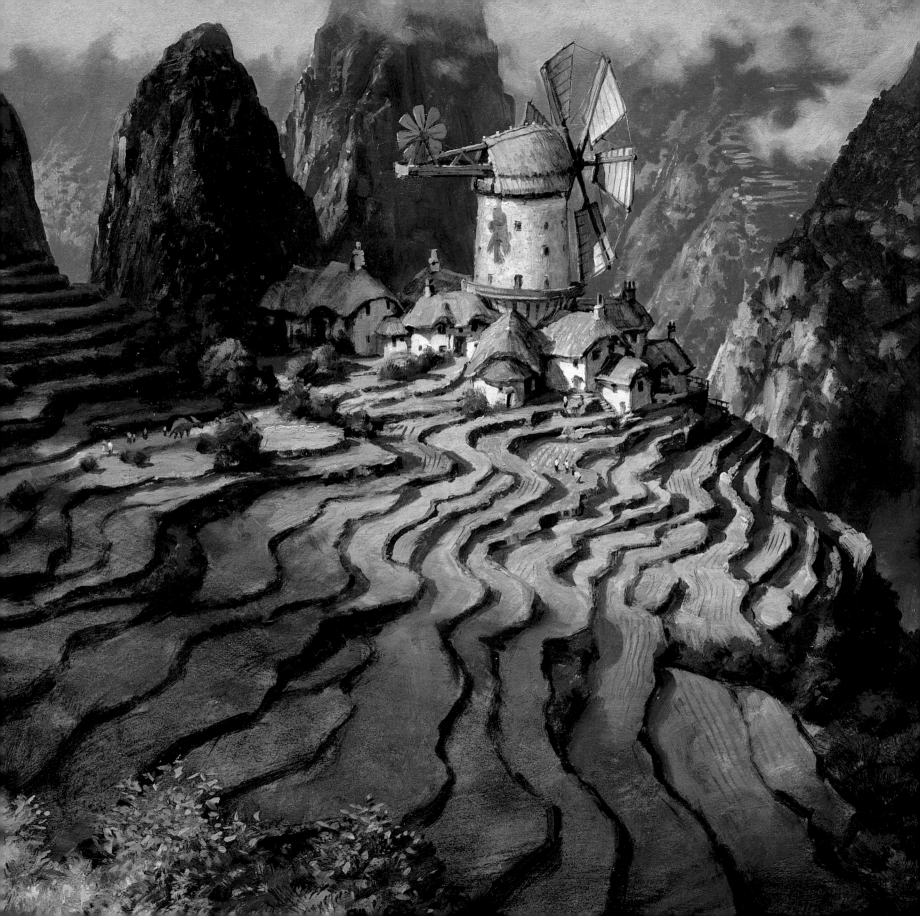

Boustrophedon, the Anchiceratops, talks to Bix as he works

We watched the plow as it went back and forth along the terraces. A farmer named Ilya Shinshik saw that we had taken an interest in his village, and told us more about it.

People and dinosaurs, he said, have nurtured this land for thousands of years, building the terraces and irrigating them with water drawn up from the valley below. Droppings from passing caravans have enriched the soil, which supports wheat, cabbage, kale, onions, potatoes, and turnips. Rice grows in the wetter sections, as well as the reed phragmites used for thatching roofs. Weavers prize the flax plant, whose strong fibers become the linen fabric for the sails of the windmill. Linen is also used in papermaking.

Artisans in Aleppo make the blank paper and ship it to the writers and printers in Chandara, who turn the paper into scrolls and books. These books and the treasures of poetry and calligraphy that they contain are given in trade for the fruits of the earth.

All of this set me to musing. In any civilization, what is the primary source of wealth? Is it the work of the farmer or that of the poet? One makes a furrow with the plow; the other, with the pen.

My thoughts were interrupted as Ilya's three children bounded into view: Olga, Valentina, and Ivan, along with their saurian friends. They took us on a tour of the mill, up and down every ladder, to show us how it all works.

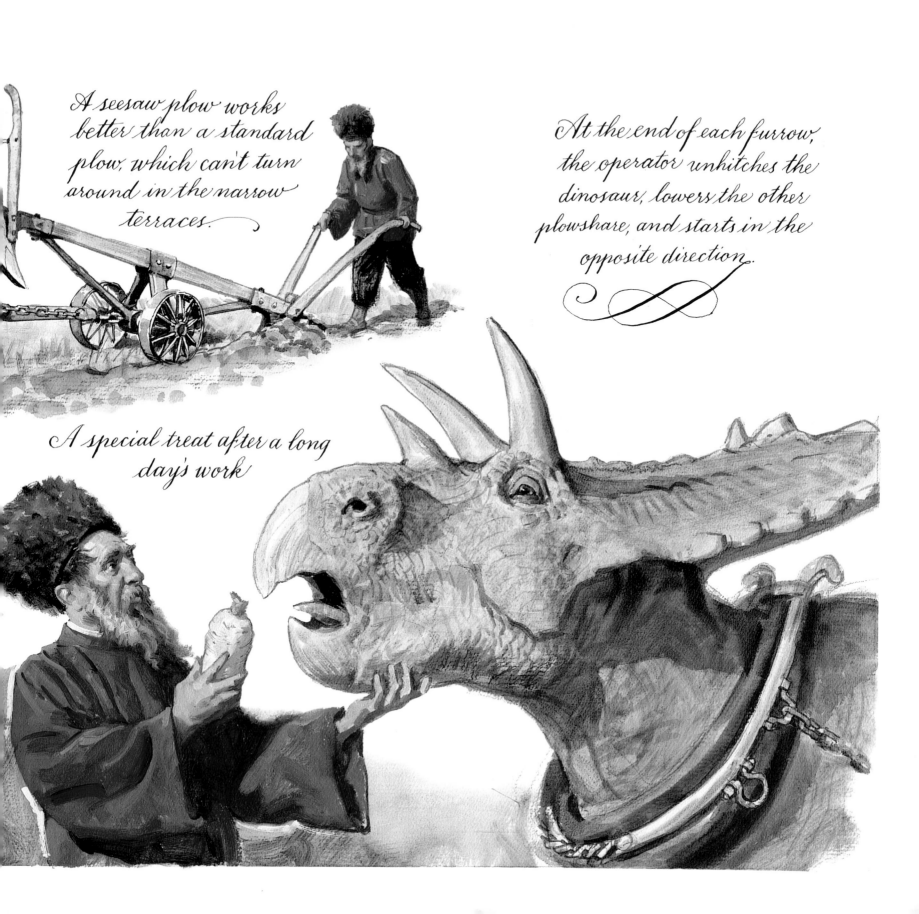

A seesaw plow works better than a standard plow, which can't turn around in the narrow terraces.

At the end of each furrow, the operator unhitches the dinosaur, lowers the other plowshare, and starts in the opposite direction.

A special treat after a long day's work

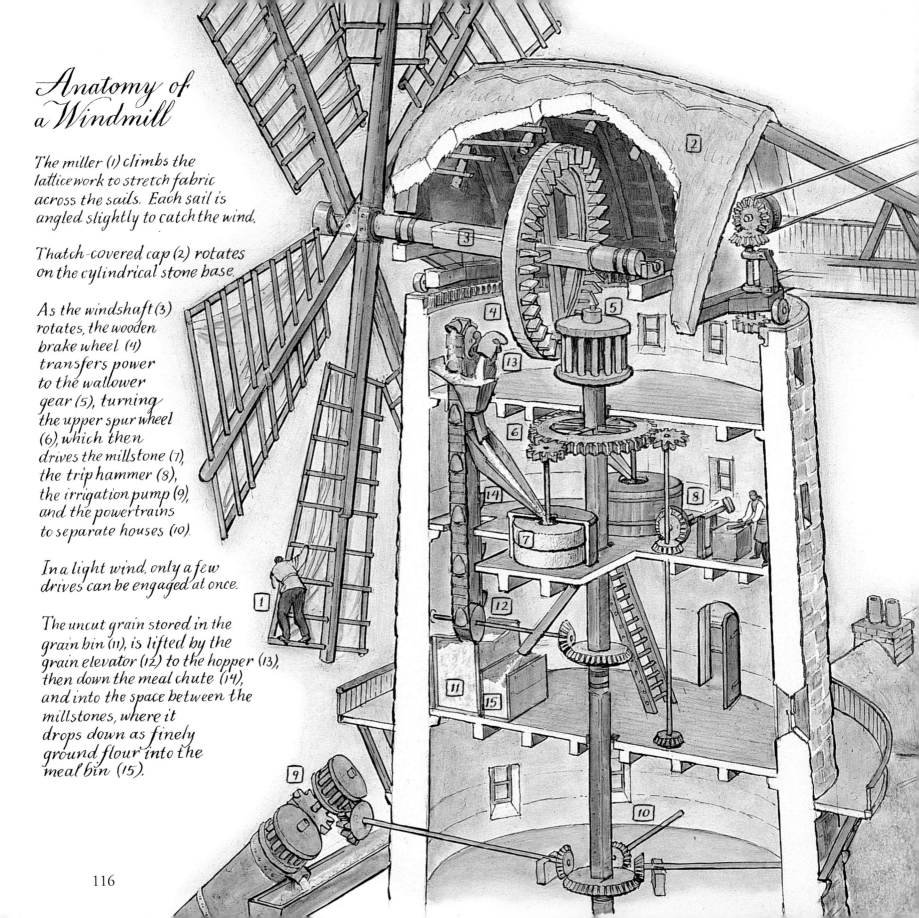

Anatomy of a Windmill

The miller (1) climbs the latticework to stretch fabric across the sails. Each sail is angled slightly to catch the wind.

Thatch-covered cap (2) rotates on the cylindrical stone base.

As the windshaft (3) rotates, the wooden brake wheel (4) transfers power to the wallower gear (5), turning the upper spur wheel (6), which then drives the millstone (7), the trip hammer (8), the irrigation pump (9), and the powertrains to separate houses (10).

In a light wind, only a few drives can be engaged at once.

The uncut grain stored in the grain bin (11), is lifted by the grain elevator (12) to the hopper (13), then down the meal chute (14), and into the space between the millstones, where it drops down as finely ground flour into the meal bin (15).

116

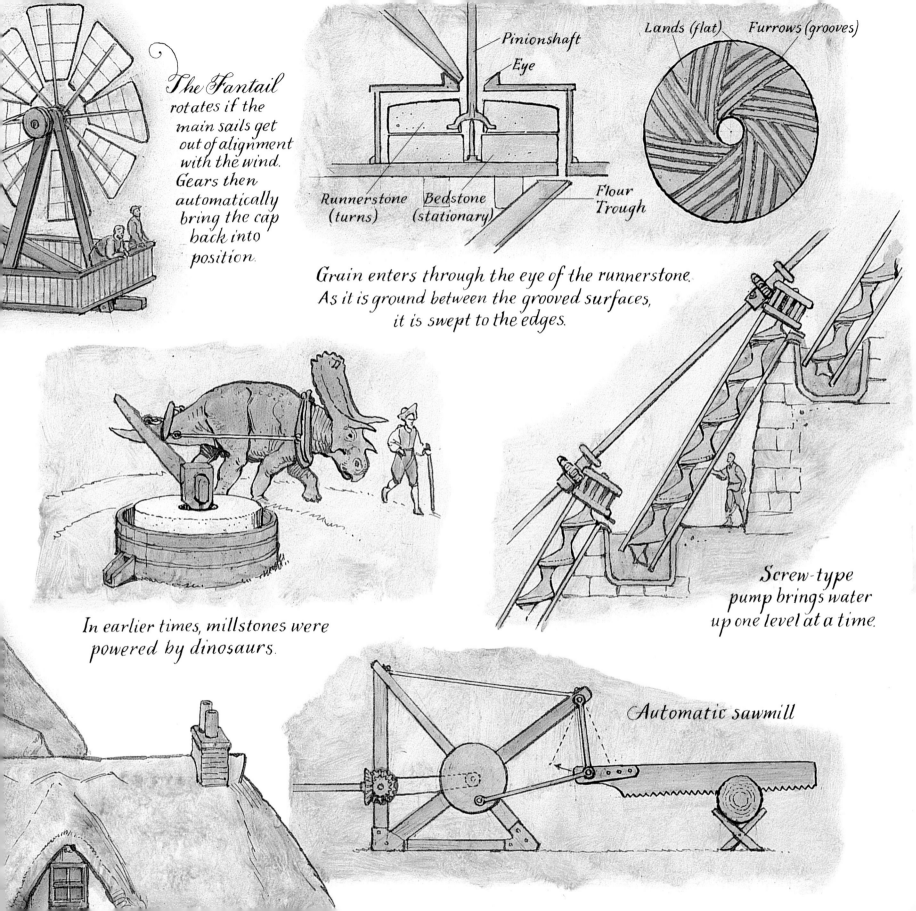

The Fantail rotates if the main sails get out of alignment with the wind. Gears then automatically bring the cap back into position.

Pinionshaft

Eye

Lands (flat) Furrows (grooves)

Runnerstone (turns) Bedstone (stationary)

Flour Trough

Grain enters through the eye of the runnerstone. As it is ground between the grooved surfaces, it is swept to the edges.

In earlier times, millstones were powered by dinosaurs.

Screw-type pump brings water up one level at a time.

Automatic sawmill

A tile in the entrance hallway

Ilya Shinshik invited us to join his family for an evening at home. We sat together around a small table and shared supper from a single bowl. His wife, Tatiana, had prepared *shchi*, an earthy, sweet and sour soup of cabbage and root vegetables, which we scooped up with hand-carved wooden spoons and thick slices of bread baked in the village oven.

The feathery dinosaurs Mirko and Shirov were more like birds than reptiles and were treated as honored members of the family. They joined in the evening games, which included Blowing the Feather, The Gardener, and Cat's Cradle. Although they didn't speak in a human language, they had a ready wit and an intense curiosity, especially about any kind of whistled tune or song.

When the conversation turned to the city of Chandara, Ilya said that he and the *Triceratops* named Polovetz would bring the turnip harvest to market tomorrow, and that Bix and I would be most welcome to ride along with him.

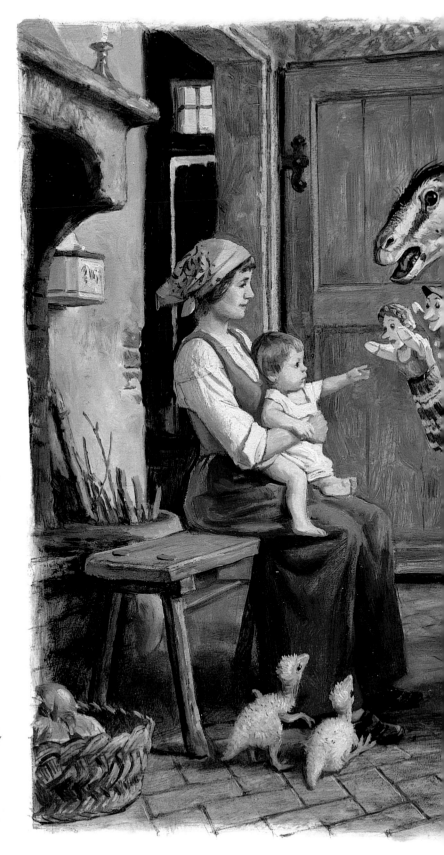

An evening at home with Beipiaosaurus and Caudipteryx

118

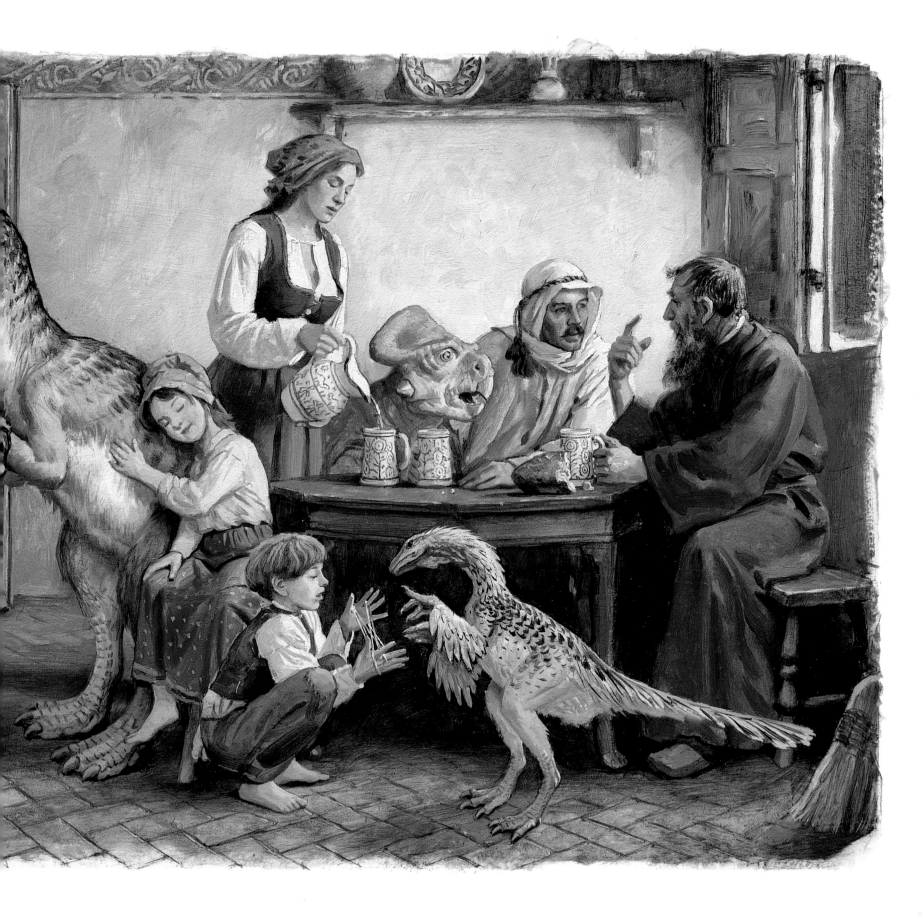

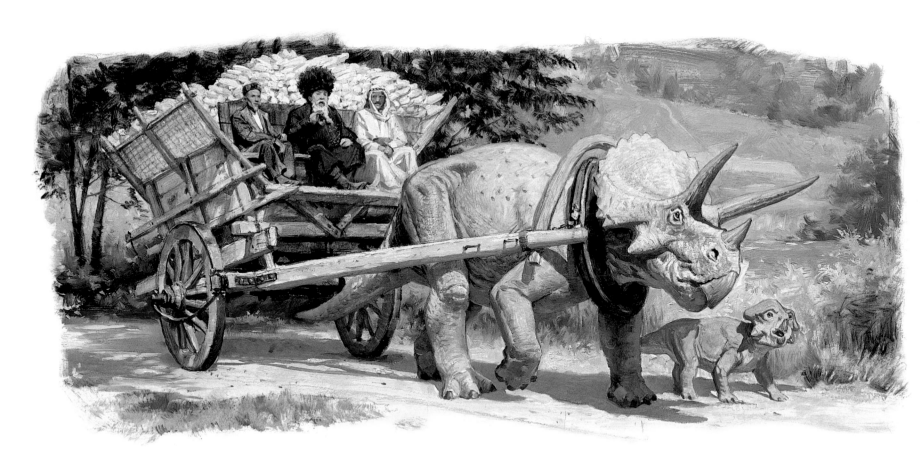

A PICTURE OF CHANDARA began to form in my mind from Ilya's descriptions. Several times in Chandara's nearly 6,000-year history, waves of humans and saurians intent on plunder stormed its gates but were absorbed and converted by the strange allure of the city. Even some giant meat-eaters like *Acrocanthosaurus* live serenely on a diet of fish and mysticism.

The city borders the Zhengtao River. Concentric canals ring the central hub of the Imperial Palace, and broad avenues radiate like spokes. Emperor Hugo Khan lives in the palace. According to Ilya, he is beloved by all of his subjects and often travels alone among them, but no one would tell me if he is a man, a maniraptorian, or some kind of tyrannosaurid warrior-king.

Ilya seemed concerned about us arriving penniless in the city, where one can't count on the hospitality normally accorded to travelers. "You will need to work," he said. "What can you do?"

This question left me rather flat. None of my scientific knowledge was of much use here, especially without my books and instruments. With my poor command of the eastern dialect and its many unfamiliar words, I was in no position to teach. And clad as a wise man—if that was what I was—I felt in short supply of wisdom.

Perhaps Ilya took pity on us, for he gave us a basket with sixteen turnips to use for barter, "until you find how you can be of service."

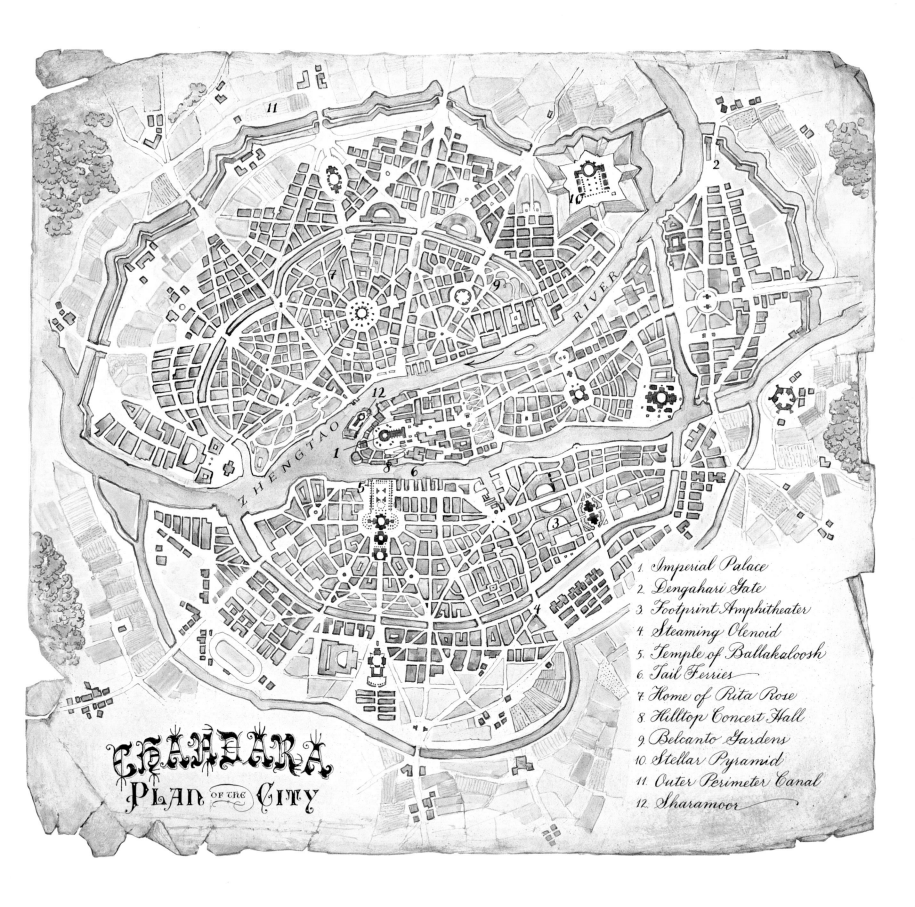

CHANDARA
PLAN OF THE CITY

1. Imperial Palace
2. Dengahari Gate
3. Footprint Amphitheater
4. Steaming Olenoid
5. Temple of Ballakaloosh
6. Tail Ferries
7. Home of Rita Rose
8. Hilltop Concert Hall
9. Belcanto Gardens
10. Stellar Pyramid
11. Outer Perimeter Canal
12. Sharamoor

ZHENGTAO

RIVER

A busy scene crowded upon us the next morning as we passed through the great stone arches of the Dengahari Gate and followed the river's edge into the heart of the city.

Skybax riders drifted high above the golden spires. Bix waded into the shallows and swam near the tree-like legs of a *Turiasaurus,* who sucked up a column of water and sent a cooling fountain over all the bathers. Women with the dawn melon harvest paddled flat-boats alongside the tail-powered ferries. Wedding-cake houseboats sounded raspy horns as they coasted by, towing extravagant floating gardens. In the distance, rising above all in a halo of golden illumination, the Imperial Palace appeared suspended somewhere between earth and heaven.

But the spirit of enchantment was not lasting. My left sandal was caked with a dinosaur dropping, into which I had blundered in a moment of inattention. When I shook off my foot in the river, the sandal came loose and nearly floated away. My right arm was bruised from being accidentally tail-swiped by a *Euplocephalus* and my head ached from the dizzying aroma of the cinnamon vendors. A group of *Sinornithoides* jumped eagerly in front of me like kangaroos to get a closer look at my mustache. And finally, a band of enthusiastic children and their monkeylike *Mesopithecus* art teacher pestered me to trade our turnips for their drawings.

Bathers, market-boats, and dinosaurs share the canals.

122

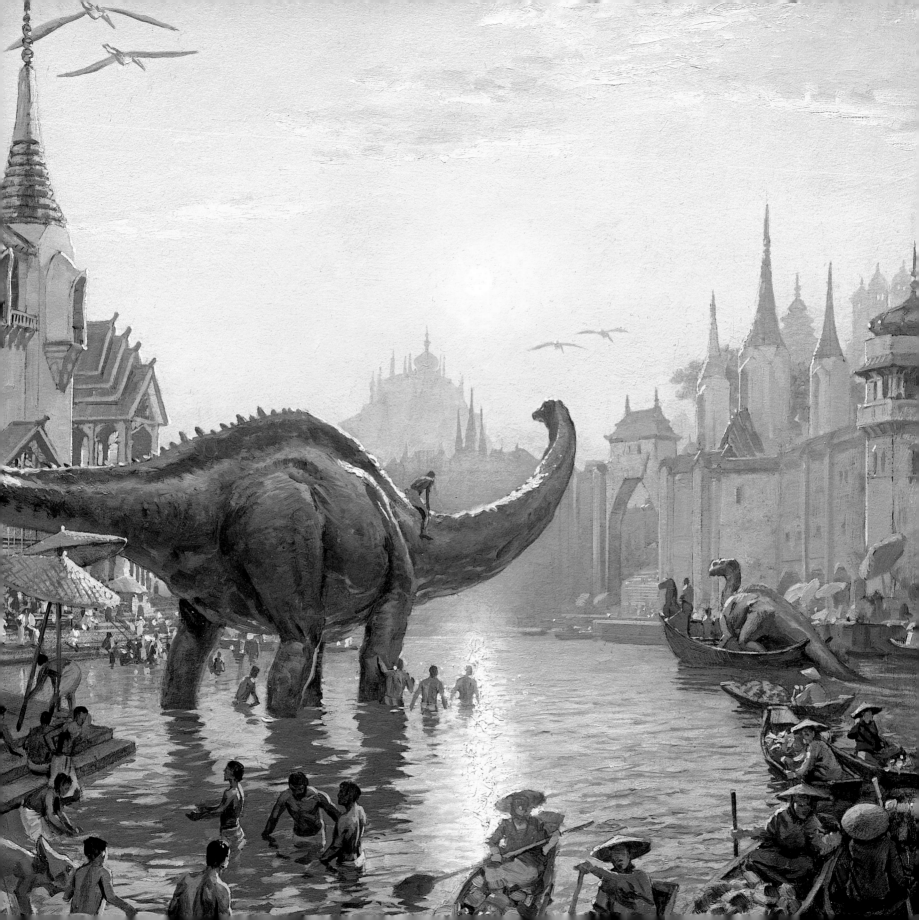

ALPHABETS OF DINOTOPIA

THEROPODA

A	B	C	D	E	F	G	H	I
J	K	L	M	N	O	P	Q	R
S	T	U	V	W	X	Y	Z	Ø
1	2	3	4	5	6	7	8	9

TRANSITIONAL

A	B	C	D	E	F	G	H	I
J	K	L	M	N	O	P	Q	R
S	T	U	V	W	X	Y	Z	Ø
1	2	3	4	5	6	7	8	9

SAWTOOTH

A	B	C	D	E	F	G	H	I
J	K	L	M	N	O	P	Q	R
S	T	U	V	W	X	Y	Z	Ø
1	2	3	4	5	6	7	8	9

CERATOPSIA

A	B	C	D	E	F	G	H	I
J	K	L	M	N	O	P	Q	R
S	T	U	V	W	X	Y	Z	Ø
1	2	3	4	5	6	7	8	9

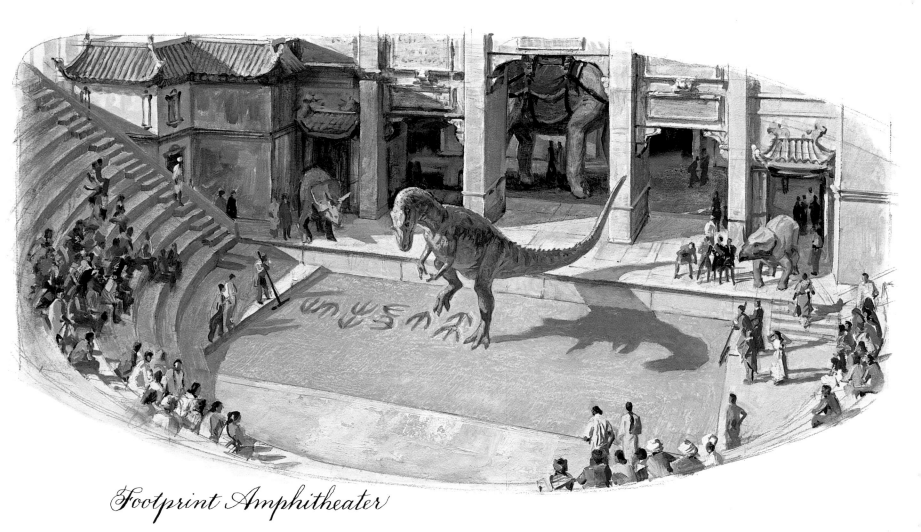

Footprint Amphitheater

The turnips didn't last long. The first two went to the monkey. Three more went into the pockets of a *Bagaceratops* fortune-teller.

Five more were spent at the Footprint Amphitheater. We entered free of charge to watch a story written out in the sandbox by the dancing raconteur. The tale unfolded in chapters of rising drama, each one ending with a tantalizing piece of unfinished business. At each point of suspension, a lovely young woman circulated around the audience to take payment before the story would continue. A burly *Centrosaurus* stood ready to eject pikers. We left before it was over.

Feeling famished, with only six turnips left, we found a small restaurant called the Steaming Olenoid. Payment was required in advance. The last six turnips were not sufficient. We also had to part with the walking stick, the water gourd, and the prayer beads.

There was no menu. Casting a glance over adjacent tables, I noticed that the delicacies of the house included a variety of large creatures with jointed legs and compound eyes. Bix ordered for us both, requesting instead amaranth leaves and milkwood buds. At last the waiter arrived and lifted the limulus cloche with a practiced flourish. I tried my best to chew the bland-tasting leaves and the bitter buds, but I could not bring myself to swallow them. Bix relished every bite.

It was getting late, and there was no place to lay our heads. Shutters were closing, and gates were fastened. But there was one hope: We still had the little book. Perhaps it was a rare treasure that we could sell to a dealer in antiquities.

We found our way to the Grand Bazaar, which is set amid the one hundred columns of the Temple of Ballakaloosh. This 5,100-year-old monument was designed by a black-headed *Shuvuuia* named Djhuty, a saurian architect-scribe who reportedly managed to escape through Dinotopia's protective circle of storms and reefs and retire in Egypt.

Our "rare book" turned out to be a list of dieting tips, written in the defunct Armakkian pictograph style. I was no "holy man" then, but merely a reforming glutton. The trade bought us only a piece of paper, some ink, and a bamboo point. Bix suggested we could write something with these to sell in the Marketplace of Ideas. We looked over the stalls and found one empty. The others were occupied by well-established masters selling sophisticated treatises and brilliant theories.

Try as I might, I could think of nothing new to say, nothing that I was sure of, nothing that I really believed.

"Write what is in your heart," said Bix.

So I scrawled in a small and shaky hand: "Everyone around me is bright and clear. I alone am lost and confused."

The lonely night descended, and the market emptied. I lay down in the back of the stall and fell into a trance-like oblivion. When I awoke the next morning a man in a strange blue suit was standing quietly reading the words. "Come," he said gently. "The emperor is very pleased with you both and has asked to meet you."

The Marketplace of Ideas

WE BOARDED the ferry. The *Iguanodon* pilot lowered his tail over the stern and began sweeping it slowly back and forth, propelling us along in a gentle rocking undulation. The Imperial Palace seemed to float up from the morning mist like a thing composed of transitory vapors. A translucent fog crept over us and veiled the views in all directions. By imperceptible degrees, it erased the ten thousand sights and sounds of the city, leaving only the voices of two faraway monks chanting to each other across the river in a monotonous antiphony.

Tarjik, our guide, explained that the emperor had passed through the marketplace by night, read our words by starlight, and perceived us to be possessed of great knowledge. On that account he desired us to be his honored guests in the Imperial Palace.

"But we're strangers here, and we're dirty from our travels," said Bix. "We know nothing of the ways of this country."

"I understand." he returned kindly. "I will help prepare you."

He explained that it was the custom each week for the emperor to have his creative ministers prepare a new work on an assigned theme. One week the theme might be "Jealous Dragon"; another time it might be "Conquering Cricket" or "Hatching Egg." In three days' time, when our meeting would take place, the emperor would like us to compose a short work on the topic of "Sorrowful Child."

Disembarking, we climbed the marble steps, pausing from time to time to cast a look back over the changing prospect. Halfway up, Tarjik brought us to the bathhouse, a sun-washed cluster of orange buildings exhaling the moist aroma of lavender and olive oil. As we stepped into the cloistered arcade, the tile ceilings flickered with the dancing light cast up from the waters.

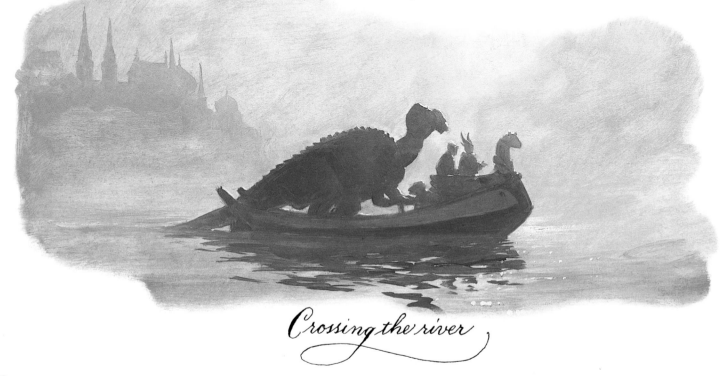

Crossing the river

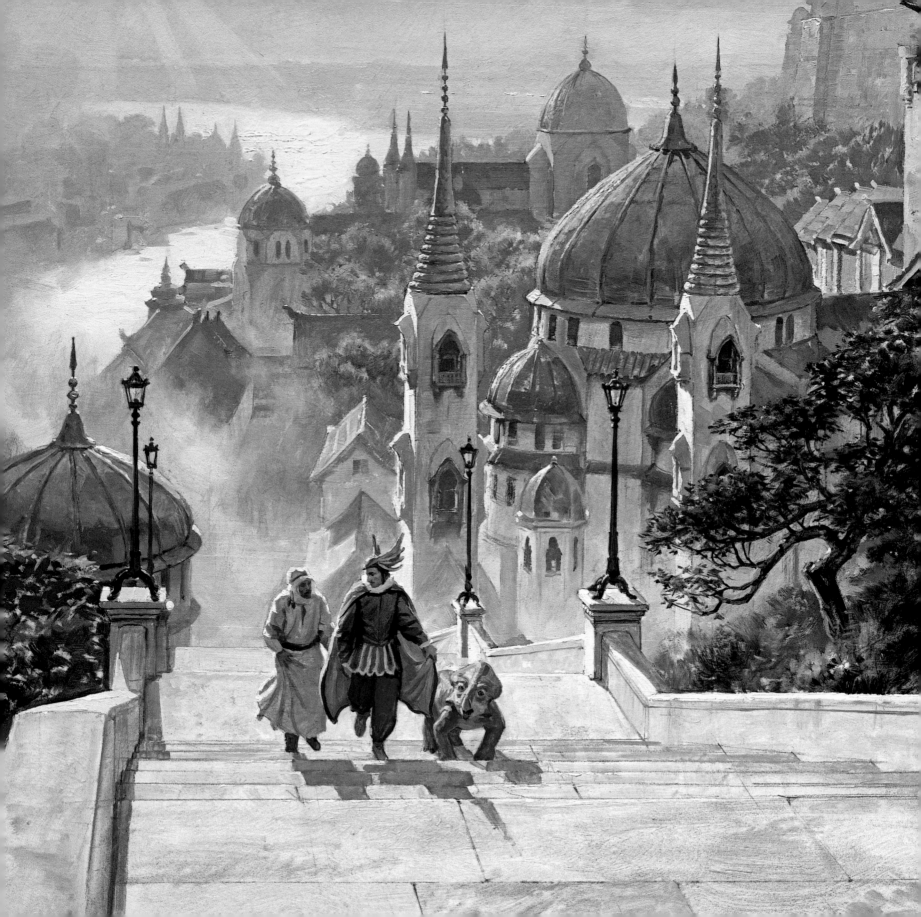

Baryonyx is proud of his teeth,
which are well suited for catching fish.
He insists on a careful brushing from
his dental assistant.

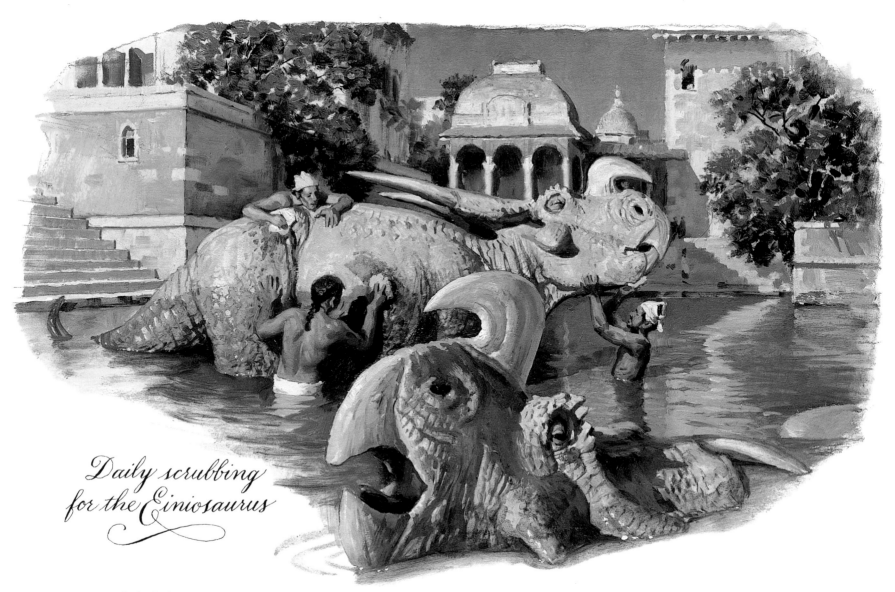

Daily scrubbing for the Einiosaurus

Bix glided through a beaded curtain into the female half of the bathhouse, while I explored the other side. I placed my sandals at the door and made my way through the maze of tiled rooms that echoed with strange voices, hissing steam, and splashing water.

The bathhouse was an extensive complex. There were spraying fountains, bubbling rapids, serene pools, and rain-washed chambers. Each place was specialized for a different preening ritual. In one courtyard, a pair of albino *Einiosaurus* received their scrubbing in a sunlit swim tank while in the next, a dozen *Camptosaurus* wallowed gleefully in bubbling black mud. Other dinosaurs had their teeth or horns scrubbed and polished to gleaming perfection. Large and small feathered dinosaurs preferred to crouch in shallow water, puffing out their feathers and lowering their arms, shaking vigorously until they were fully soaked. I was content with a bar of soap, a towel, and a simple tub all to myself with a view over the rooftops.

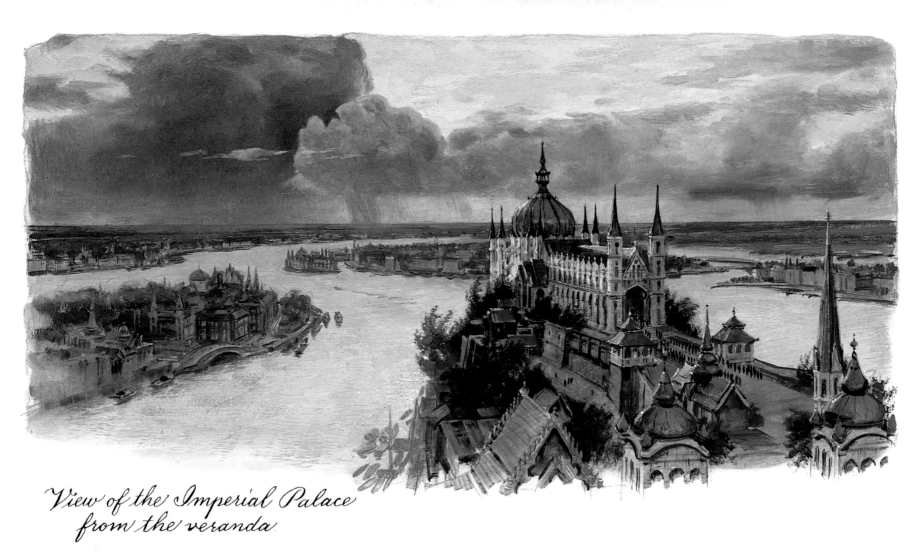

View of the Imperial Palace from the veranda

Wearing a new silk robe and slippers, I met up again with Bix and Tarjik and retired to the guest quarters. A fresh-laid tray of steaming dumplings, little pots of mild sauces, a bouquet of sliced fruit, and a selection of greens for Bix were awaiting us on the wide veranda.

I pondered the theme of the "Sorrowful Child." Why should anyone suffer, I wondered, when I was enjoying such comfort? The gentlest murmur of distant thunder called across the drowsy valley. Little bronze bells suspended from under the eaves seemed to jingle in answer.

Two humans and a saurian beckoned us to join them in the next room. We entered. Twelve pedestals with twelve different vases of flowers were spaced evenly along the walls. On the wall behind each vase hung a mysterious painted landscape. The dream-tenders—for so we supposed them to be—instructed us with signs to choose our favorite landscape and partake of its fragrance. Then they conducted us to the sleeping rooms, turned back the covers, and departed.

That night yielded a rich harvest of dreams. It was with my mind still "trailing clouds of glory" that I awoke the following morning.

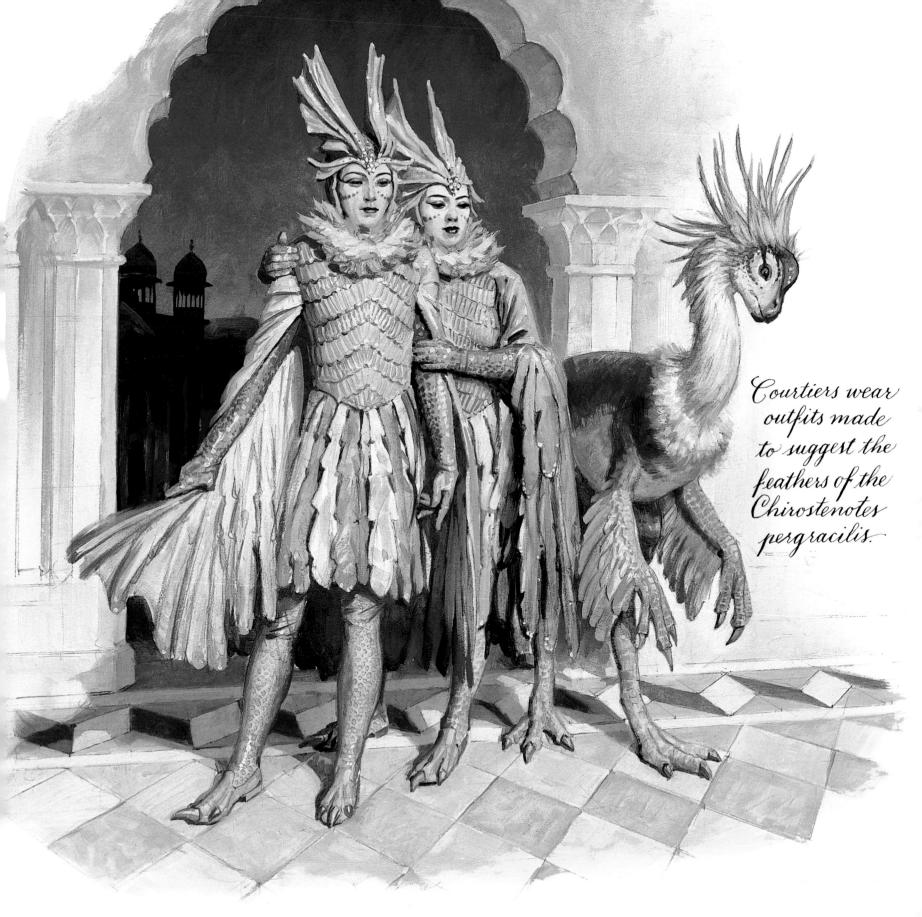

Courtiers wear outfits made to suggest the feathers of the Chirostenotes pergracilis.

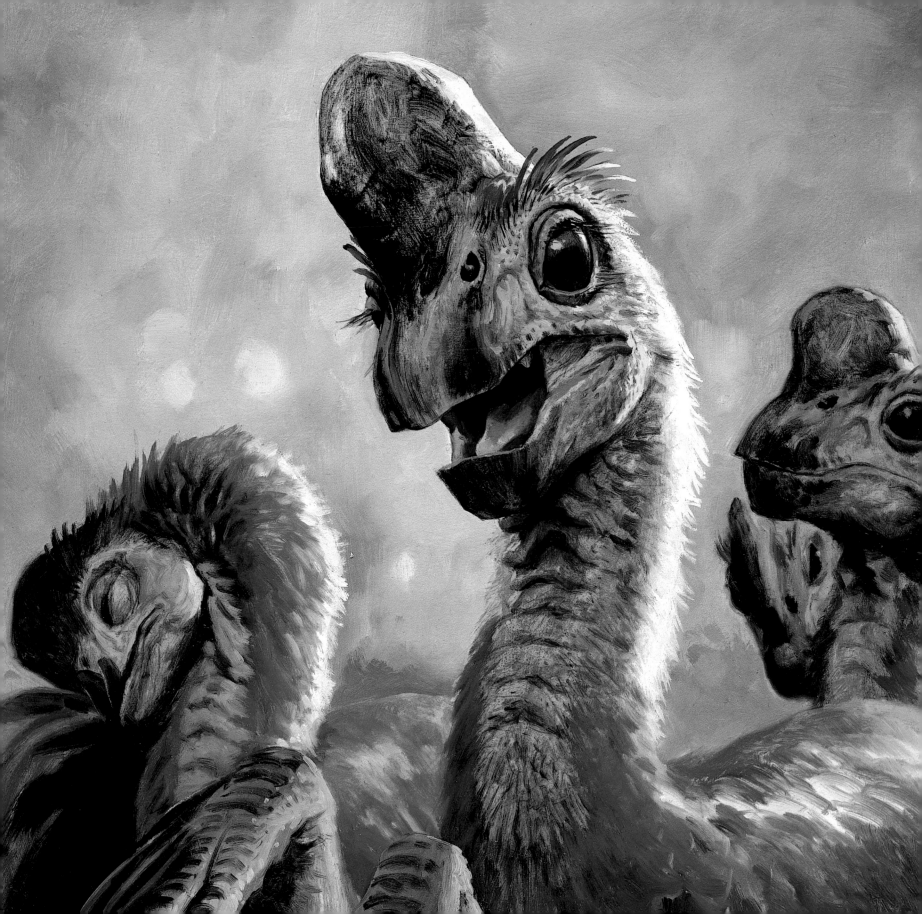

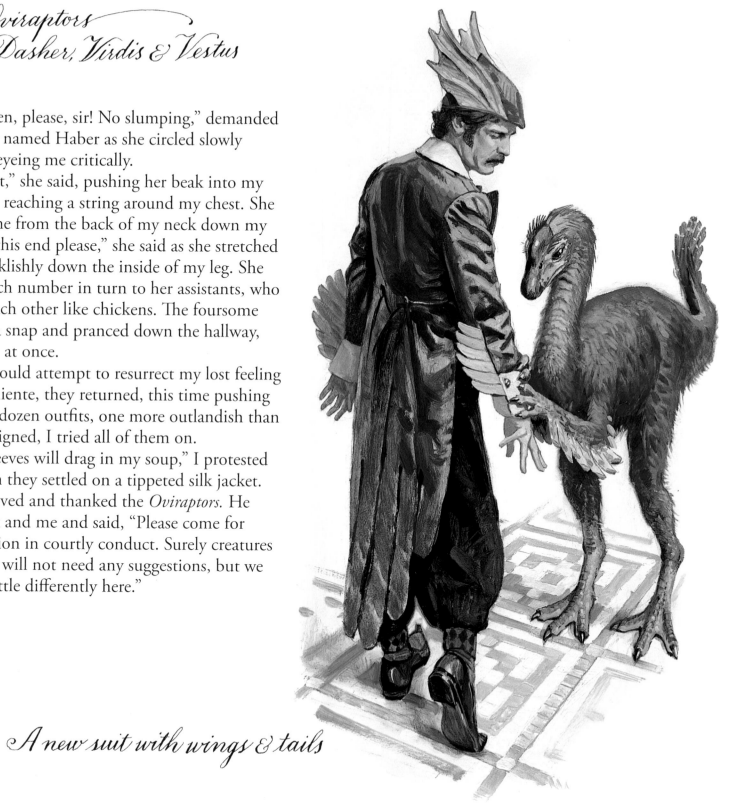

Four Oviraptors
Haber, Dasher, Virdis & Vestus

"Straighten, please, sir! No slumping," demanded an *Oviraptor* named Haber as she circled slowly around me, eyeing me critically.

"Arms out," she said, pushing her beak into my stomach and reaching a string around my chest. She then ran a line from the back of my neck down my arm. "Hold this end please," she said as she stretched the string ticklishly down the inside of my leg. She called out each number in turn to her assistants, who clucked to each other like chickens. The foursome broke off at a snap and pranced down the hallway, chattering all at once.

Before I could attempt to resurrect my lost feeling of dolce far niente, they returned, this time pushing a cart with a dozen outfits, one more outlandish than the next. Resigned, I tried all of them on.

"Those sleeves will drag in my soup," I protested meekly, when they settled on a tippeted silk jacket.

Tarjik arrived and thanked the *Oviraptors*. He turned to Bix and me and said, "Please come for your instruction in courtly conduct. Surely creatures of your grace will not need any suggestions, but we do things a little differently here."

A new suit with wings & tails

135

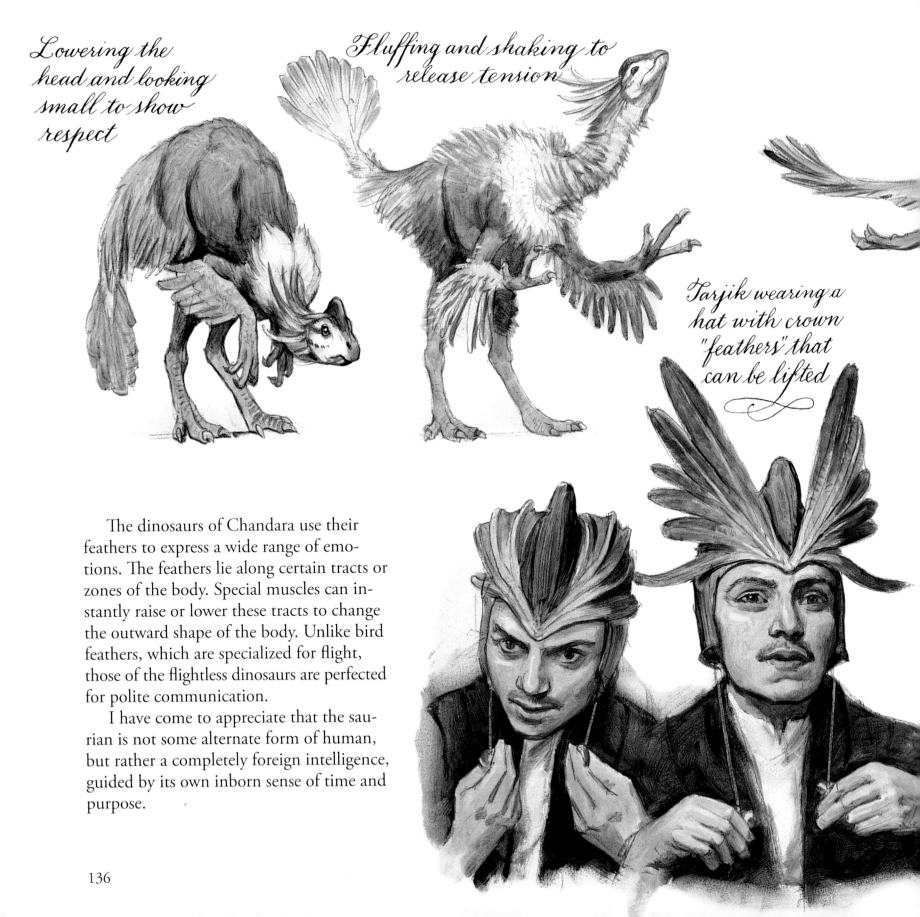

Lowering the head and looking small to show respect

Fluffing and shaking to release tension

Tarjik wearing a hat with crown "feathers" that can be lifted

The dinosaurs of Chandara use their feathers to express a wide range of emotions. The feathers lie along certain tracts or zones of the body. Special muscles can instantly raise or lower these tracts to change the outward shape of the body. Unlike bird feathers, which are specialized for flight, those of the flightless dinosaurs are perfected for polite communication.

I have come to appreciate that the saurian is not some alternate form of human, but rather a completely foreign intelligence, guided by its own inborn sense of time and purpose.

136

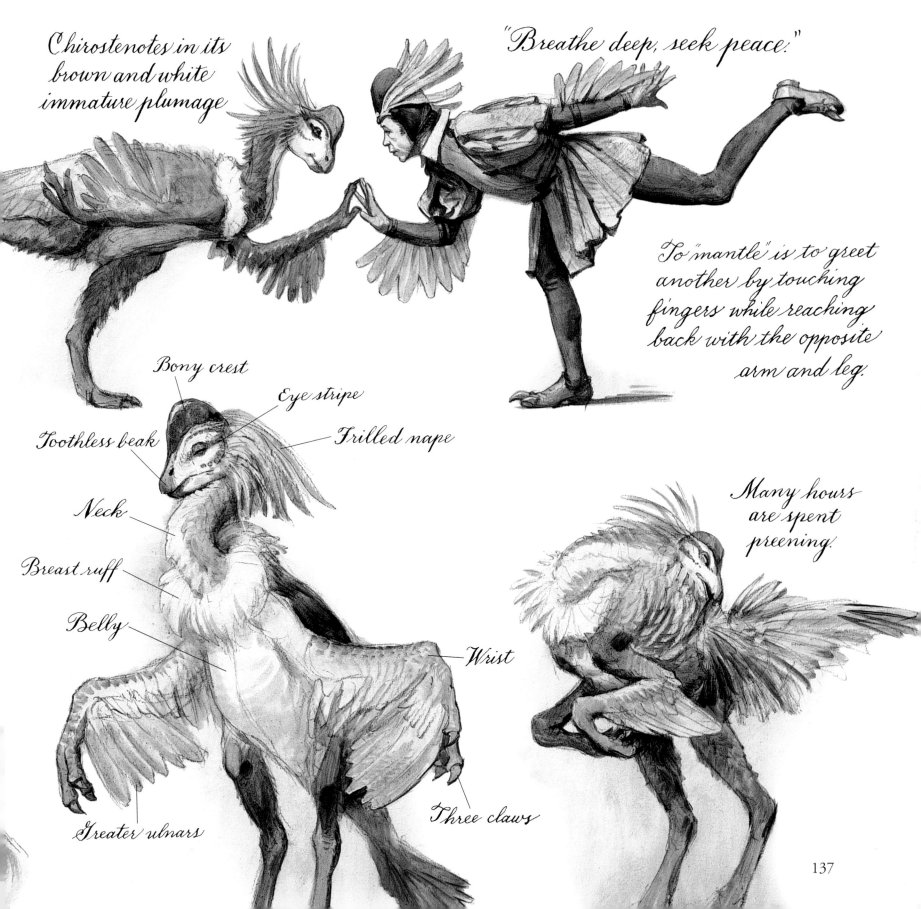

Chirostenotes in its brown and white immature plumage

"Breathe deep, seek peace."

To "mantle" is to greet another by touching fingers while reaching back with the opposite arm and leg.

Bony crest

Eye stripe

Toothless beak

Frilled nape

Neck

Breast ruff

Belly

Wrist

Many hours are spent preening.

Greater ulnars

Three claws

137

The Scholar's Stairway

Tarjik took me to see the Imperial Academy, the core of the palace complex. The dormitory building, at left, is connected to the lecture room at right by means of the Scholar's Stairway, used mainly by the students in the Pen and Rose fraternity. Before dawn, at the sound of the gong, the students use the stairway on their way to class. The freshmen, in their purple robes, must carry all the heavy books and climb upstairs, keeping always to the right. Students of the upper college in their robes of green have earned the privilege to go downstairs, bearing always to the left. Any student with late or incomplete work must make ten uphill circuits as punishment. Professors engaged in long philosophical arguments often stroll carelessly down the stairs for hours.

Even after painting this scene from the south tower, I would not have believed it, had I not walked it myself many times in both directions.

The Pen & Rose
Fraternity

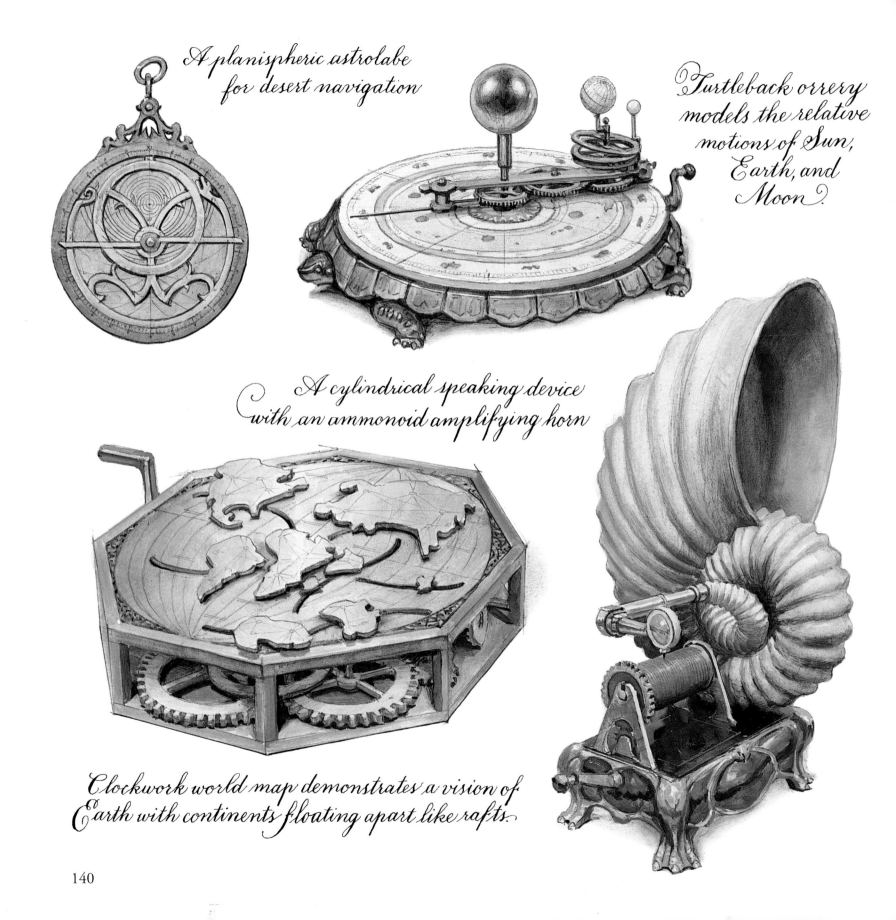

A planispheric astrolabe for desert navigation

Turtleback orrery models the relative motions of Sun, Earth, and Moon.

A cylindrical speaking device with an ammonoid amplifying horn

Clockwork world map demonstrates a vision of Earth with continents floating apart like rafts.

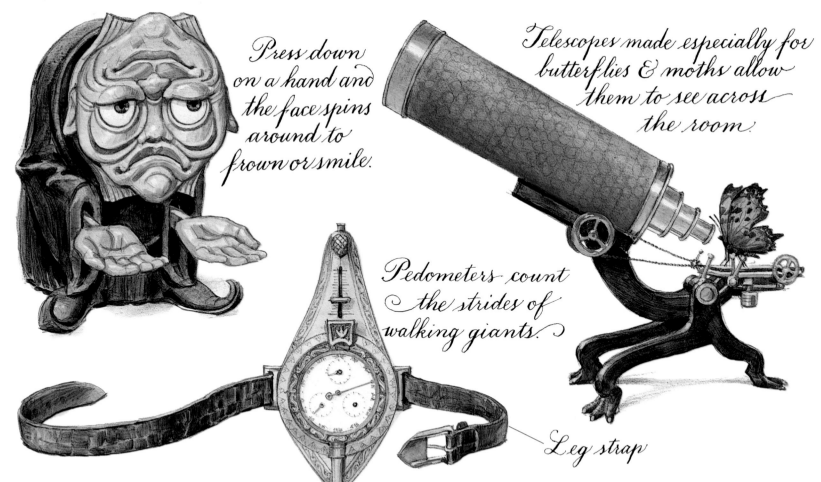

Press down on a hand and the face spins around to frown or smile.

Telescopes made especially for butterflies & moths allow them to see across the room.

Pedometers count the strides of walking giants.

Leg strap

Passing from the stairway, Tarjik brought us to see a few of the classrooms of the academy. There are over 150 such rooms, each devoted to the various arts and sciences. Every room is furnished with red velvet perches and couches of all sizes and descriptions to suit the needs of the various saurian and human students.

Shelves along the wall of one room contain scientific instruments, a few of which Tarjik demonstrated. One device, for example, works as follows: The action of a clockspring turns a wax cylinder, onto which a vibrating needle inscribes a record of any music sounded into the horn. When the cylinder is made to turn later, the music speaks again with remarkable fidelity. But such curiosities seem to be of small interest here, where music is already in such abundance.

The academy has many of the familiar subjects of inquiry, such as astronomy, chemistry, and physics, but also many others, such as adversefluology, undulomancy, and cryptocatoptrics.

Bix asked Tarjik if there was a college for the conduct of war, and he said there was no longer, but there remained a small storehouse of dusty arms and armor from earlier times. But then he brought to our attention a sign nailed through the wall fresco. In large red letters, it said "THE TYRANNOSAURS ARE COMING!" signed, "Arthur Denison, Minister of Peace."

I was speechless, thunderstruck. A gong sounded. My time to meet the emperor was at hand.

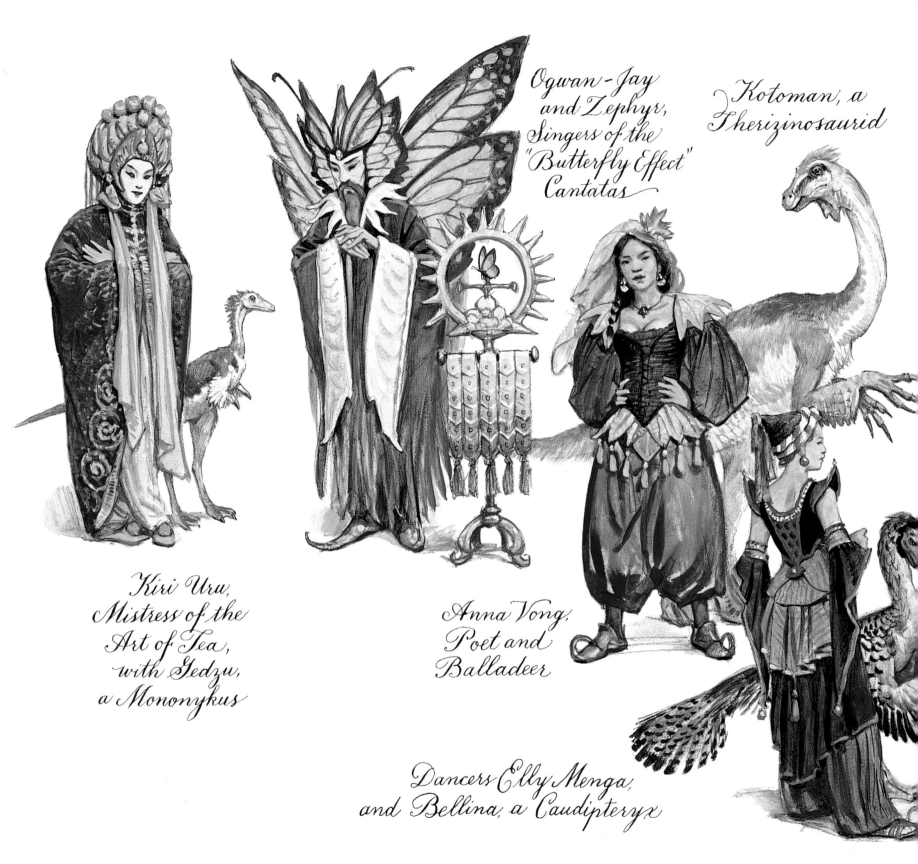

Kiri Uru,
Mistress of the
Art of Tea,
with Gedzu,
a Mononykus

Ogwan-Jay
and Zephyr,
Singers of the
"Butterfly Effect"
Cantatas

Kotoman, a
Therizinosaurid

Anna Vong,
Poet and
Balladeer

Dancers Elly Menga,
and Bellina, a Caudipteryx

At last Bix and I were summoned into the palace for our audience with the emperor. After a final sprucing, we entered the great hall, intricately carved from white marble on the outside and ornately painted within. A carpet of variegated hues led 1,000 feet along the center of the hall to a short stairway at the far end, where the throne room itself was veiled behind a series of curtains.

The ministers closest to the emperor are all manner of artists: dancers, musicians, calligraphers, painters, and poets, whose work brings pleasure to the emperor and peace to the realm. On their weekly excursions away from the palace, they also share their work with all of their fellow citizens and countrymen. Chandara's artists live in seven great houses perched along the slopes around the base of the palace.

I met a few of these artists in turn as they got ready to perform their pieces on the theme of the "Sorrowful Child." In twos and threes they answered the summons of the chancellor and passed through the curtain. Bix and I stood ready for our turn. Just then I recognized a familiar figure approaching us, scuffing his boots, and biting his cigar. It was none other than Lee Crabb.

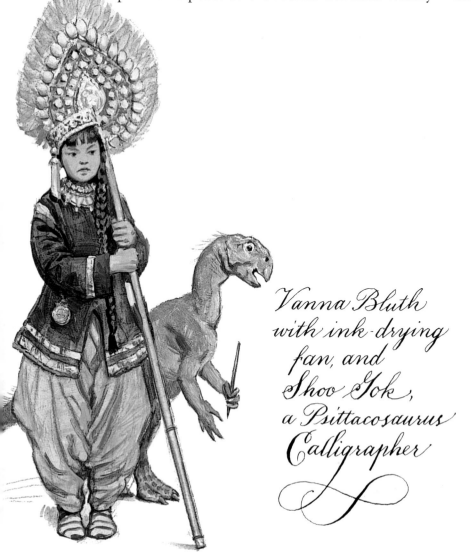

Vanna Bluth with ink-drying fan, and Shoo Jok, a Psittacosaurus Calligrapher

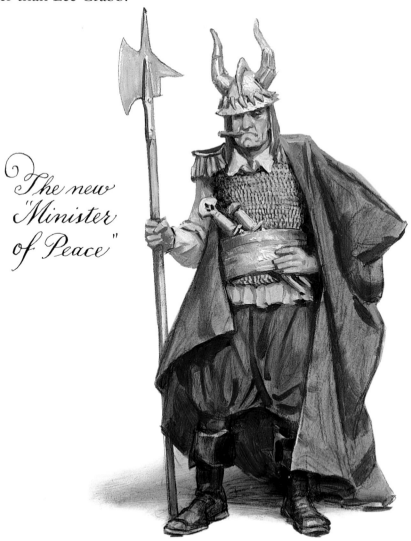

The new "Minister of Peace"

143

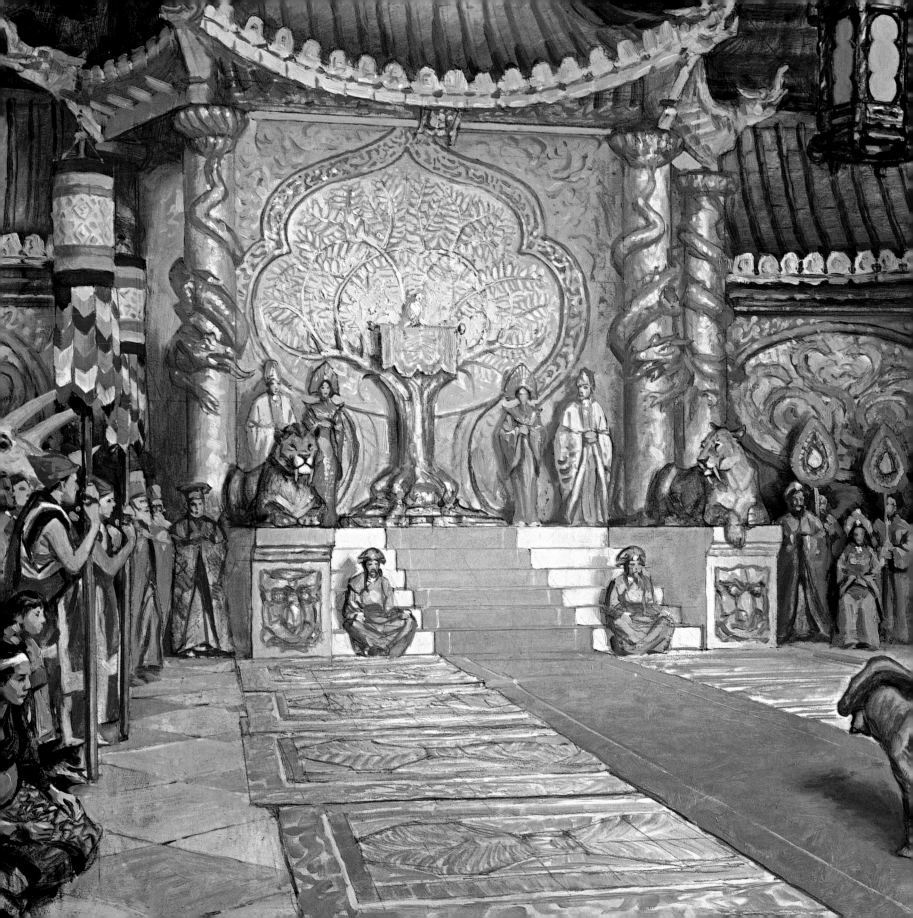

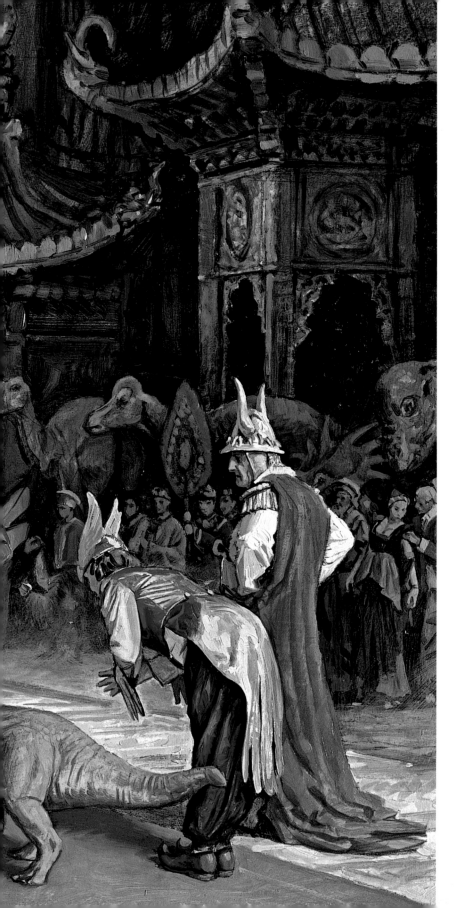

Before any of us could say a word, the three of us were called into the throne room. There was no throne, rather an ornate tree carved in wood with a high perch amid the leaves. Hugo Khan was neither a man nor a *Tyrannosaurus,* as I had anticipated, but rather a small birdlike dinosaur, something no bigger than an eagle. The sound of a children's chorus and the fragrance of incense permeated the air. I inclined my head forward to try to show respect.

Crabb swaggered alongside, scattering oaths and ashes. He muttered between his teeth, "You're a fool to kowtow like that."

"Who do you think you are, Crabb?" I returned, sotto voce.

"I'm not 'Crabb' anymore. I'm *Denison*. Play along! It'll be worth your while."

The chancellor, speaking for Khan, said, "Arthur Denison. Please speak first about the theme."

I had opened my mouth to speak, but Crabb stepped forward. "Thank you, your honor," he said, "'Sorrowful child' . . . Well, as I've been saying, we've got to watch out for tyrannosaurs invading, because they're out to kill off our way of life. If we don't do something to stop them now before they make trouble, there's going to be a whole lot more children being sorrowful."

"Thank you, Mr. Denison," said the chancellor, with a touch of weariness. He then turned to me. "Sir, you are the Guest of the Marketplace this week. Would you please be so kind as to give us your name?"

"Yes, your Excellency," I said. "*My* name is Arthur Denison."

Paying respects in the throne room

The Four-Winged Microraptor

"The emperor wishes to see you up close," said the chancellor. "Please do not fear. Make a perch with your hand." I reached up my arm the way I had seen falconers do.

The emperor flew toward me in a smooth motion, flapping his four wings, with his long tail streaming behind. He landed on my hand and folded his rear wings. He peered into my eyes with a hypnotic mixture of seriousness and humor. After a pause, he asked for one of his ministers to come forward with a movable perch, where he alighted. Bix translated his words, which were like musical phrases, often blend-

ing two pitches at once, in the way of a wood thrush.

"This man," Khan said, indicating Crabb, "also claims to be Arthur Denison. Do you know him?"

"I know him," I said, trying to contain my anger. "He is Lee Crabb. He stole your invitation from me, and he has taken my name as well."

Khan turned to Crabb. "What do you have to say to this?"

"I didn't steal the invitation," Crabb said. "I just borrowed it. I wanted to meet you, your worship, and to serve you. Besides, what does a name matter? You might call me Crabb, or anything else you please."

Khan fell silent to consider. He reached back unexpectedly to preen a tail feather. Then he said to Crabb: "You say you wish to serve me and that you are willing to have a new name. I shall give you one. Henceforth your name shall be 'Grungchock.' In the tyrannosaur language this means 'Courageous Provider of Sustenance.' You have been a guest in this court for two weeks. In that time you have been gathering weapons from our storehouse. This, you say, is to protect us. But these weapons, and the fear that made them, will not end the hunger of the *Tyrannosaurus*, nor in any way relieve suffering. So we shall put them to a different use."

He called for the Master of Metal Arts to come forward. "You shall take the metal from these weapons and fashion it into a very large cooking pot."

Crabb's eyes widened and he puffed nervously on his cigar. The emperor chuckled. "I see what you are thinking," he said. "No, no. You will not be the food. You, Grungchock, will be the chef. You will go to the Shaoling monastery in Silver Bay. There you will find the *Acrocanthosaurus* warrior-monks. You will provide them daily with fish and eels. They are peaceful and safe as long as you properly respect them and nurture them."

"May I ask," Crabb asked feverishly, "what happened to their last chef?"

"I regret that he did not take his job seriously enough. Let us that say he provided sustenance unintentionally."

"Mr. Denison," Khan said, "we still haven't heard your thoughts on today's theme."

I had a prepared a little poem, but now, after seeing the masterful performances of the other artists of the court, I kept it folded up in my pocket. "Your Excellency," I said. "Yours appears to be a magnificent empire, with great joyfulness and prosperity. But perhaps somewhere in this city there is a single child whose heart is heavy. If you could tell me and Bix where to find that child, we will go there to try to relieve its sorrows."

"I am well pleased," said the emperor. "Because you have shown concern for the least of my subjects, you shall be greatly rewarded."

Promising to return on the morrow, he took to the air, flying out from the throne room through a big window and into the evening sky above Chandara.

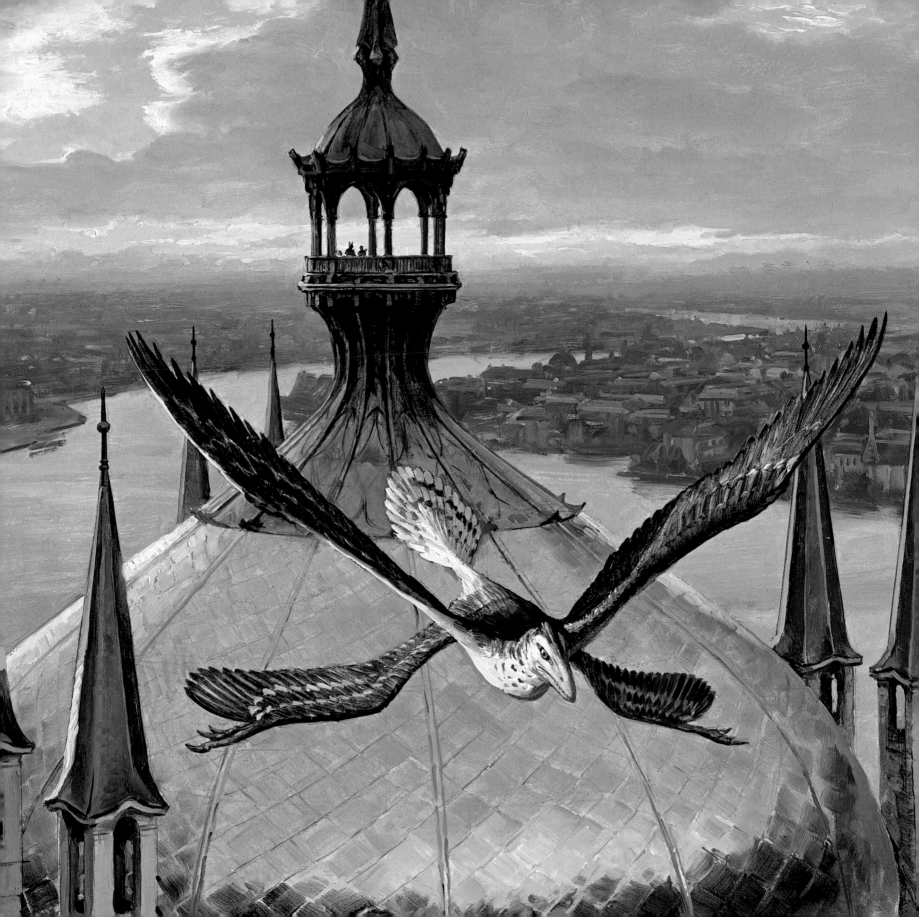

Rita Rose and Jeffer, a Europasaurus hatchling

The session in the palace was over. Crabb was escorted to a waiting ferry. The rest paid their respects to each other and went home to their abiding places. I climbed to the cupola to see the sunset. Far down below, I could see the emperor gliding down from the heights until he was just a floating speck above the rooftops.

Where did Hugo Khan go? Bix talked to one of the scribes next morning. During that night he flew over the streets, avenues, and alleys of the city he loved, watching over all the houses.

It was the custom in Chandara, before going to bed, to place a shoe on the windowsill and to leave in that shoe a note with a wish or a need. Khan stopped to read every note and consider how to respond to it.

On the windowsill of one particular house, a girl had left a note on behalf of her tiny hatchling. The creature was the only survivor of an accident that claimed the lives of the rest of his family. He was no longer willing to walk and both of them were growing more and more despondent.

At the home of Rita Rose

The next evening we arrived at the house of Rita Rose and Jeffer. We knocked on the door—Bix and I and a few of Chandara's finest puppeteers and magicians. We told a tale or two, sang a few songs, and drew some merry pictures. It was a glorious night of laughter that melted all the sorrows and mended our own hearts in the bargain. Jeffer, the young *Europasaurus,* not only walked again, but a short time later climbed up every step to the palace to meet the emperor.

One day soon thereafter, the emperor found Bix and me gazing toward the western horizon. We were thinking of our faraway friends. Many weeks had passed since we left Waterfall City. Were the flood waters still high? Were the star galleons at Bilgewater about to fly? Had the village of Jorotongo moved on? How deep were the snows around Thermala? I even wondered about Crabb, the old scalawag, by now meeting the warrior-monks of Shaoling.

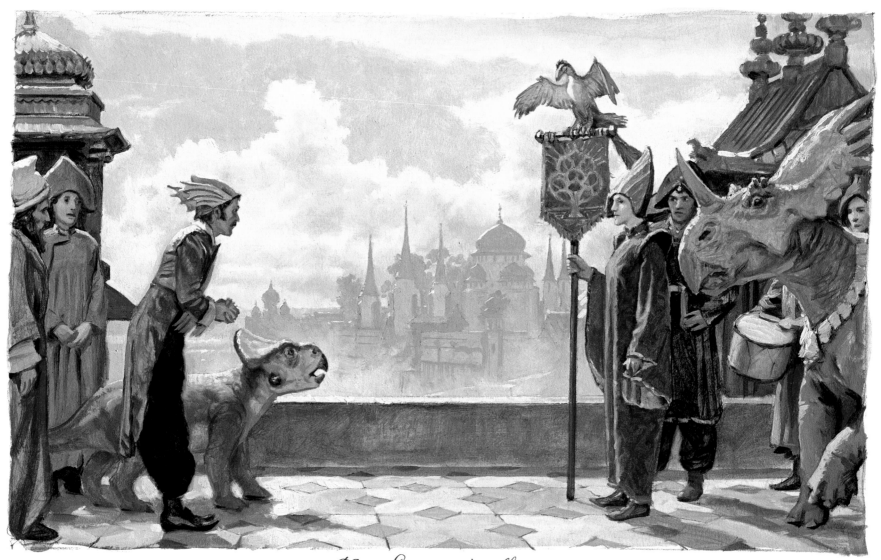

The Emperor's offer

"I can see that your hearts are wandering far from here," the emperor observed. "If you wish to go home, I will give you an escort, but we would miss you here. I must ask if you will stay with us in Chandara. I will need you, Bix, with your skills at language, to help me with translation. Arthur, I want you to take your place among the scientists and artists here at court. Perhaps you can begin filling the empty pages of your book with pictures of this city and all the lands hereabout. If your book could be seen in Sauropolis and Waterfall City, we might open the door of understanding between our empires."

Bix and I talked it over. In time, no doubt, our paths would lead us back again to our friends and to those favored places of our earlier journeys. Having completed our odyssey to Chandara, we realized that our quest had really just begun. There were many new wonders to be discovered.

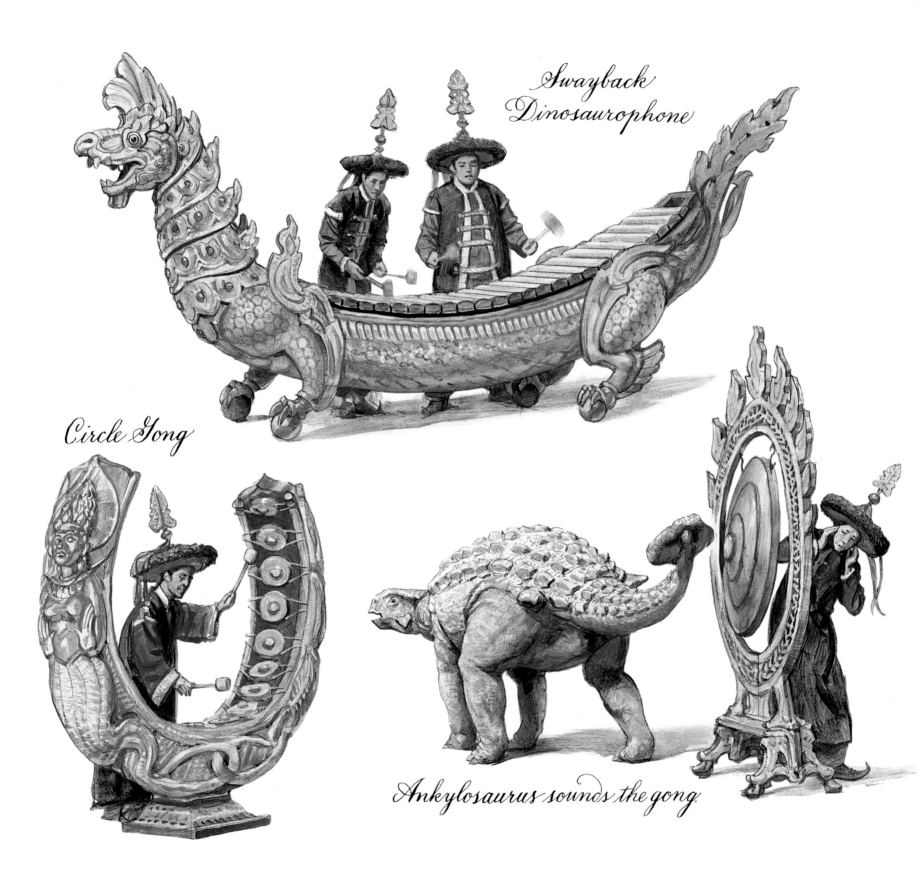

Swayback
Dinosaurophone

Circle Gong

Ankylosaurus sounds the gong

152

The "Concertuba" has never gone out of style.

When Bix and I announced our decision to remain, "at least for now," the emperor fluffed his feathers and shook in delight. The musicians brought out their instruments, as they did every week, for the Hilltop Concert—rather earsplitting, it must be admitted. The streets were full of creatures singing far into the night. It was a long time before the city settled back into silence. Before dawn next morning, with my heart rejoicing, I walked alone through sleepy streets down to the edge of the Zhengtao River to watch the sunrise.

Step-dancing Protoarchaeopteryx can't fly, but they get some lift from their small wings.

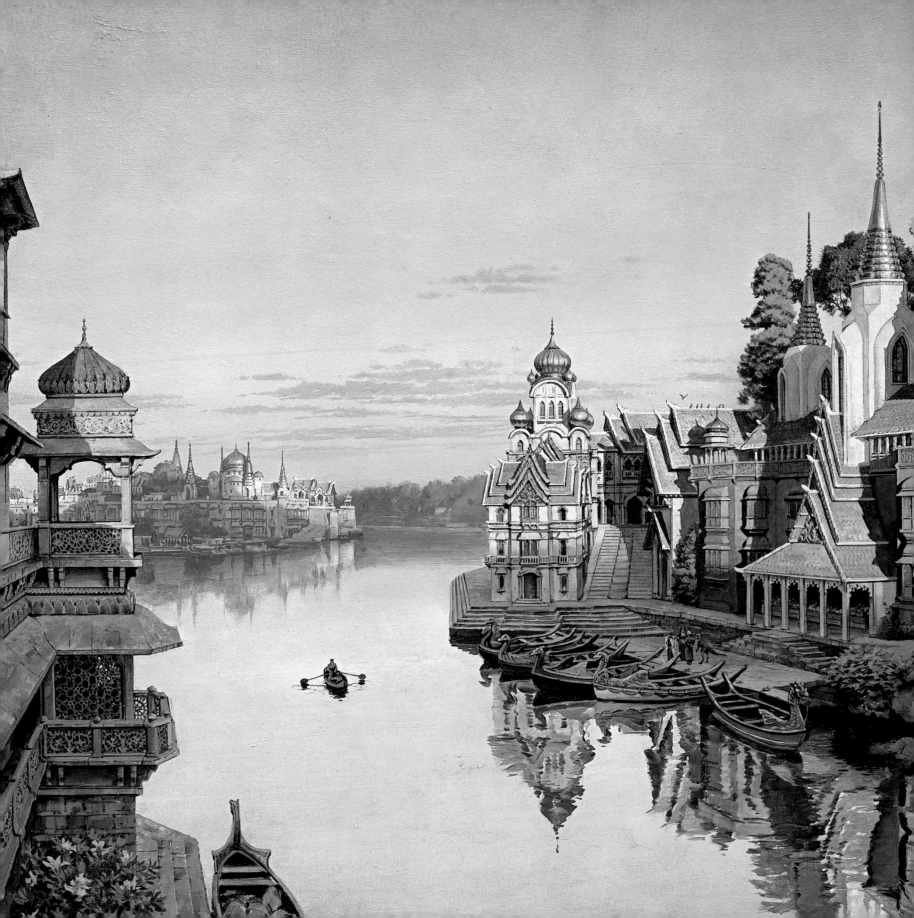

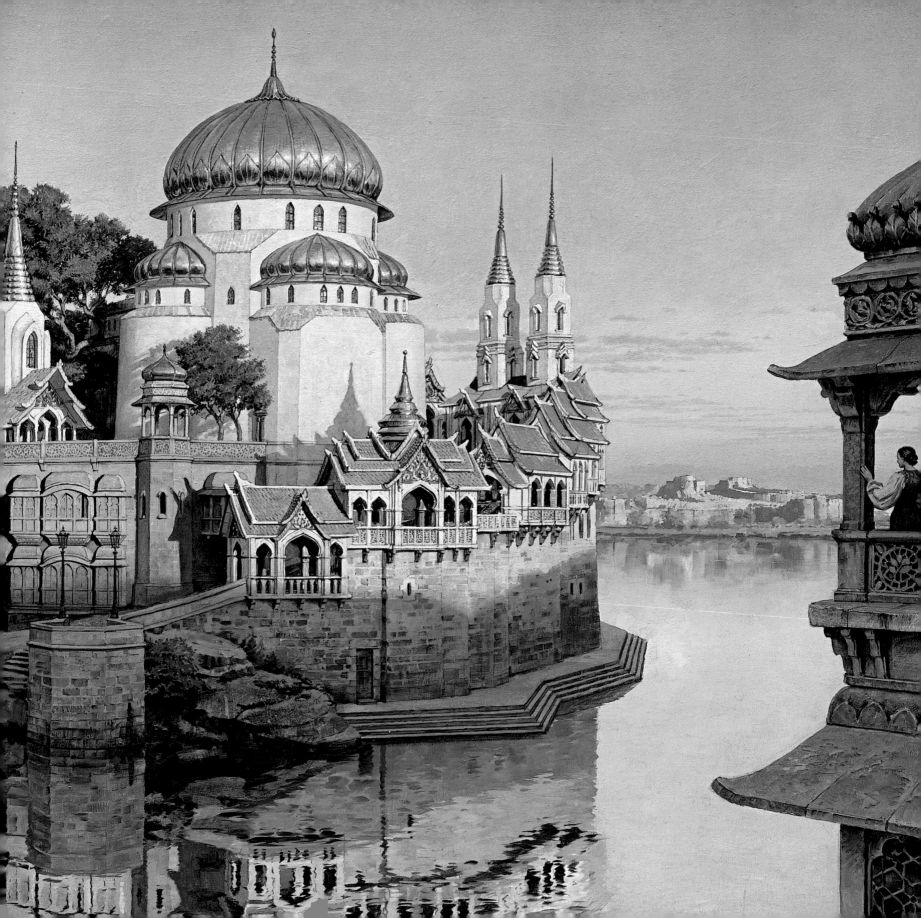

Garden Chorale

Serenely

1 Take me down to see the gar - den, Show me what the sun has made;
2 In a seed, a tree is hid - den, That a rain - drop can re - lease;
3 Join me on the wind - ing path - way, All we have is just this day;

Ev' - ry leaf is reach - ing up - ward, Drink - ing light and cast - ing shade.
In an egg, an Ul - tra - saur - us Will be - come a mas - ter - piece.
Win - ter will be here to - mor - row, Sum - mer's emp - ire can - not stay.

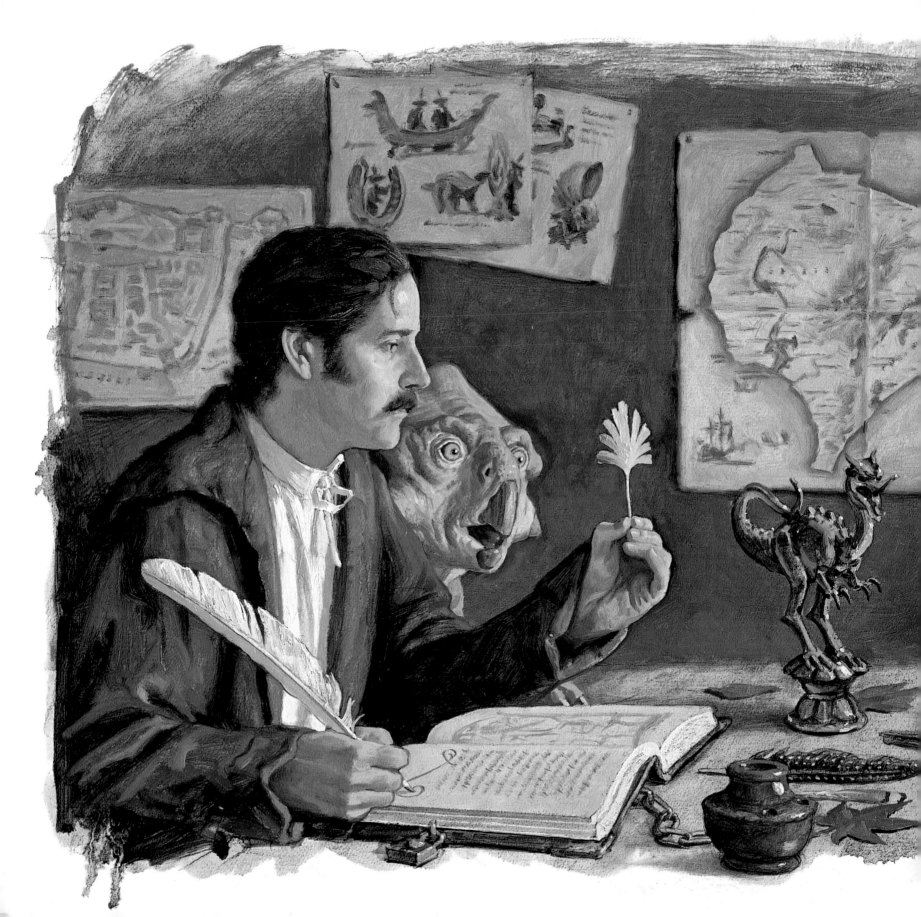

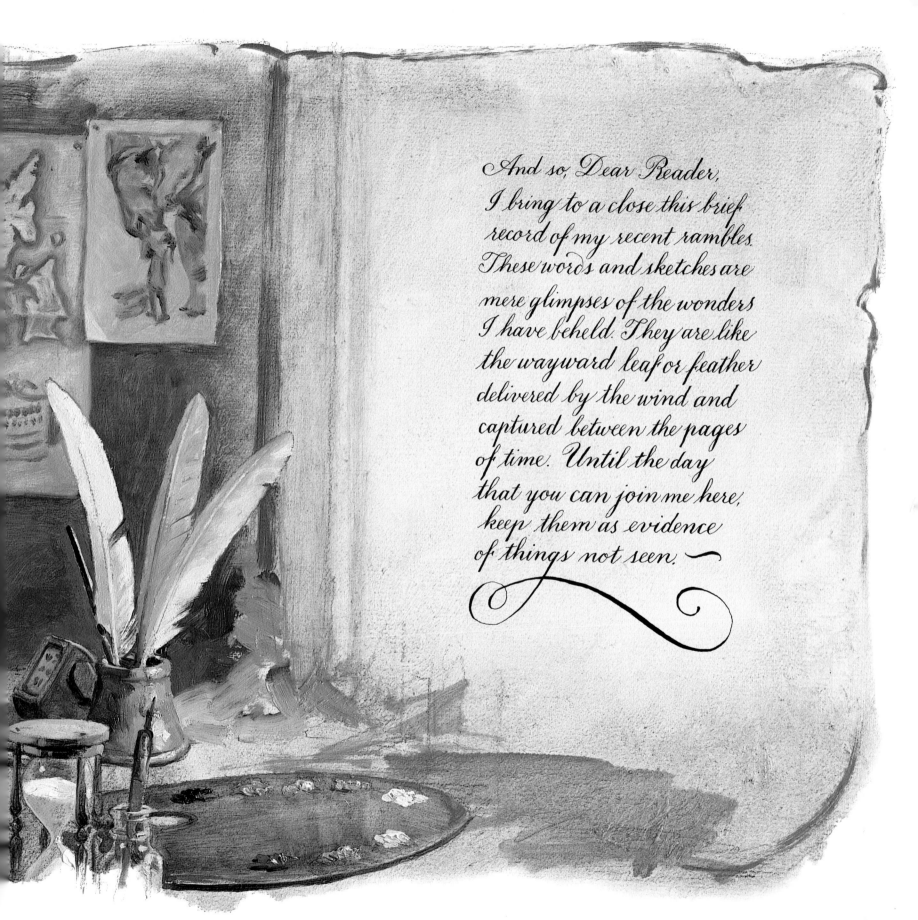

And so, Dear Reader,
I bring to a close this brief
record of my recent rambles.
These words and sketches are
mere glimpses of the wonders
I have beheld. They are like
the wayward leaf or feather
delivered by the wind and
captured between the pages
of time. Until the day
that you can join me here,
keep them as evidence
of things not seen.